Advance Praise for *The Devil*

"With *The Devil Wears Rothko*, Barry Avrich has produced yet another terrific examination of the truly historic art crime that brought down the country's oldest art galleries. He gets to the root of the crime and, in doing so, serves up the ultimate caveat emptor."

—Anthony Amore, bestselling author of *The Art of The Con* and *The Rembrandt Heist*

"*The Devil Wears Rothko* is a deep dive into a fascinating story of greed and duplicity in the art. A must-read for those interested in true crime, art forgery and the lines people will cross to get what they want."

—B.A. Shapiro, *New York Times* bestselling author of *The Art Forger*

"Hold your breath! This is a story about chaos. Avrich nails it.

The players are clever, ruthless charlatans hell-bent on deception and profit.

Start reading this book, and you will not put it down until you are finished, at which point you might just read it again."

—Jon S. Dellandrea, author of *The Great Canadian Art Fraud Case*, *The Group of Seven*, and *Tom Thomson Forgeries*

"The underside of the art world with a cast of characters worthy of a B-movie. A riveting true crime scandal."

—Don Thompson, author of *The $12 Million Stuffed Shark* and *The Orange Balloon Dog*

THE DEVIL WEARS ROTHKO

INSIDE THE ART SCANDAL THAT ROCKED THE WORLD

BARRY AVRICH

A POST HILL PRESS BOOK
ISBN: 979-8-88845-452-7
ISBN (eBook): 979-8-88845-453-4

The Devil Wears Rothko:
Inside The Art Scandal that Rocked the World
© 2025 by Barry Avrich
All Rights Reserved

Cover design by Josh Sinclair, BT/A Advertising

This book, as well as any other Post Hill Press publications, may be purchased in bulk quantities at a special discounted rate. Contact orders@posthillpress.com for more information.

This is a work of nonfiction. All people, locations, events, and situations are portrayed to the best of the author's memory.

No part of this book may be reproduced, stored in a retrieval system, or transmitted by any means without the written permission of the author and publisher.

Post Hill Press
New York • Nashville
posthillpress.com

Published in the United States of America
1 2 3 4 5 6 7 8 9 10

Dedicated to Faye Avrich for introducing to me to the intoxicating world of art; and to Jay Hennick who sent me headfirst into this incredible story.

CONTENTS

Preface..ix

Foreword..xv

Cast of Characters ..xvii

Chapter 1: To Catch a Spider 1
Chapter 2: Frame by Frame: Creating the Perfect
Storm for Fraud ... 17
Chapter 3: A Real Market for Fake Art...................... 24
Chapter 4: The Provenance of Pedigree: The Rise of
the Knoedler Gallery 40
Chapter 5: An Imperfect Reputation 55
Chapter 6: Ann Freedman: Born to Sell 62
Chapter 7: Bonnie, Clyde, and a Master Forger: A
Hollywood Casting Dream Come True 74
Chapter 8: The Con Is On.. 82
Chapter 9: Born Again, To Sell 102
Chapter 10: A House of Beautiful Cards 118
Chapter 11: I Will Set You on Fire: A Collector's Scorn 130
Chapter 12: A Pound of Flesh by Design.................... 139
Chapter 13: The Trial of the Century 151

Chapter 14: The Aftermath..178

Endnotes...200
Index ..208
Acknowledgments..222

PREFACE

IN 2019, WHEN I set out to make the documentary *Made You Look* to explore an extraordinary scandal that rocked the art world, I never imagined the depth of greed, lies, and bizarre cast of characters that I would ultimately encounter. The research, production, and eventual release of the film on Netflix exceeded what I thought people in this world were capable of. To this day, I am still getting emails and calls either from victims or tipsters who are making claims that certain scoundrels in my cast are up to their old tricks again.

Making a documentary is vastly different and, in many ways, more complex than a scripted film. But what made this project so Hollywood and deliciously addictive was a cast of characters that even my favorite screenwriters David Mamet (*Wag the Dog, The Untouchables*) or Steven Zaillian (*Schindler's List, American Gangster*) would be envious of. Where else can you have the inexplicable union of wealthy and allegedly brilliant master-of-their-domain art collectors, an oily conman selling fakes (and woman), a highly respected and pedigreed art dealer, a grandson of a controversial, famed industrialist, a Chinese immigrant

desperate to be a famous artist, and a gaggle of art world experts desperate for everything to be authentic?

It was perfection. Making the film was one of the greatest thrills of my life as everyone involved was totally committed to telling their side of the story, and perhaps engage in an often humorous and puzzling form of revisionism.

So why write a book now following a release of the film? The answer is simple: It is the story that keeps on giving, with new facts and characters surfacing. Since the Covid-19 pandemic, the art world and collectors have become more susceptible to art fraud, due to greed and a significant increase in wealth driving the demand for art.

The Devil Wears Rothko charts the explosive demise of New York's oldest and most prestigious art gallery with detailed and salacious insight into one of the world's largest art frauds, involving an $80 million deception that duped high-profile experts, famous collectors, and museums. The story also follows the behind-the-scenes making of a film about a very opaque world where secrets are kept and dirty laundry is exposed. Until now. The book also features new evidence uncovered during the making of the film and new reporting on a stream and trend of new art cons and fake art being sold to unsuspecting collectors every day.

The scene of the crime was the Knoedler (pronounced *Nude-ler*) Gallery, located in New York's ultra-wealthy Upper East Side. The gallery was originally established in 1827 as Goupil & Cie, a highly successful print publishing house, international auction house, and merchant of contemporary art and collectibles.

Goupil & Cie became a leading art dealership in nineteenth-century France and eventually became a worldwide

THE DEVIL WEARS ROTHKO

trader in fine art reproductions of paintings and sculptures, with a network of branches and agents in London and other major art capitals across continental Europe and in New York City in 1846. Michael Knoedler, an employee of Goupil & Cie, bought the New York gallery in 1857, changed the name to the Knoedler Gallery, and ran it with his son Roland. After Roland retired in 1928, the management of the firm passed to his nephew Charles Henschel, and then to Roland Balaÿ (Michael Knoedler's grandson). The firm was sold to industrialist and collector Armand Hammer for $2.5 million in 1971 and ran continuously until closing abruptly at the end of 2011.

What follows is our sordid tale of greed, deception, and absurdity.

In the spring of 2000, Glafira Rosales, a woman from Long Island no one in the art world had ever heard of, walked into the Knoedler Gallery and met with the gallery's director, Ann Freedman, for the first time. For the next fourteen years, Rosales, along with the help of her then-boyfriend, Jose Carlos Bergantiños Diaz, and Pei-Shen Qian, a Chinese immigrant and master forger, would run an $80 million forgery ring through Knoedler, selling or consigning forty expertly crafted counterfeits, among them, Robert Motherwell, Jackson Pollock, and Mark Rothko. Freedman's question of complicity was the headline and nagging question. What did she know? What role did the experts play that mistakenly "authenticated" the fakes? Should the collectors have known better? And what was renowned Canadian art collector David Mirvish up to when he invested in the fakes along with Freedman to be later sold at an obscene profit?

Collectors that had purchased fake art from Freedman panicked, resulting in many of them suing and a few threatening bodily harm to Freedman. The next decade would be a snake pit of lawsuits, finger pointing, diving for cover, and one outrageous trial.

Welcome to a world that is notoriously opaque with pathological levels of discretion. There is no oversight, and most players get away with tons of ethically dubious behavior. Many of the collectors who purchased fake works from Knoedler maintained their veneer of privacy, choosing instead to settle with the gallery out of court—except for Domenico De Sole, who insisted on going to trial to get his pound of flesh, in return for the fake Rothko for which he paid $8.3 million.

The trial unearthed one of the greatest scandals the art world has ever seen and laid bare the chain of suspicious dealings that brought down what had once been a storied gallery. The details of Knoedler's raised questions about whether the lack of transparency at the high end of the art market can destroy the market, or if forgery will continue to plague the market.

In the following pages, we will go inside the scandal and expose the criminal masterminds, the complicit players that looked the other way, and the greedy collectors who were prepared to accept a promise over provenance to elevate their collection and status. The book will also trace the forgeries in delicious detail and chronicle the often dramatic and hilarious trial through the eyes of its key players, including defendants, victims, lawyers, and expert witnesses.

I'll feature new evidence and spectacular interviews that have never been seen or heard before from collector and victim Domenico De Sole, Knoedler Gallery president Ann Freedman,

THE DEVIL WEARS ROTHKO

gallery owner Michael Hammer, and forgery mastermind Jose Carlos Bergantiños Diaz. *The Devil Wears Rothko* is the ultimate crime thriller that exposes how even the 1 percent is susceptible to falling prey to those that see them coming.

Fun fact: One collector bought a fake Jackson Pollock for $7.2 million that had the artist's signature misspelled.

This book was not written for art experts, art world journalists, or historians, so spare me the clichéd critiques about omissions and what you already knew before reading the book. I wrote this for anyone who loves a great crime caper.

The structure of the book is such that I want the reader to understand the art world, the collectors, and what led to this perfect storm. If you want to get to the juicy parts, you can skip the early chapters that set the table for the crime that unfolds.

Regardless, welcome to a world to which you are mostly not invited. Some people love art. Others don't care about it at all. They just make the world uglier by preying on those who have a passion for art beyond reason.

Have fun. I did.

FOREWORD

AFTER DIRECTING THE VERY successful documentary *Made You Look*, Barry Avrich has now written the definitive book about the Knoedler Gallery story.

Beautifully written, the book sheds light on the shady side of the art world as it chronicles the scam and the subsequent art "trial of the century" that ended with the demise of the oldest and most respected art gallery in North America.

My life lesson and advice to art collectors after enduring this cataclysmic episode is to buy the art you love and want to look at every day. I never built my collection as an investment. For me, art makes you feel good; it's an escape from life into a world of beauty and serenity.

The takeaway from Barry's wonderful book is that everyone can fall in love with art, but you must allow yourself to be seduced with your eyes wide open.

This book is not only for art lovers but also for anyone who enjoys a good read.

—Domenico De Sole
Former chairman of the board, Sotheby's
Former chairman and CEO, Gucci Group
Cofounder and former chairman, Tom Ford International

CAST OF CHARACTERS

Ann Freedman, President, Knoedler Gallery, Victim/Conspirator (?)
Michael Hammer, Owner, Knoedler Gallery
Glafira Rosales, Art Dealer, Convicted Fraudster
Jamie Andrade, Knoedler Gallery Associate
Jose Carlos Bergantiños Diaz, Criminal Mastermind
Jesus Bergantiños Diaz, Jose's Brother, Co-conspirator
Pei-Shen Quin, Master Forger
David Herbert, Art Dealer
Alfonso Ossorio, Painter
Mr. X, Supposed Art Collector
Mr. X Jr., Supposed Son of Collector
Jack Flam, CEO, Dedalus Foundation (Motherwell)
Ronald Spencer, CEO, Pollock-Krasner Foundation
Sharon Flescher, Executive Director, International Foundation
 for Art Research (IFAR)
Domenico and Eleanore De Sole, Collectors, Victims
Pierre Lagrange, Collector, Victim
David Mirvish, Collector, Victim(?)
Dore Ashton, Art Historian
Dana Cranmer, Art Conservator

Ruth Blankschen, Knoedler Gallery Bookkeeper
Jack Levy, Collector, Victim
Peter Paul Biro, Master Art Authenticator
Luke Nikas, Lawyer (Ann Freedman)
Christopher Rothko, CEO, Rothko Foundation
E.A. Carmean, Art Expert
David Anfam, Art Consultant, Rothko Expert
Stephen Polcari, Art Historian
Jason Hernandez, Prosecutor, Southern District New York
James Martin, Orion Analytical
Patricia Cohen, Journalist (*The New York Times*)
Perry Amsellem, Lawyer (Dedalus Foundation)
Charles Schmerler, Lawyer (Michael Hammer)
Melissa De Medeiros, Assistant (Ann Freedman)
Michael Shnayerson, Journalist (*Vanity Fair*)
Michael H. Miller, Journalist (*The New York Times*)
Marjorie B. Cohn, Art Historian, Curator
Julian Weissman, Weissman Fine Art, Conspirator/Victim(?)
Maria Konnikova, Psychologist, Author, Poker Player
Isolina Corbelle, Daughter of Glafira Rosales, Art Dealer (Soli
 Corbelle Art)

CHAPTER 1

TO CATCH A SPIDER

THE YEAR WAS 2002. It was a crisp, autumn day in New York City when Glafira Rosales walked into the Knoedler Gallery located on East 70th Street, prestigiously snuggled in between some of the priciest private real estate in the world. The Knoedler Gallery was a five-storey, turn-of-the-century, white townhouse building that at any time had $100 million worth of art on its walls, and another thousand dirty secrets.

The Knoedler Gallery was owned by the infamous Hammer family, a dynasty that had a fancy pedigree but also a lurid past of espionage, stolen art, alleged cannibalism, and empire building.

The gallery had seen massively profitable and influential times during its 125 years and was now facing a desperately dark and lean period. The art world was changing rapidly and the Knoedler Gallery needed a miracle, or it was going to be reduced to a real estate trophy for sale. While the Hammers were content with cashing in on their grandfather Armand's real estate acumen, the gallery's ambitious and relentless director, Ann Freedman, was looking for a Hail Mary at any cost.

Rosales was that Hail Mary. She was forty-eight, of Mexican descent, and well-dressed in head-to-toe designer clothes from the Max Mara coat to the Gucci scarf and the Fendi purse. She looked like many of the other well-heeled women walking up and down Madison Avenue. What distinguished her was her demure, almost shy personality and the crudely wrapped large package that she was carrying. The package was wrapped in nondescript brown craft paper and held together with string.

She spoke with a slight Spanish accent and asked to see the gallery director. She had a painting to sell. The interesting thing about Freedman is that she is not a snob in a very snobby world. Unlike her peers in the art world, she appreciated that a billionaire often doesn't look like what we think a billionaire should look like, and that anyone can stumble upon a priceless piece of art without even knowing it. Conversely, the gallery world saw Freedman as icy cold and dismissive of her peers. If I were casting a feature film, the part of Ann Freedman would be offered to Meryl Streep.

What Freedman saw in Rosales was a well-dressed woman who seemed to know enough about art to play the role of a knowledgeable art savant without any pretension. Freedman liked her. What happened next would change the destiny for both women in ways that were unpredictable, outrageous, and scandalous.

Rosales carefully unwrapped the object she was carrying. Freedman nearly fainted. They were both looking at a stunning Mark Rothko painting. Freedman was speechless.

Bringing a Rothko to market for sale was rare and would certainly create a much-needed headline and sale for Freedman and the gallery. She had a hundred questions for Rosales about the painting.

Rothko, part of the famed abstract expressionist movement, experienced massive success late in life before being lost to suicide at age sixty-six. His work was rarely available at auction as most collectors kept the work in their families for generations. When his work was sold, it was not uncommon to see major bidding wars. The last big price achieved at auction for a Rothko was $82.5 million for *No. 7* (1951), from the Harry and Linda Macklowe Collection at Sotheby's in November 2021. Six months later, two wider 1960s canvasses sold by the estate of Anne Bass fetched $66.8 million and $49.6 million.

Over the next few hours, and subsequently the next ten years, Freedman had her Hail Mary multiplied by a hundred. Rosales had a total of forty priceless paintings just like the Rothko, and other masterpieces to sell. The Knoedler Gallery would sell the collection over time for nearly $80 million.

By 2012 both Freedman and the gallery were now back on top as one of the most enviable galleries in the art world. There is no spoiler alert here in that the art Rosales was selling was fake. She knew it, but was Freedman a willing accomplice or a victim of a con just like her clients who bought the fakes?

One of the most compelling things I've discovered in the decades I've been interviewing the likes of murderers and moguls, rock stars and swindlers, is that those who put up the biggest protest, and initially decline being interviewed, in fact, truly want to tell their story, flaws and all. It is almost a Freudian endeavor to spin, alter, and manage reputation and personal legacy.

Ann Freedman is that person. She was once the doyenne of the New York art scene armed with a killer rolodex of billionaire art collectors on speed dial, such as hedge fund king Steve Cohen

and Hollywood mogul David Geffen. She once represented artists such as Frank Stella, Jules Olitski, Jasper Johns, and Robert Motherwell, each commanding millions for their work. She was in the ultimate seat of power, with her throne being a 150-year-old powerhouse gallery.

Freedman's own meteoric rise was worthy of a Hollywood story. She studied art and dreamed of being an artist herself. When she recognized she wasn't talented enough, she pivoted to where the big money was—selling the art versus making it.

Hammer had heard about Freedman's hustle and elevated her quickly to the gallery's director and eventually to president where she would later report to Hammer's grandson, Michael. (More on that nightmare later.)

Rosales told Freedman she had a collection of dozens more paintings such as this one from the lucrative abstract expressionist period that included more works by Rothko, Pollock, and Motherwell, among others. Freedman was near giddy. These works of art rarely come for auction, beyond this purported collection of never-seen-before masters. Freedman nearly collapsed from what she called a religious experience.

Rosales told Freedman an impossible story that the art had no written paperwork that defined its provenance (the lineage of ownership). She simply said it came from an anonymous collector who was at one time hiding his homosexual affair with the married benefactor that gave him the collection. Rosales was brilliant in that her story was peppered with enough believable facts that hooked Freedman immediately and let her believe she had uncovered a massive modern day art discovery that would save her and the gallery.

THE DEVIL WEARS ROTHKO

Freedman would buy the art from Rosales at an average price of $700,000 per canvas and then sell each painting from anywhere from $7 million to $9 million per painting to a frenzied group of collectors. Ultimately, Freedman would gross more than $80 million for the gallery. She personally received a commission of $10 million.

In the Rosales fakes, Freedman had her miracle. She was once again powerful and the talk of the town. Her enemies were incredulous about the newfound collection, but there was no disputing the sales she was making or the prestigious art appraisers who were authenticating the works. Freedman's discoveries were featured on the cover of art magazines, purchased by art institutions, and shown in major art shows.

All was well in the world of Knoedler, until it was discovered, one by one, that all the art that Freedman had purchased from Rosales was fake. Game over. Knoedler and Freedman were pariahs. For the next five years, Freedman and Hammer settled vicious lawsuits, faced scathing media coverage, and yet miraculously avoided criminal prosecution.

As things were somewhat settling down for Freedman, a friend of mine who knew her, an art collector, suggested that she meet me and talk about a film idea I had.

After a few cancelled meetings, we would finally meet for late afternoon drinks on a cold autumn day in 2020. Freedman was curious. She loves studying people as an anthropological experiment. I think it was what made her a brilliant salesperson. We both wanted to study each other.

I told her to meet me at a hotel located a few blocks from her Upper East Side gallery that was astonishingly located three

blocks from where the now-infamous and defunct Knoedler Gallery was previously located.

The extraordinarily beautiful Knoedler building that had once housed the gallery was sold quickly by its owner, Michael Hammer, after the scandal forced it to close. Hammer sold the building to Leon Black, a controversial investor, art collector, and past board chair of the Museum of Modern Art (MoMA) for $31 million.

Black attracted headlines himself in 2020, when it was revealed that he paid his friend, the notorious Jeffrey Epstein, more than $150 million for financial advice. There is some strange six-degrees-of-separation shit going on when a billionaire buys a building tainted by a massive art scandal for the purpose of converting it into a private residence that happens to be a block away from Epstein's house of horrors.

Black lavishly renovated the former gallery into his personal residence and featured his massive "real" art collection that included Edvard Munch's *The Scream* that he bought for $119 million, and a rare work by Raphael for $29 million after a four-party bidding war in 2013.

Freedman met me at the Jean-Georges restaurant inside the elegant The Mark Hotel. The Mark was located across the street from the famed The Carlyle, the hotel where eight years earlier, one of Freedman's disgruntled clients threatened to set her on fire in a fit of rage when he found she had sold him a fake Jackson Pollock for $8.3 million. Freedman perversely offered to resell the painting for the seething French hedge fund king.

The Mark had become one of the Upper East Side's toniest hotels where the rich and powerful stayed when they were in town for the Met Gala and the major seasonal big-ticket art

auctions. I was not going to take a woman who had once been the Queen of the New York art scene to a diner.

I did find it odd that she didn't object to a venue that would most likely be frequented by her prior clients or have art dealers seated a few tables away from us. I would learn quickly about Freedman, whether it be hubris or obliviousness, that she did not shy away from her past sins or those who talked about her in less than flattering terms.

Freedman arrived dressed head-to-toe in cashmere, resembling a thinner version of the character Beatrice Arthur played in the Norman Lear series *Maude*. She is tall, wiry thin, and powerful looking. She surveyed the room and said, "Well, no enemies present," and proceeded to spin a yarn about the countless collectors she had wined and dined in this same room. I had chosen well, and I made a note to myself that if she agreed to be filmed, I would shoot all the interviews in a suite in this very hotel. In fact, we did end up doing this, even though Freedman found the art in the hotel "hideous."

I found an odd contradiction in Freedman's personality. She was a strange blend of your kooky aunt who couldn't stop talking and the icy character that Meryl Streep played so well in portraying *Vogue* editor Anna Wintour in the film *The Devil Wears Prada*, but far less elusive. She was confident but fully knew she had fallen from grace. She accepted no responsibility for the scandal and yet she does regret the decisions she made.

Over the next three hours and a few bottles of expensive Montrachet Chardonnay wine that she ordered, which I paid for, she would tell me her side of the story. She was a great storyteller. I was intoxicated by her and yet I was not convinced that she was as innocent as she claimed. "Barry," she claimed, "I was

the victim here." Our drinks segued to dinner around the corner at Sant Ambroeus, an upscale and intimate Italian restaurant on Madison Avenue.

Sant Ambroeus would be the setting for many of our dinners over the next years, before and after we began filming. The very first night we dined there, on what she would call my "audition" and what I would refer to as spinning a web, she did turn heads when she walked in. The patrons were older, very rich Upper East Side-establishment types who knew very well who she was. I was the question mark in their eyes.

When I told her that various people were looking at us, she identified all of them one by one with a great story. Many of them in the past had begged her to sell them art, inviting her to lavish dinners at their homes. She did not seem too fussed by it. Collectors came and went like the four seasons, and what truly bothered her was no longer being part of the exclusive club of art dealers and museum directors who once fought for her attention, coveted her client list, and envied her access.

Today, the art dealers and gallery owners avoided eye contact with her at art shows and crossed the street to avoid her. Freedman was deeply hurt by this. She told me that every one of them was guilty of making mistakes in buying fake art, being fooled just like she was. She could never understand why she, now also a victim, was suddenly exiled from a kingdom she once ruled.

Over dinner and more wine (she seemed to have a hollow leg), she told me her side of the story, the victim story. As with every subsequent encounter we would have after this first dinner, Freedman comes to the party with a tote bag filled with dozens

THE DEVIL WEARS ROTHKO

of photocopied newspaper articles featuring stories about people who were the victims of massive art cons.

Freedman had victim profiles, great historical research, and psychological reports on those who execute cons and those who fell for them. She spoke endlessly about people who fall victim all the time. She too was a victim of a con, not a con artist.

Over dessert, she then moved on to the next collection of tote bags. It was almost as if she were a classy bag lady. In the six months of meetings with Freedman before we began filming, I schlepped away fifty-five tote bags of articles. Anything to declare? Yes, a hernia. Tote bags number four, five, and six contained her evidence that she was a victim and not a criminal.

To bolster her case that she was duped, Freedman showed me a voluminous cache of evidence that supported her position that "anyone would have believed that the Rosales art was the real thing." She said: "Barry, people discover lost art in barns and attics everyday." We were the last ones in the restaurant by the time Freedman rested her case.

On the surface, it did look like Freedman was a pawn in a sophisticated crime. Her extensive evidence showed that many art experts, museums, galleries, and pedigree art publications either exhibited, promoted, or authenticated the art.

Freedman was a great salesperson, and I was hooked. Her claims of steadfast innocence were credible, but I would need to dig further and cross examine her on film, should she agree to participate. She was still unsure if she wanted to go on camera. We agreed to meet at her gallery the next morning, where I knew I had to close her. No Freedman, no film.

That night, I could not sleep. I knew I had a great film and if I could convince Freedman to be in it, I would let my audience

9

decide whether she was a guilty or innocent player in one of the largest art crimes of the century.

The next morning, I wandered into Freedman Art, located at 72nd and Madison, a mere three blocks away from the now-defunct Knoedler Gallery. Her two-floor gallery was modest and a major departure from the large and impressive open spaces of the Knoedler. Freedman Art was located on the third and fourth floors of a small building over an Italian restaurant. To get to her gallery space, you had to take a shaky, small elevator that seemed to let out a groan as it slowly rose to each floor, finally letting out a gasp when the doors opened at Freedman Art.

Freedman had two floors displaying mostly unknown artists and occasionally a trophy piece of art that she was selling on consignment for an estate or a past client who trusted her. Since the scandal, Freedman had surprisingly managed to eke out a living by selling art on what was called the "secondary market." This consisted of collectors or estates wanting to unload what could be an impressive piece of art directly to a seller without having to go through the costly auction process.

Freedman still had a list of buyers looking for deals and she had not lost her ability to sell fast and hard. And, of course, she could earn a commission selling the piece and, in some cases, get a secondary commission from the buyer as well. In the many times I visited her gallery, she would not let me leave without trying to sell me something I couldn't afford.

On the bright, crisp morning that I arrived, she proudly showed off the art she was offering, including a few stunning pieces on consignment. After everything she had been through and accused of, she maintained a remarkably trusting relationship

with artists such as Stella, Olitski, and Helen Frankenthaler, Motherwell's widow.

Today, instead of tote bags, she laid out more evidence on a massive table to support her innocence. She would add to the buffet of paper every few minutes by asking her shy daughter Jessica to photocopy or print out another article or photograph. Freedman was such a great storyteller. I had to get her locked in for the film. Now, it was my time to pitch.

She took me to a living room area where she entertained prospective buyers. It was beautifully furnished with modern pieces that she proudly claimed were designed by her close friend, the famed designer Holly Hunt. Before I could open my mouth, she said: "You know I really like you. But I said no to *60 Minutes*." Anderson Cooper himself had called her for an interview, and she found him aggressive and didn't trust his perspective on the story.

She had refused most interview requests and where she did agree to go on the record, she ultimately felt her words were taken out of context, leaving her further damaged. In a recent episode of the CNBC crime series *American Greed*, she felt she was portrayed as a villain and gluttonous art dealer that preyed on victims. She said making my film was a no-win option for her. Now, I had to be the salesperson.

A few weeks back, I contacted mogul and art collector Domenico De Sole, asking him to be interviewed for the film. De Sole had been a victim of the Knoedler scandal. He had purchased a Rothko from Freedman for $8.3 million and was beyond furious when he discovered it was a fake.

He was the only victim that took Freedman and the gallery to court in what would be the art trial of the century. It was a

surprisingly public move for a person like De Sole, given that he was the chair of a major auction house and the mogul that not only sold the Gucci empire, but also created Tom Ford, the fashion powerhouse designer.

Approaching De Sole was sort of a dry run before meeting Freedman. I didn't want to make the film without a victim, and I felt that if I could convince De Sole, who had nothing to gain by being in my film, then maybe, whatever tactic I came up with could work on Freedman.

Although De Sole had settled his suit against Freedman, he still wanted his pound of flesh. Negotiating with him was like swimming with sharks. I was way out of my league. He was angry. He blamed Freedman for everything. Even though he had an art consultant vet the Rothko, it was Freedman who owned the con.

Like Freedman, De Sole felt that his previous twenty-minute interviews had been unjustly edited into sixty-second soundbites. The more I listened to him, the more I realized he was in the business of vanity. His entire career from Gucci to Ferragamo, from Sotheby's to Tom Ford, was about vanity. I needed to appeal to his own sense of vanity to close the deal. I told him that I was making a feature film, not a thirty-minute newsmagazine of soundbites. He would have hours to tell his side of the story. Unedited and uncensored. He would be the star of the story.

I sent him my other films to screen. He agreed. Vanity prevailed. He wanted to tell his side of the story. We would film his interview, along with that of his wife Eleanore, at their breathtaking home in a gated community on Hilton Head Island, South Carolina. The De Sole cantilevered home featured some of the

greatest art I have ever seen in a private collection, including a real Rothko.

Cut back to Freedman and our meeting in her gallery. She went back and forth, vacillating as to whether to participate. Cue vanity. I said to her: "Ann, I can't promise that this film will vindicate you. However, in your own unedited words, you can finally tell your side of the story. You will be the star of the film. Not a journalist or television reporter. Just you."

In fact, this was something that I would tell her over and over during the making of the film. She would get upset when she heard I had interviewed what she called "enemies." And yet she wanted to hear everything they said about her. I gave her the opportunity to respond to some of their often-damning comments. I told her I would be fair. I sent her my previous films to watch. I always let my audience decide who is guilty and who is innocent, even in a story with a lot of blame to go around.

And then I had her. She presented me with a piece of paper that had a carefully thought-out list of people she felt should be interviewed—all of them to support her innocence. She looked at me and said: "Do you think this documentary could be made into a feature film? Could there be real money involved?"

And then came the kicker: "Who would play me?" she asked.

Vanity trumps all.

I had one last person to convince before she signed on, but I was feeling confident. Freedman was now sending me five or six emails a day with suggested names of people who agreed to be interviewed, and dozens more clippings of educated people like herself who had fallen for art cons. She wanted me to talk to the lawyer who represented her in the De Sole trial and assisted in settling another ten lawsuits from angry collectors.

Luke Nikas would not be a problem for me. Although a fierce litigation specialist, legal warrior, and co-chair of his firm's art litigation and disputes practice, Nikas never met a camera he didn't like. Prior to my walking into his office, he had made dozens of television appearances on the Knoedler case alone, including on CNN, *60 Minutes*, and *American Greed*. He worked with actor Alec Baldwin to turn this same story into a web series or podcast, which they eventually did.

Baldwin was fascinated with the Knoedler con, having also been a victim of a fake art sale. He would later interview me on a panel when the film screened at the *Hamptons International Film Festival*. He told me he felt Freedman was guilty.

The Nikas office walls were covered in framed newspaper clippings and a lot of fake art seized during the Knoedler case. Vanity. Nikas loved the idea of participating in the film and we had chemistry. He was a showman and I love a storyteller. During the filming, Nikas even gave us access to all his files in prepping Freedman for the De Sole trial, as well as her infamous interviews with the Federal Bureau of Investigation and the fierce prosecutors from the Southern District of New York.

I found it somewhat entertaining that when the film was finally released on Netflix in 2020, I received an email from Nikas, who had previously not seen the film, congratulating me on its release. Freedman, however, did not like it.

On with the show. With the Nikas blessing and unbridled enthusiasm, we began setting the scene for what would be six filmed sessions with Freedman. She insisted we have dinner or lunch after every session. She would take my temperature as to where I felt the story was going. Of course, she had another tote bag filled with articles and "evidence" for me. Her guilt or

THE DEVIL WEARS ROTHKO

innocence was a question that my crew and I debated over dinner after every filming session with her. She was icy cool and had an answer for everything, despite an ocean of red flags.

The next year would be a balancing act to keep Freedman engaged. She was often spooked by my stories of people, whom she despised, who had joined me for interviews. She was leery and yet intrigued by my wild trip to Lugo, Spain to track down the mastermind of the Knoedler con, Glafira Rosales's husband, Carlos Bergantiños, and my journey to a fake art factory in Shenzhen, China. These stories worried her, as they were pulling focus away from her. But with another dose of vanity on my side, my leading star, my Norma Desmond, would stay the course and always be ready for her closeup.

CONVINCING ANN FREEDMAN, MANAGING director of the Knoedler Gallery, and architect of one of the world's most infamous scandals, to tell her story for the first time ever was one of the greatest challenges of my documentary-filmmaking life. She is a combination of P.T. Barnum and Anna Wintour. Within the dark paneled walls of Jean-Georges at The Mark, followed by several bottles of Montrachet, she agreed. Listening to Freedman fervently recount her side of the story was like watching Bill Clinton deny any misadventures with Monica Lewinsky. She honestly believed she was the "victim" and perhaps she was, but it was fascinating to listen to her spin. At the end of the story, she wanted me to almost applaud as if I had just watched Laurence Olivier deliver a tremendous stage performance. I stared at her and nodded and was reminded of what my close friend, the late actor, James Earl Jones had told me once backstage after a performance in London's West End:

"When you witness someone that has given a mediocre or sub-standard performance, you should knock on their dressing room door and simply say, 'Look at you, you've done it again.'" And that is what I said when Freedman asked me about her version of the story would play on camera, She smiled and I knew then she would be great on camera.

Also fascinating was the fact that, after this scandalous fiasco, Freedman opened her new gallery, Freedman Art, just two blocks from the now-shuttered Knoedler Gallery, on 70th Street. She has no discomfort passing her impressive former headquarters every day on her way home from her new gallery. In fact, on the last day of shooting our film, I asked her to walk past the building that destroyed her career and made her a pariah in the art world. She happily agreed to do a few takes for our cameras. For the last take, the one we used in the film, she walked by the Knoedler and gave it an "easy come, easy go" shrug, then kept on walking. I found that to be quite chilling.

IF ONLY THOSE WALLS COULD TALK.

CHAPTER 2

FRAME BY FRAME: CREATING THE PERFECT STORM FOR FRAUD

TO MOST PEOPLE, IT seems impossible that sophisticated art collectors, wildly savvy moguls trained to spot unsavory business practices, and even seasoned and prestigious art experts could fall for something too good to be true. And yet, there was and still is a perfect storm of temptation brewing in the art world that can seduce anyone.

As Ariel says in Shakespeare's *The Tempest*: "Hell is empty, and all the devils are here."

Where there is a well-executed fraud, there is a financial motive that intersects with opportunity and rationalization, in what experts call the fraud triangle. In the case of the Knoedler fraud, you have a perfect storm: an almost unstoppable, unregulated art market, white-hot with insatiable art collectors; art dealers who are brilliantly pumping up the next art world rock star; and a group of brilliant scoundrels dealing in art forgery, who know exactly how to prey on those who have vast white

walls to cover in their new Palm Beach estate, or collectors looking to use the art market to protect and trade assets.

What could go wrong?

The current market for collecting art is studied annually by two significant players. First, there's Art Basel, the world's leading art fair producer, that stages massive fairs in Basel, Miami, Paris, and Hong Kong. Second, there's the investment bank UBS. UBS publishes a survey that studies the demand for art based on spending, economic and social trends, and future plans to collect, based on a comprehensive sample that includes collectors, galleries, artists, and institutions.

The bottom line—the art market, subject to fluctuations, continues to chase enormous growth. It is easy to date this book by commenting on the current art market; however, as of this writing, the market has slowed due to economic, political headwinds and changing generational tastes. 2024 brought steep declines with large auction houses reported earnings to be down by 27% according to analytics from ArtTactic. Global change has seen two of the richest regional art markets, UK and China experience major downturns. The potential new and harsh tax regime might trigger a large exodus of wealthy collectors. London has been attempting to establish itself as the new digital art capital of the world to play catch up in what has become a diversified art ecosystem. And China has seen sales decline in art for the last few years. Astute art collector Jonas Prince recently declared the Chinese art market to be over.

However, it does not take an art historian or academic to predict the resiliency of the art market in the face of a challenging climate. The thirst for art and global wealth always seem to succeed in shaping the entire art market. In an attempt to trim

the fat, certain large galleries have reduced their hours and have closed down certain locations to then size up marquee locations. And both galleries and auction houses have begun experimenting with blurring the lines by merging art and luxury retail to reach new audiences and boost revenue. From limited editions of plates to cushions, Gagosian and Sotheby's have partnered with artist estates to produce and sell products through their own stores and other retail partnerships.

Who is buying what?

To properly dissect the crime explored in this book, you need to fully understand what and who is driving the art market and why so many are ripe to be defrauded. Let's introduce the DNA that makes up our potential, unsuspecting victims of fraud (based on recent Art Basel-UBS statistics and the suggestion that there will be minor changes in spending behavior in the near future):

- Despite recent challenges the art market, has seen an annual exchange of arts and antiquities valued at over $50 billion, or 16.5 percent of the personal luxury goods market ($392 billion).
- Of the collectors surveyed, over 70 percent said they plan to buy more art, indicating the resilience of the market in the face of COVID-19, war, and economic and political turmoil.
- Around 49 percent of collectors plan to borrow to finance their collections, reflecting their desire to own art at any cost.
- The US maintained its position as the leading market worldwide, accounting for 42 percent of sales by value. China remains the second-largest global art market aside

from trending decline (19 percent), while the UK moved to third place with a share of 17 percent. France remained in a stable fourth position at 7 percent of global sales.

- Most spending is on paintings (64 percent) with works-on-paper and sculpture seeing declines. (Works-on-paper encompasses a diverse range of media, from drawings and paintings to prints and multiples.)
- Confidence in global online sales resurged, reaching an estimated $11.8 billion, a rise of 7 percent year-on-year from 2022, and accounting for 18 percent of the market's total turnover.
- The wealthiest high-net-worth (HNW) collectors buy either works of deceased artists, spending more than $1 million on their art, or top tier, well-established artists.
- Female artists were a minority in collections, but the highest spending collectors had the highest share of female artists.
- Spending on digital art continues to decline and represents just 1 percent of the HNW total expenditure. This is coupled with the collapse of the NFT (non-fungible token) digital art market, which has seen declines to about 2 percent of the value at its peak.
- Gen X collectors outspend the millennials for paintings.
- Of the HNW collectors surveyed, 86 percent purchase their art from a dealer, with auction houses being the next most widely-used channel (Christie's sold approximately $3.2 billion worth of art in 2023). While both public auction and dealer sales saw slight decreases, the decline in auctions was more severe, falling by 7 percent versus a 3 percent drop in dealer sales. Private sales at

- auction houses went against the declining trend, increasing by 2 percent year-on-year.
- When asked what motivates them to buy art, 57 percent of collectors said for self-identity and pleasure (self-identity is status), while 28 percent said for financial purposes.
- In further exploring the financial capacity of HNW collectors surveyed (with the US being the largest center of global wealth), a large majority had personal assets valued at over $500 million. China has the most billionaires (814) but saw the loss of 155 billionaires in 2023. The US has 800 billionaires with a collective wealth of $5.2 trillion and Russia has 120 billionaires.
- The wealth of billionaires grew steadily during the pandemic, with some seeing 64 percent growth, according to Forbes' annual compilation of the world's billionaires. That is a stark contrast to other historical recessions. Fun fact: Bernard Arnault (LVMH) saw his estimated wealth grow by one-third to $221 billion.
- Not all billionaires collect art, with most allocating wealth from between 5 percent to more than 19 percent to art. The average is 15 percent for those with wealth under $5 million and 30 percent for those with wealth over $50 million.
- Nearly half of the collectors surveyed have been collecting for more than ten years.
- The average size of a personal collection is forty-eight works, while one-quarter of the HNW collectors had larger collections of one hundred works or more.

The purpose of this by-the-numbers exercise was not to bore you to death, but to give you a sense of a world of voracious art

collectors, who will go beyond the beyond to get their hands on a piece of art for a multitude of reasons.

Those buying art generally break down into the following categories:

- Investors: For profit or store of value.
- Collectors: To maintain family heritage or for culture.
- Aficionados: For decorative, conspicuous consumption, or emotional fulfillment.

Art can be defined as a luxury good whose value depends on the artist's pedigree. Investing in art (especially in its contemporary forms) can bring returns higher than the equity markets. Art can also be a good hedge against inflation. However, all this comes with numerous red flags. The art market is opaque, and the art you buy could have negative carry (in other words, the cost of holding an art investment might exceed the value while owning it).

There are collectors who buy art to launder money. Most art transactions are private with very subjective, high pricing. Once purchased, art can be hidden or disappear for generations until it is eventually sold again. Large quantities of art bought via auction are then shipped to freeports. Freeports are ultra secure warehouses where billionaires store art, gold, cars, and wine, and exist to offer a tax advantage as the goods are technically in transit and therefore not subject to tax. There are freeports in Switzerland, Luxembourg, and Singapore, and *The Economist* magazine reports that the location in Geneva is believed to have as much as $100 billion in art currently stored there.

Art is an insider's market. There are too many players, such as dealers and art consultants who keep key information to

THE DEVIL WEARS ROTHKO

themselves (more on consultants later—not my favorite group of people) and reward select clients or even themselves with highly sought-after work before making it available to the open market.

There is a well-established hierarchy in the art world that dictates who gets the first pick of a new collection or a rare find coming to the market. Most often, pedigreed collectors will either be invited to private showings at galleries before second-tier collectors or the general public get to see anything. Alternatively, they might be sent images via email or text messages with an opportunity to gobble up the art quickly. It is not unusual to walk into a new show on an opening night and see most of the collection already sold or on hold.

Quite often, when touring a gallery, there are hidden rooms where only high-value collectors are invited to see selected works that are not available to the rest of the public.

CHAPTER 3

A REAL MARKET FOR FAKE ART

BEFORE WE EVEN DIG into the world of fake art, it is important to define the word "provenance." It's a term you will see often in this book, and it can determine the difference between fake and authentic art.

Dr. Sharon Flescher is the former executive director of the International Foundation for Art Research (IFAR). IFAR is a not-for-profit educational and research organization that offers impartial and authoritative information on authenticity, ownership, and theft concerning art. IFAR defines provenance as "the history of ownership of a specific piece of art, where you can trace the work from the current owner or collector all the way back to the studio where the artist created the work."[1]

There are several types of provenances that provide data about the history of a piece of art. Anecdotal provenance refers to understanding the artwork's origin based on ownership claims without documented evidence. If these claims can be verified, they contribute to a more reliable record of the

artwork's provenance. But this can be very unreliable as you will see in the Knoedler case, where stories about provenance were simply fabricated.

The most reliable form of provenance is an all-inclusive documentation that would involve invoices, gallery consignment reports, exhibition catalogs, certificates of authenticity from the artist or artist's foundation, export licenses, or photographs that trace the artwork's history.

Even in an era of photo shopping manipulation and artificial intelligence, there is nothing better than having a photograph of the artist standing in front of the actual work of art in question. As you will see in the Knoedler case, authenticity documents can be falsified, claiming the work is created by someone else or is from a different era.

Provenance is vital since the value appraisal is inadequate to serve as authentication for the artist, or the era of the artwork. Getting artwork appraised and authenticated are two separate processes.

Collectors and museums use provenances for reasons beyond detecting forgeries. They use provenance to determine the whereabouts of European artworks collected between 1933 and 1945, when the Nazi regime looted thousands of artworks from Jewish collections. Provenances is extremely useful in the cases of archaeological artifacts collected before 1970, when the United Nations passed accords to protect the world's cultural heritage. The same could be said for art taken from colonized regions in the nineteenth and early twentieth centuries, when colonial powers looted works.

Ultimately, the ideal provenance for a collector is to have a signed statement of authenticity from the artist or an expert on

the artist. While anything can be copied or falsified, these are generally good options.

Some dealers claim that the provenance must be withheld to protect the identity and secrecy of the previous owner. This is what Rosales told Freedman. This is a red flag. Also, a signature on a piece of art is not provenance—physical, certified documents must prove the artwork's origin.

In addition, a value appraisal does not authenticate the artist or era either. Any document being provided must be investigated. You must be able to trace the qualified individual's signature, the artist in the question, or previous owners back to real people. Many will say trust only qualified authorities such as those that have a significant art background and experience with the artist or published papers about the artist.

But as we saw in the Knoedler case, major experts were fooled and most of the victims trusted the pedigree of the Knoedler Gallery. Just as it was not required to ask Tiffany's to disclose a particularly precious diamond's past based on the legendary jeweler's pedigree, so too, the thinking was, it was not necessary to ask a major gallery to reveal a masterpiece's background. They would just buy it. Even Domenico De Sole testified: "I assume if I am buying a Gucci handbag at a Gucci store, it's a real Gucci handbag."[2]

Luke Nikas, one of the leading art law experts in the world and Freedman's lawyer, argues that provenance is complicated when you look at the 1940s and 1950s during the abstract expressionist period. "Many artists," Nikas claims, "kept poor records and even traded their work for goods and food, making it difficult to track down a chain of provenance for a painting."[3] In the Knoedler case, the forgers, of course, created their own

provenance. Freedman told me that many wealthy collectors during that same period would buy a large amount of work from a starving artist without getting documentation. That was more than seventy-five years ago. The market is still white hot and attracting charlatans like moths to a flame, selling loads of fake art.

Fake art became prevalent because there were not enough works to satisfy demand. A robust market for valuable goods creates widespread counterfeits. For example, travel around Manhattan and behold the bevy of dealers selling fake Louis Vuitton and Chanel purses, scarves, and wallets on just about every street corner surrounding Times Square. It's no different in the art world, except fake art was not a headline until art acquired serious monetary value.

Forgeries are everywhere because, quite frankly, the market is on fire, and has been since 1990, when the first of a select few paintings including Pierre-Auguste Renoir's *Bal du moulin de la Galette* (1876) broke records, selling for $170 million (adjusted for inflation). In 2023, Pablo Picasso's *Femme à la montre* (1932) sold for $139 million, while Gustav Klimt's *Lady with a Fan* (1917) went for $109 million—just two examples of the $2.4 billion worth of art sold at auction in 2023 without any sign of decline. Calling all forgers!

The art market is now at a nexus where forgeries comprise a large portion of the market. European law enforcement experts suggest "as much as half of the art in circulation is fake." Thomas Hoving, the former director of The Metropolitan Museum of Art, stated that a shocking 40 percent of the pieces at The Met are fake. And other experts have suggested that 50 to 70 percent

of what is offered for sale in the art market is most likely fake. Wonderful! And yet the art market thrives.

When I sat down to interview Nikas for the film, he began with a joke to illustrate the complexity and enormity of fakes:

> A new young curator comes in and says, "I want to do this great exhibition. I want to select the greatest forgeries and have an exhibition in this museum and so everyone can see what great work has been created by these forgers. And we can have a story surrounding authenticity in art." And the senior curator looks at the new curator and says, "Well, we've got a problem. The greatest forgeries are already on the walls of this museum."[4]

Long before Jose Carlos Bergantiños Diaz, the criminal mastermind that brought down the Knoedler Gallery, determined there was more money in fake art than fake caviar, selling forgeries can be traced back to the Renaissance period.

In and around the late 1400s, there was a class of wealthy collectors and art patrons that were buying large quantities of art. Suspicious of some of the early copies that were appearing in studios they visited, collectors asked artists to sign their works to ensure their authenticity.

Even the highly sought-after artist Michelangelo created forgeries. In 1496, he sculpted a sleeping Cupid and then covered it in buried dirt to make it appear older. He sold the sculpture to a cardinal, who eventually discovered that it was artificially aged. The cardinal demanded a refund from the dealer who sold him the piece. Michelangelo also had a habit of copying other

THE DEVIL WEARS ROTHKO

artists' drawings, keeping the originals, and then returning copies in their place.

Fast forward to the 1940s and Han van Meegeren, a Dutch painter who set out to prove his talents by forging famous artists. He made loads of money even when his work grew sloppy due to alcoholism and a morphine addiction. One of his Vermeer forgeries was sold to Hermann Göring, a central member of the Nazi high command. Van Meegeren was arrested in his home country for selling Dutch cultural property to the Nazis, an act of treason punishable by death. Van Meegeren was fortunate. Even though the work was a fake, he was convicted of falsification and fraud charges but sentenced to only one year in prison. In 1947, a newspaper poll found van Meegeren to be the second most popular man in the Netherlands, after the prime minister.

Born in 1906 as Elemér Albert Hoffmann, artist Elmyr de Hory changed his name, telling people that his father was a wealthy diplomat. After escaping prison in Germany during World War II, de Hory created and sold forged art, claiming it was from a Hungarian family estate. He was so good at his craft that many of his forgeries appeared in several art books. While being investigated by the FBI and Interpol, de Hory died of suicide in 1976. Orson Welles's film *F is for Fake* (1974) was inspired by the exploits of Elmyr de Hory.

I love this next story as it bears such a cunning resemblance to the Knoedler case. In the 1980s, conman John Drewe worked with John Myatt, a struggling but brilliant artist. Drewe, posing as a nuclear physicist, commissioned works by Myatt for his own personal use and then convinced him to paint forgeries. Drewe sold the fakes to dealers, put them up in auctions and galleries, and even tried to donate them to museum collections.

And just as Bergantiños did twenty years later, Drewe falsely aged Myatt's works with vacuum dust, varnish, and rusted picture frames. Drewe also created fake provenances for the art by forging certificates of authenticity, invoices, and documents he claimed were from previous owners. Drewe also manipulated published art archives by introducing false records and replacing old records with new pages. Eventually his scheme was unraveled by his ex-girlfriend, who saw him smearing dirt on an "original" Alberto Giacometti painting, found in a stack of fake documents. She reported him to the police and to the Tate in London. To save his skin, he claimed he was an arms dealer being framed and a British intelligence agent, while Myatt was a neo-Nazi operative.

The jury found him guilty in six hours and sentenced him to six years for conspiracy to defraud, two counts of forgery, and one count of theft. He served two years in prison.

Profiled on CBS's *60 Minutes*, and perhaps the most successful forger of all time, Wolfgang Beltracchi spent forty years forging paintings by the likes of Max Ernst, Heinrich Campendonk, Max Pechstein, and Fernand Léger, before being convicted in 2011 for selling $45 million in fake art.

Beltracchi claims to have made $100 million from his forgeries during his career, and only served three years of a six-year sentence. Not one to be modest, Beltracchi calls himself one of the most "exhibited painters in the world," with some of his forgeries appearing on the cover of a Christie's auction catalog. He said, "In my thoughts, I created an original work, an unpainted painting by the artists of the past." Since his release from prison, he has returned to painting, this time under his own name, earning him millions again.

British artist Eric Hebborn began his career working for an art restorer, where he found a treasure of old materials to begin forging new works. He eventually moved to Italy to open a gallery where he sold his fakes for millions.

Outrageously arrogant, Hebborn wrote a book called *Drawn to Trouble* slamming the art world, while exposing that he deceived art experts who were willing to claim his forgeries were real for the sake of economic profit. In 1996, after publishing *The Art Forger's Handbook*, Hebborn's body was found was on a street in Rome, his skull broken. His death remains an unsolved crime.

American-born Ken Perenyi is known as one of the most skillful forgers of eighteenth- and nineteenth-century British and American paintings. In 2012, based on several leads, the FBI began investigating Perenyi using new technology on several pieces he had sold through auction houses. After a five-year investigation and thirty years of forging art, Perenyi was never convicted. He then began openly selling fake paintings as reproductions.

Perenyi claimed, "I'm convinced that if these artists were alive today, they would thank me. I'm somebody that understands and appreciates their work."[5]

Even legendary comedian Steve Martin fell victim to art forgery. Martin purchased a 1915 painting by German impressionist Heinrich Campendonk for $850,000 to add to his vast collection that includes authentic (we hope and assume) works by Picasso, David Hockney, and Roy Lichtenstein. Martin sold the work through Christie's auction house without knowing it was fake and with Christie's approving its authenticity. The work has since been attributed to Beltracchi.

Geert Jan Jansen, a skilled Dutch forger, began as a gallerist and then started selling fakes as originals to fund a lavish lifestyle. Jansen, who had used the name Van den Bergen, was arrested May 6, 1994. When police investigated his castle, they found 1,600 forged artworks including Jean Cocteau, Joan Miró, and the most popular target of forgery, Picasso. He was living the life of a "luxurious aristocrat" in a massive, white-walled castle filled with art.

Jansen went on trial in September 2000 in Orléans, France. However, most of the charges were later dropped. Two of the buyers disappeared and only two remained. Eventually Jansen was sentenced to one year's imprisonment.

We will explore the grandest scandal of them all, the Knoedler Gallery art fraud, in detail in the forthcoming pages. But here is a quick and yet incredible take on this story by Pei-Shen Qian, a struggling artist who emigrated to New York City in 1981 with a dream of becoming a famous artist like his fellow country man, Ai Weiwei. Sadly, fame eluded him, and he got drafted by an oily couple to make incredible fakes in his tiny garage. For the next decade, the triumvirate succeed in conning the art world by selling them $80 million of fake art.

When studied deeper, the rationale given by forgers for defending their illegal behavior is that they love "inflicting embarrassment upon the rich elite of the world." In some cases, perhaps like Knoedler, the financial success is so great, the forger simply can't stop.

And for buyers, the psychology is almost custom tailored to match what the forger is looking for in a dupe. Buyers want works by famous artists and are willing to be deceived to possess

THE DEVIL WEARS ROTHKO

art at any cost. Undoubtedly, the number of fakes reflects the willingness of everyone to believe the fakes are real.

Why are buyers so easily seduced? When a buyer and then owner, acquires a piece of art, they each believe they are becoming a part of the art's history with a physical connection to the artist. They become part of the provenance. In the Knoedler case, Eleanore De Sole admitted to having a powerful emotional reaction at the thought of potentially owning a Rothko.

Additionally, owning art serves its own interests of owning an original and gaining financially from a collection that might sell for even more outrageous prices later.

Perhaps. But the art economy was designed to accept that fakes are a living part of its ecosystem, and many collectors and museums have little interest in investigating the authenticity of what's in their collections.

Tom Flynn, an art critic and historian, wrote: "The art market is a web of social and economic interdependencies crafted from the complex relationship between art and economics and draws its very sustenance from the tenebrous boundary between the two."[6]

Basically, it means don't screw with the golden goose.

There are many museums that will forever keep their fakes and forgeries hidden, labeling them as works "in the manner of" or "from the circle of" a famous artist. Nancy Hall-Duncan, a respected art curator and writer, said: "Museums exist to protect and exhibit genuine works of art; authenticity is at the heart of a museum's purpose. Though both have been breached in serious ways in recent years, the attempt to preserve our culture and morality depends upon our ability to recognize the truth, including whether or not artworks are authentic."[7]

In the case of the Knoedler Gallery, there were museums, galleries, and respected art publications very willing to exhibit and publish beautiful but forged works of art.

Now, I have thrown around both "fake" and "forgery" as specific terms. There is a difference. A forgery is a work done in the style of a given artist and signed with that artist's signature. It is a deliberate attempt to deceive. A fake is a work that replicates an existing work of art. Copies, reproductions, and replicas are not fakes until they are represented as originals. Both fakes and forgeries follow the market, reflecting whatever collectors are lusting after.

Most established collectors will not blindly buy a piece without relying on advice from their gallery salesperson or art consultant. So, forgers have found inventive and, in many cases, barely visible ways to fool even the most seasoned authenticator. Forgers have a toolbox of tricks, including converted medieval choir books as vellum sheets, used old cupboards for panel paintings, buried works to simulate aging, dirt and vacuum cleaner dust to age the back of paintings, old nails and wire from century old frames, or K-Y Jelly paints to simulate weighted brushstrokes. The result is that many forgeries go undetected for years.

Forgers will create a trail of provenance so brilliant that authenticators and critics have been, at times, ridiculed for suggesting a work could be "wrong."

Here are a few examples of extraordinary cases of forged art:

- A gift of a thirteenth-century French reliquary that listed as provenance the collection of Count Camille of Renesse-Breidbach from J.P. Morgan, the financier, to The Metropolitan Museum of Art. The rock crystal and

THE DEVIL WEARS ROTHKO

bejeweled reliquary was considered authentic for more than a century. In 1980, a technical investigation showed its flaws. Only the rock crystal at the center of the base was original; the remainder of the piece was composed primarily of nineteenth-century craftsmanship.

- Han van Meegeren painted a fake Vermeer: *Christ and His Disciples at Emmaus*, circa 1936–1937, on a doctored seventeenth-century canvas. He used badger hairbrushes and as many period pigments as possible, including lapis lazuli for the blue. He even devised a means of simulating the slow drying process of oils with a mixture that simulated Vermeer's linseed oil. Van Meegeren then had it authenticated by Dr. Abraham Bredius, a leading scholar. Even though some experts suspected it was a fake, *Christ at Emmaus* was sold to the Dutch Rembrandt Society for the equivalent of $4.7 million on today's market. When the painting was eventually traced back to van Meegeren, the forger had to prove his authorship by painting the same work in front of six official witnesses.

- The Getty Kouros, a life-sized statue in the form of a late archaic Greek kouros (sculpture that depicts young male nudes) was bought by the J. Paul Getty Museum in 1985 for $10 million and has been declared a fake by many experts. Some forensics determined that the marble was artificially aged. The museum still lists the sculpture as "potentially authentic."

- In 1999, a ring of forgers started selling fake Andy Warhol, Roy Lichtenstein, and Picasso prints on eBay. They managed to con more than 10,000 victims, making a profit of $10 million before being shut down in 2010.

- In the spring of 2000, Paul Gauguin's *Vase de Fleurs* was offered at auction at Christie's. Unfortunately, both the original and a forged copy of the 1885 painting showed up at Christie's and Sotheby's at the same time. The painting consigned to Christie's proved to be a forgery.
- Salvador Dalí created an entire industry for fakes attributed to him, by simply signing blank sheets of paper prior to the print-making process. While many of those sheets became legitimate prints, others went on to be used to create pirated prints that the artist never saw.
- Even Costco, in 2004, sold three fraudulent Picasso drawings, all accompanied by forged documentation, to a San Francisco collector.
- Between 2010 and March 2015, New York art dealer Eric Spoutz repeatedly sold dozens of works of art he falsely claimed were by well-known artists. He used forged documents to convince buyers of the authenticity of those works, including Willem De Kooning, Franz Kline, and Joan Mitchell, through various channels, including auction houses and on eBay. To deceive his victims into believing the works of art were authentic, he created and provided forged receipts and letters from deceased attorneys and other individuals. His own website claims he has placed works to private collectors, corporations, and museums including the Smithsonian Institution and the Rock & Roll Hall of Fame. Spoutz was sentenced to three years in prison in 2017.
- In 2018, a French museum dedicated to artist Étienne Terrus concluded that eighty-two of its 140 works were fake.

THE DEVIL WEARS ROTHKO

- In 2024, David Voss was sentenced to 5 years in prison for being the mastermind behind 5000 fakes purported to be the work of Norval Morrisseau, the late Canadian First Nations artist.

While producing my documentary *Made You Look*, I stumbled onto a factory in Shenzhen, China that employed dozens of skilled artists specializing in just about every school of art, from old master renaissance art to abstract expressionist paintings. The factory owner, "Henry," was filling orders for thousands of paintings, some original, many of them copies of famous works. Whether the factory was producing widespread forgeries with signatures may have been in question, it did make a brilliant copy of a Jackson Pollock, and signed it perfectly as Jackson Pollock. The piece hangs on my wall and holds zero value or threat of confiscation as the original hangs in the Museum of Modern Art in New York City.

The factory in China might help answer the question as to where many of the forgeries are coming from. It's been well investigated and reported that China, with its low wages and reliance on exports, leads the forgery business with mass production, utilizing art students who create copies by the thousands.

The New York Times reported that artist Zhang Libing, twenty-six years old, painted more than 20,000 Vincent van Goghs in a third-floor stall, where the Chinese man's socks and fresh art dried side by side. The large copying factories like the one I visited have assembly line systems; they claim that because the works are handmade, they do not violate copyright laws.

Of course, that is false.

In 2014, China's Lucheng Museum was ordered closed after nearly one-third of the 8,000 items on display were found to be

fake. In 2013, the Jubaozhai Museum in China was closed due to suspicions that nearly *all* its 40,000 artifacts were fake.

Around the world, many countries are getting serious about catching forgers. Scotland Yard has its Art-and-Antiquities Squad, Interpol has the Antiquities Tracking Task Force, and Italy has the Command for the Preservation of Cultural Heritage, which has reportedly confiscated more than 85,000 fakes in the last fifteen years. For its part, the FBI has created the Rapid Deployment Art Crime Team.

However, the jail sentences are very light, and most task forces are more interested in wire fraud or money laundering as opposed to worrying about rich people who can afford to get conned.

In a recent nod of recognition to the murky and unreliable world of provenance, The Metropolitan Museum of Art established a newly created position of "head of provenance research" in 2024. They lured away Lucian Simmons, Sotheby's former vice-chairman and worldwide head of restitution. This was a response, finally, to academics and law enforcement officials who have been scrutinizing The Met's collection of over 1.5 million artifacts, because of a concern over many of the items' provenance, from illegal looting and Nazi appropriation, to fakes.

There was, perhaps, another step forward in shining a light on the shadowy world of private art—one of the most unregulated markets in the world. It came when a New York judge in 2024 ordered Sotheby's to reveal the seller and buyer in the auction of an old Italian master work of art. The ruling came about after heirs of the collector who lost the artwork during the Holocaust filed a claim. This is significant as auction houses have long shielded the identity of buyers and sellers, causing

THE DEVIL WEARS ROTHKO

concern for money laundering and tax evasion goings-on in the art world that the US government has chosen not to regulate with any significance.

Thomas Danziger, an art market lawyer, told *The New York Times*: "Good auction house specialists can talk for hours about the merits of a painting, but will always develop laryngitis when asked for the name of the painting's owner."[8]

Auction houses counter they engage in anonymity to protect sellers and collectors by avoiding broadcasting who is spending vast sums of money and those that own major collections. Regardless, it is a sliver of light into a very opaque world.

Also, it's important to note before we unspool the Knoedler story that it is rare for a dealer or auctioneer not to have transacted, inadvertently or otherwise, in works of doubtful integrity. There is a huge degree of caginess among art world players when cases of forgery are discovered.

Caginess. Welcome to the world of art. Welcome to a world of endless forgeries.

CHAPTER 4

THE PROVENANCE OF PEDIGREE: THE RISE OF THE KNOEDLER GALLERY

THE DATE NOVEMBER 11, 2011 (11/11/11) was a day to remember for more than just the armistice that ended the First World War. On that symmetrical date in the art world, the Knoedler Gallery suddenly announced it was closing its doors and going out of business after a storied 163 years. The announcement stopped Miami Basel cold in its tracks as gallerists huddled in their booths to read the rather abrupt posting on their website:

"It is with profound regret that the owners of Knoedler Gallery announce its closing, effective November 30, 2011. This was a business decision made after careful consideration over the course of an extended period. Gallery staff are assisting with an orderly winding down of Knoedler Gallery."[9]

Once one of the most respected and venerable epicenters of art in New York City, Knoedler Gallery's "business decision" was obviously the result of the unyielding scandal from the sale

THE DEVIL WEARS ROTHKO

of dozens of works falsely attributed to artists such as Jackson Pollock, Mark Rothko, and Robert Motherwell. A legendary pedigree was dashed by an FBI investigation, lawsuits alleging fraud, racketeering, breach of contract, breach of the covenant of good faith and fair dealing, unjust enrichment, and the list of sins went on and on.

Knoedler & Company, known as the longest running fine art gallery in New York and one of the oldest in the nation, was the catalyst for art collecting in America.

The Getty Research Institute, now home to the extraordinary Knoedler Gallery archives, features material from the gallery's 55,000-volume art library dating back to 1863. It tells a jaw-dropping story of its history featuring clients such as the legendary robber barons of the late nineteenth and twentieth centuries, such as Henry Clay Frick and Henry O. Havemeyer. They used their untaxed fortunes to acquire massive amounts of art and began a grand tradition of donating their collections to launch America's most venerable public museums. Yes, Knoedler began before The Metropolitan Museum of Art (1870), The Museum of Modern Art (1929), and The Whitney (1931). Those museums were all benefited by Knoedler clients such as Benjamin Altman, Jules Bache, George Blumenthal, Stephen Clark, Edward Harkness, George A. Hearn, Robert and Philip Lehman, John L. Loeb, and J.P. Morgan, all of whom endowed their collections.

Within the archives, the rich list of Knoedler American blueblood clients includes Andrew W. Mellon, Paul Mellon, and Ailsa Mellon Bruce, who were the principal founders of the National Gallery of Art. More than half of the famed Frick Collection came from Knoedler, and Norton Simon, the Rockefeller family,

John Severance, Mary Emery, and Charles Taft, who contributed thousands of the greatest masterpieces in North America that built America's museums.

Michael Knoedler emigrated from Paris to New York in 1846 to manage a newly opened branch of Galerie Goupil, purveyors of popular prints and art supplies. Galerie Goupil was established in 1827 by Adolphe Goupil in Paris, later merging with Rittner and Co., founded in 1829, to become Rittner & Goupil in 1841, then Goupil & Vibert, and finally Goupil & Cie on the Boulevard Montmartre in Paris.

They were a central force in the French art market in the nineteenth century and carried the work of nineteenth-century academic artists, principal figures of the Barbizon School, and some of the impressionists, with minor trade in Old Masters, particularly Dutch.

Goupil's daughter Marie married the painter Gérome Etienne Boussod, another Goupil son-in-law, and succeeded Adolphe as head of the Galerie Goupil in 1875. In 1884, the business name changed to Boussod, Valadon & Cie. In 1878, the general director of the gallery was Theo van Gogh, brother of the world-acclaimed artist, who introduced works by the impressionists.

Fun fact: Vincent van Gogh began working for The Hague's branch of Goupil & Cie on July 30, 1869, as a junior apprentice. Van Gogh was relatively successful as an art dealer and stayed with the company for several years. However, being an art dealer began to lose its appeal, and he engrossed himself in Bible reading. In late March of 1876, van Gogh left to pursue a career in the clergy and then reluctantly decided to become a painter.

The internationally renowned gallery began in Paris and gradually opened branches in London, Brussels, The Hague,

THE DEVIL WEARS ROTHKO

Berlin, Vienna, New York, and Australia. The location in The Hague was opened thanks to the influence of van Gogh's uncle Cent who was also an art dealer. Cent had created a name for himself as a successful art dealer and he realized that he would soon be in competition (or in partnership) with Adolphe Goupil. In February 1861, the two men met in the Paris headquarters and formed a partnership. By the end of the year, Goupil & Cie opened in The Hague.

In 1848, Goupil & Cie opened its New York branch to sell reproductions of French prints. The firm's office in New York—an initiative of Léon Goupil (the son of Adolphe Goupil), Théodore Vibert, and the agent William Schaus—was established in 1848 at 289 Broadway on the corner of Duane Street near City Hall.

In 1857, Michael Knoedler, an employee of Goupil and a manager of the New York firm, bought out the interests of the firm's New York branch, conducted the business under his own name, and diversified its activities to include the sale of paintings. The office was then established in a larger space at 366 Broadway between today's Tribeca and Chinatown neighborhoods.

Knoedler, the firm's New York manager, transformed the gallery into a major dealer of old-master paintings and British art. His success with these works influenced American art consumption, as collectors' tastes began to shift away from French Salon paintings. Though Knoedler was not the only art dealer selling this type of work, by the 1890s he was a major supplier to the American market.

When Knoedler purchased the New York Goupil office in 1857, most American museums had not yet been formed, and were relatively inaccessible to Western European centers of art.

As the US witnessed a rise in personal fortunes from the steel, mining, iron, and railroad industries in the nineteenth century, more Americans had the financial means to begin collecting art. The new money fueled an art market that Knoedler helped establish, driven by the decline in the nobility's fortunes and changes in tax legislation in Europe. It saw artwork from Europe being sold in the US.

When Roland Knoedler, Michael's son, became a partner in the business in 1877, the firm became known from then on as M. Knoedler & Co. Roland took over the firm after the death of his father in 1878 and with Charles Carstairs opened galleries in Paris and London.

In 1907, Knoedler acquired seven portraits of the Cattaneo family by Anthony van Dyck. Three of those paintings now form part of the Widener Collection at the National Gallery of Art in Washington DC. By the early twentieth century, the Knoedler Gallery had become one of the main suppliers of old master paintings in the US and would continue to serve as a major channel for the procurement of masterworks.

Among the wealthy clients of Knoedler were civic-minded collectors, including John Taylor Johnston (1820–1893), the son of a banker who would become the founding president of The Metropolitan Museum of Art; Robert Leighton Stuart (1806–1882), a major donor to the New York Public Library; and Catharine Lorillard Wolfe (1828–1887), the daughter of a real estate developer and tobacco heir. Wolfe became the first donor to provide both a collection gift and an endowment to The Metropolitan Museum of Art.

Knoedler developed very close relationships with Henry Clay Frick and Andrew W. Mellon. A large portion of the

paintings in The Frick Collection in New York were acquired during Frick's lifetime through the Knoedler Gallery. In 1900, Charles Carstairs and Roland Knoedler were present at Mellon's wedding, celebrated in England.

FOLLOWING THE RUSSIAN REVOLUTION in 1917, the Soviet Union was continuously in need of foreign currency, facing fierce economic sanctions on the international market. For years, there were rumors that Russia would begin selling its treasures from the Hermitage Museum, which had been founded in the eighteenth century by Empress Catherine the Great. European dealers monitored the situation and took many train trips to Leningrad to see if they could buy art. Most came back empty-handed.

A newspaper in Germany one day announced that Joseph Duveen, a British art dealer, was planning on buying the entire Hermitage collection. While the deal fell through, an incredible sale was nonetheless accomplished by Knoedler, with US banker Andrew Mellon as its unlikely client.

Mellon, who had become US Secretary of the Treasury under presidents Warren G. Harding, Calvin Coolidge, and Herbert Hoover, had been hostile to the USSR's Communist regime. He opposed Stalin's attempts to penetrate the American market with cheap goods. However, along with two other collectors who purchased artworks from the Hermitage, Armenian oil magnate Calouste Gulbenkian and Armand Hammer, who did business in the Soviet Union in the 1920s, Mellon used his power and influence to buy art from Russia under the guise of the international economic context for the Soviet government.

The Knoedler archives now housed at the Getty document the purchase of the twenty-one paintings that Mellon acquired through a chain of intermediaries, including Sandro Botticelli's *The Adoration of the Magi* and Rembrandt's *Joseph and Potiphar's Wife*. The twenty-one paintings that Mellon acquired from the Hermitage would form the nucleus of the collection of the National Gallery in Washington, DC.

By 1930, the Communists, again desperate for cash, decided to sell more masterpieces from the Hermitage. Knoedler wanted everything he could get his hands on, including works by Giorgione, Botticelli, Raphael, Leonardo, Titian, Paolo Veronese, Giovanni Battista Tiepolo, Diego Velásquez, Bartolomé Esteban Murillo, Van Dyck, Rembrandt, Gerard ter Borch, Gabriël Metsu, Frans Van Mieris, Gerrit Dou, Jacob van Ruisdael, Pieter de Hooch, Lucas Cranach the Elder, and many others. Knoedler, along with Andrew Mellon, bought it all.

Over the years, Mellon purchased more than 125 works from Knoedler. At that time, there were virtually no museums in the US other than the venerable Smithsonian Institution. The Met would not be born for a quarter century. And yet fortunes were being made in oil, lumber, railroads, steel, and finance, and the wealthy were buying art by the dozen for their grand homes.

When Roland Knoedler retired in 1928, the management of the firm passed to his nephew Charles Henschel, along with Carman Messmore, Charles Carstairs, and Carstairs' son, Carroll. In 1956, Henschel died and E. Coe Kerr and Michael Knoedler's grandson, Roland Balaÿ, succeeded him. Balaÿ, at ninety-four, was the last living Knoedler family member to have been involved with the firm.

Prestigious art museums and important private collections in the US likely own works of art that at one point or another, or more than once, sold through Knoedler & Co.

After World War II, the gallery promoted the work of Willem de Kooning, Barnett Newman, Louise Bourgeois, Eva Hesse, and Arshile Gorky, along with European artists such as Salvador Dalí, Henry Moore, and Wassily Kandinsky.

Knoedler dominated the art market in America, weathering 165 years of American history and changing tastes.

By 1970, a new breed of robber barons had different tastes. The original robber barons flocked to Knoedler—men such as railroad builder Jay Gould, banker J.P. Morgan, oil monopolist John D. Rockefeller, real-estate speculator John Jacob Astor, and sugar refiner Henry O. Havemeyer, snapping up so many of the old masters, which later became the core of several key public collections (the Frick for one, the National Gallery for another). But those men had begun to fade away.

The Knoedler Gallery's brilliance was in taking chances on contemporary art from one era to the next—from Degas and Manet to John Singer Sargent and William Merritt Chase. It did miss the abstract expressionists when they emerged and came so close to bankruptcy.

Knoedler was now in trouble.

In 1971, industrialist Armand Hammer, always having an eye for art and a bargain, bought the revered gallery for a mere $2.5 million.

Hammer himself is the subject of books, magazine profiles, and a salacious television series, not to mention the great-grand-father of his namesake grandson Armie, who has had his own eccentricities exposed, including bizarre allegations of

cannibalism practiced on his girlfriend. Hammer had a murky history of collecting art for nearly half century before buying the near-bankrupt Knoedler Gallery.

In the Soviet Union, Hammer found a willing audience where he would broker lucrative barter deals, exchanging desperately needed American wheat for millions in furs, jewelry, caviar, and priceless pieces of art sitting in the Hermitage, the Soviets' legendary art museum and home to one of the greatest art collections in the world.

Some would call Hammer a spy; others called him a genius. Regardless, he would begin a legacy of buying and selling art, some of it fake, some of it stolen by Nazis, and most of it priceless. For a time, Hammer's business ties with the Soviet Union enabled Knoedler to host museum-quality shows from Soviet national collections.

When Hammer took over Knoedler, he hired Lawrence Rubin as Knoedler's director. Rubin was a well-connected art world figure with a discerning eye and a nose for the next generation of art buyers.

Rubin went to work to reverse the gallery's stale reputation and attracted prominent contemporary artists such as Frank Stella, Richard Diebenkorn, Robert Rauschenberg to the gallery. And so began the gallery's last golden phase of selling modern art.

The gallery's new reputation and old pedigree made it a go-to place for purchasing modern and contemporary art. For the artists, being represented by Knoedler could be a huge enhancement for their career.

Hammer had hired Ann Freedman a few years back from the André Emmerich Gallery where she was a receptionist and

made her a sales associate at Knoedler. Rubin, inclined to long lunches with his artists, eventually left the business of selling to the beyond-ambitious Freedman.

When Knoedler's long-time director Lawrence Rubin left, so did many of its contemporary artists whom Rubin had brought to the gallery. The succession plan was for Freedman to run the gallery alongside Donald Saff, a Knoedler vice-president since 1992. Freedman had other plans. Saff was demoted to being a consultant. Saff told *The New York Times* that Freedman had "interfered" with Hammer. "Between Ann's skills with sales and the contacts I have with artists, this gallery could have been a powerhouse," he said.

There was no question that the art world was on fire. While the market crashed briefly in 1990, signs of recovery began in 1994 with record auction sales. As the nineties continued, the market for contemporary art was overtaking the prices commanded by impressionist and modern art.

Even in the days following the shocking collapse of Lehman Brothers in 2008—a $600 billion bankruptcy filing triggered by the subprime mortgage crisis—the art world was Teflon. Sotheby's, as *The New York Times* reported, was an "oasis far removed from the grim news of the financial world." In less than forty-eight hours, 223 works—all by the British artist Damien Hirst—were purchased by collectors.

By the sale's end, the entire auction brought a total of $200.7 million, breaking the record for a single-artist auction set in 1993, when a Picasso sale with eighty-eight works brought $20 million.

As Michael Finkel wrote in his wonderful book, *The Art Thief*, when referring to the infamous art thief Stéphane

Breitwieser, "his sole motivation was to surround himself with beauty to gorge on it." That was the motivation of the continued frenzy in the art world.

And yet, when Freedman took over Knoedler in the mid-nineties, the gallery was already fading, eclipsed by sexier galleries such as Gagosian and Mary Boone, which had prospered throughout the eighties in SoHo by selling contemporary works to a hot stream of Wall Street money.

A short side note on gallerist Mary Boone. As the owner and director of the Mary Boone Gallery, she played an important role in the New York art market of the 1980s. Her first two artists, Julian Schnabel and David Salle, became internationally known, and in 1982, she had a cover story in *New York Magazine* tagged "The New Queen of the Art Scene." Boone is credited with championing dozens of contemporary artists, including Eric Fischl, Ai Weiwei, and Barbara Kruger. In 2019, she was convicted for tax evasion, sentenced to thirty months in prison and ordered to pay $3 million in restitution. Her comment on sentencing: "If I'm going to be the Martha Stewart of the art world, I would hope to do it with the same humility, humor, grace, and intelligence."[10] This happened while I was filming Freedman; he took a strange satisfaction in her conviction. She felt she was not alone in being vilified. The art world is certainly not immune from a colorful list of characters that continue to cut corners and cheat collectors. In late 2024, esteemed New York art advisor, Lisa Schiff, who once advised actor Leo Dicaprio, pleaded guilty to wire fraud after cheating dozens of clients out of $6.5 million in the sale of artworks.

THE DEVIL WEARS ROTHKO

With Rubin gone, Freedman was successful for a time, selling artists such as Helen Frankenthaler, Frank Stella, and younger artists Donald Sultan, John Duff, and Caio Fonseca, plus work from the estates of David Smith, Adolph Gottlieb, Richard Pousette-Dart, Herbert Ferber, and Nancy Graves. Freedman told the media that the gallery sold to American private collectors, mainly from outside New York. Her rolodex included many California moguls and huge estates.

In 2022, the Getty Research Institute in Los Angeles bought the Knoedler Gallery archive, a vast trove dating from around 1850 to 1971. It incorporated stock books, sales books, a photo archive, and files of correspondence, including illustrated letters from artists and collectors provided for invaluable storytelling.

The archive is an inclusive, inside look at the history of art collecting in the United States and Europe from the mid-nineteenth century and onward that includes incredible art transactions tracing their provenance to Knoedler.

Here are some transactional highlights of how this once illustrious gallery made and owned the market for nearly 165 years:

1. Winslow Homer: *The Gulf Stream*, 1899. Metropolitan Museum, New York.

 When Boston-born Winslow Homer, one of the nineteenth-century's foremost artists, created *The Gulf Stream*, every artist who saw it pronounced it "great." It was sold to The Metropolitan Museum of Art in 1906 by Knoedler & Co. The purchase was important as it was an indication that the Metropolitan Museum was serious about building its contemporary American art collection.

2. Rembrandt: *Self-Portrait*, 1658. Frick Collection, New York.

Knoedler bought a half share in 1907 for £15,500 and sold it to their client Henry Frick the same month for $225,000. This became the pattern; Colnaghi, a prestigious British art dealer, would procure works and partner with Knoedler to sell them to American millionaires. The informal partnership lasted for four decades, yielding profits for both parties.

3. Anthony van Dyck: *Marchesa Elena Grimaldi*, c. 1623. National Gallery of Art, Washington.

Purchased from Trotti & Cie., Paris, in 1907, it is one of five family portraits from the Cattaneo Palace, Genoa, three of which Knoedler sold to capitalist and collector, Peter A.B. Widener of Philadelphia in 1908 for $450,000.

Knoedler would go on to sell several van Dycks, now in the Frick Collection.

Widener purchased more than two dozen paintings from Knoedler, including Johannes Vermeer's *Woman Holding a Balance*. Knoedler acquired a quarter-share for £5,500 in 1910 and within a year sold it to Widener for $145,000. The bulk of Widener's collection was given to the National Gallery in 1949.

Fun fact: Nearly a century later, Freedman engaged in the same practice—using wealthy collectors to buy a share of a painting then flipping the work to another buyer. One of Freedman's investors was renowned Canadian theater impresario and astute collector David Mirvish. More on that later.

THE DEVIL WEARS ROTHKO

4. Diego Velásquez: *The Portrait of Philip IV in Fraga*, 1644. Frick Collection, New York.

 London dealer Thomas Agnew bought this masterpiece from Spanish royalty, Prince Elias de Bourbon, Duke of Parma, in 1910, flipping it to New York gallery Scott & Fowles, from whom Knoedler took a half interest at £41,500. Knoedler then sold it to Frick in 1911 for $475,000.

5. Johannes Vermeer: *Officer and Laughing Girl*, 1655–1660. Frick Collection, New York.

 Colnaghi sold the Vermeer to Knoedler in 1911 for £36,000, who immediately sold it to Frick for $225,000. Knoedler handled more than half a dozen Vermeers now in American museums.

6. Giovanni Bellini: *St. Francis in the Desert*, c. 1480. Frick Collection, New York.

 Considered the greatest Bellini outside Europe, Colnaghi purchased *St. Francis in the Desert* from Mary Ann Driver (Lady Holloway), with Knoedler taking a half-share in 1912 for £17,000 in a sale for £45,000 to a collector. Knoedler flipped it a year later for £60,000, and sold it to Frick in 1915 for $170,000.

 All in all, Frick bought more than 225 pictures from Knoedler, many for his new mansion on Fifth Avenue.

7. Piero della Francesca: *Madonna and Child Enthroned, with Four Angels*, c. 1460–1470. Sterling and Francine Clark Art Institute, Massachusetts.

 In 1913, collector, horse breeder, and heir to the Singer sewing company fortune, R. Sterling Clark, acquired the greatest Piero della Francesca outside Europe through

Knoedler. Colnaghi had bought it from Jane Margaret Seymour and sold Knoedler a half-share in 1913 for £7,500. When Knoedler sold it several months later to Clark, its share was $79,012.

Fun fact: Seymour was married to ship builder and owner James Ismay, brother of J. Bruce Ismay, the chairman of the White Star Line that owned the ill-fated *Titanic*.

8. Rembrandt: *The Visitation*, 1640. Detroit Institute of Arts, Michigan.

The masterpiece was acquired by Colnaghi from Alfred de Rothschild with Knoedler taking a half-share in 1924 for $25,048. W.R. Valentiner, director of the Detroit Institute of Arts, procured the painting in 1927 for $150,000, paid for by the city.

9. Honoré Daumier: *L'Amateur d'Estampes*, c. 1860–1863. Sterling and Francine Clark Art Institute, Massachusetts.

Knoedler's Paris branch purchased the painting from Parisian art dealer George Bernheim in 1925 for $16,966. It was flipped to R. Sterling Clark to go with his Degas and Renoir, which he bought from Knoedler a few months earlier for $26,730.

Of course, the archives at Getty have thousands more transactions, all illustrating the horse-trading nature of the art world and the massive profits being made. Not much has changed today.

CHAPTER 5

AN IMPERFECT REPUTATION

LONG BEFORE THE KNOEDLER downfall and eventual closing in 2011, the gallery was subject to a history of scandal and various legal disputes.

In 1887, Edmond Knoedler and one of his gallery employees, George E. Pfeiffer, were arrested and charged with selling lewd and immoral pictures in the print department. Most of the items seized were reproductions, including a rendering of Alexandre Cabanel's pseudo-mythological eroticized *The Birth of Venus*. They were both found guilty and fined.

Throughout the 1950s and 1970s, the gallery was involved in a multitude of disputes involving Nazi-looted art and forged art. Some of the gallery-affiliated sales from the 1930s and later 1950s would prompt legal action decades later.

ONE OF THOSE DISPUTES occurred between 1997 and 2000, where Knoedler found itself a third-party defendant to a

dispute between the Seattle Art Museum and Elaine Rosenberg, heir of Paul Rosenberg, an important Jewish art dealer in Paris, whose collection was confiscated by the Nazis during World War II and included 162 paintings.

In 1954, Knoedler sold a 1928 Henri Matisse painting, *Odalisque*, to Virginia and Prentice Bloedel, who bequeathed it to the Seattle Art Museum in 1991, with full ownership in 1996. In 1997, Elaine Rosenberg sued the Seattle Art Museum to recover the painting. The museum turned around and blamed Knoedler, alleging fraud and/or negligent misrepresentation at the time of the 1954 sale.

Knoedler successfully demonstrated that it was not a party to the Bloedel's bequest to the museum and therefore should not be party to the lawsuit. In June 1999, the Seattle Art Museum returned the painting *Oriental Woman Seated on Floor* (also known as *Odalisque*) to Rosenberg.

In 2004, Knoedler had to defend itself over the sale of another painting stolen during World War II. In 1955, the gallery sold *Spring Sowing*, a painting by the Italian artist Jacopo da Ponte, to the Springfield Library and Museum Association for $5,000. The bill of sale stated that the defendant "covenants with the grantee that it [is] the lawful owner of the of the art." However, in 1966, the director-general of the arts for the Italian government wrote to the Springfield Museum's director, claiming that *Spring Sowing* belonged to the Uffizi, a museum in Florence, Italy.

The painting was on loan to the Italian embassy in Poland before World War II, and it went missing during the war. The gallery staff admitted that the painting was probably the one stolen from the embassy and returned it to the Uffizi in 2001. The Springfield Museum then sued Knoedler, alleging breach

THE DEVIL WEARS ROTHKO

of contract, breach of implied warranty, fraud and deceit, negligence, and misrepresentations, among other counts.

Both parties settled out of court, and while the terms of the settlement are not public, the court not only refused to dismiss this case but also declined to decide it at the pleading stage. It ruled that the statute of limitation, since the 1960s, had been "tolling"—a legal concept allowing for a delay in the period set forth by a statute of limitations.

Of course, Knoedler was not the only gallery in New York—or Europe, for that matter—that knowingly or not, dealt in stolen Nazi art. After the Second World War, the art market was rife with stolen art looking for buyers and huge profits. There are hundreds of unrecovered looted art; some museums will never publicly display certain works of questionable provenance that were most likely stolen. In one museum in Europe, I was secretly shown a few hidden pieces that had the addresses of Jewish homes where the art was stolen by the Nazis.

In another shadowy, Nazi-looted art case, Camille Pissarro's *Rue Saint-Honoré in the Afternoon. Effect of Rain* (1897)—considered a masterpiece of French-impressionism—has been in a legal abyss for decades. The courts have had to deal with various questions raised in a lawsuit by the California-based heirs of the original owner who were looted by the Nazis.

As with much Nazi-looted artwork, the history of the Pissarro painting is long and complex. German citizen Lilly Cassirer Neubauer inherited the Pissarro painting in 1926. As German Jews, Neubauer and her husband were subjected to the discriminatory racial laws of the Third Reich, including the "Aryanization" of the property of German Jews. Hitler appointed Berlin art dealer Jakob Scheidwimmer to appraise Neubauer's

Pissarro painting and then demanded that she "sell" it to him. The payment—$350 in Reichsmarks—was deposited in a blocked bank account to which Neubauer had no access. She and her husband fled Germany in 1939.

Scheidwimmer then swapped the Pissarro for three German paintings from the collection of Julius Sulzbacher, a Jewish art collector. After the Sulzbacher family fled Germany, the Gestapo seized the Pissarro and hundreds of other paintings.

After the war, Neubauer believed her painting was lost or destroyed but she and Sulzbacher filed claims against Scheidwimmer for restitution or compensation. In 1954, the US Court of Restitution Appeals confirmed Neubauer was the owner of the painting. In 1957, Germany established a process for claims related to Nazi-looted property. Neubauer dropped her claim against Scheidwimmer and filed one with Germany for compensation.

In 1958, Neubauer, Sulzbacher, and Germany entered into a settlement agreement with respect to the painting and two of the three paintings Sulzbacher had swapped for it. In that settlement, Neubauer was paid the agreed value of the painting as of April 1, 1956 of 120,000 Deutschmarks or $400,000 in current value.

Here's the curve ball. The Pissarro painting was not destroyed. After being sold numerous times in Nazi government auctions, the painting ended up in California where The Frank Perls Gallery of Beverly Hills acquired it and then sold it in 1951 to a collector who asked the gallery to place the Pissarro with Knoedler on consignment. Knoedler then sold the artwork in 1952 to St. Louis art collector Sydney Schoenberg, before it was sold again in 1976 to Swiss industrialist and art collector Baron Hans Heinrich Thyssen-Bornemisza, a man who had his own share of scandals.

THE DEVIL WEARS ROTHKO

Now, here is where the story becomes a legal nightmare for Neubauer, the painting's original owner. In 1988, the Baron and the government of Spain entered into an agreement for the Baron to loan his collection to Spain and establish a private, nonprofit foundation—the Thyssen-Bornemisza Collection Foundation—to "maintain, conserve, publicly exhibit, and promote" his artwork collection.

In 1993, Spain purchased the collection from the foundation. From October 1992 to the present, the foundation has owned and publicly displayed the Pissarro painting at its museum in Madrid.

In 2000, Neubauer's heirs discovered the Pissarro was in Spain and petitioned that country and the foundation to return the painting. Spain denied the request. Subsequently, five members of the US Congress wrote to Spain and the request was likewise refused.

On May 10, 2005, Neubauer's heir, California resident Claude Cassirer, filed suit against the foundation and Spain in the US District Court for the Central District of California. For the past twenty-five years, the Cassirer family has been trying to get the painting back from the national museum in Spain.

The California District Court asked the California Supreme Court for guidance on how the comparative impairment analysis should be applied. In 2023, a three-judge panel ruled against the family's appeal to retrieve the Nazi-looted artwork that currently hangs on public display in a Spanish museum.

A year later, the Cassirer family faced a massive setback when an appellate court, in a highly technical decision, determined Spanish law, not California law, applied to the case, meaning the museum had acquired the painting through adverse possession.

The court ruled that because the museum, which acquired the painting in 1993, had held the painting for a minimum of six years before the Cassirer family petition made a claim for it, Spanish law dictates the museum has fair possession of it. And because the Ninth Circuit court determined to follow Spanish, and not California law, the painting will remain with the museum for now.

The museum's leadership maintains it did not know the work was stolen, while Cassirer's legal team has argued any knowledgeable art collector would surely have known the work, which could be worth up to $60 million, was once the property of Lilly Cassirer. "There is no dispute that the Nazis stole the painting from Lilly," Judge Carlos Bea, one of the three circuit judges to hear the appeal, wrote in his opinion.

In a dissenting opinion, Circuit Court Judge Consuelo Callahan wrote that she agreed with the decision from a legal standpoint but was troubled by it. Spain, Callahan wrote, "should have voluntarily relinquished the painting."

Cassirer said: "We were all just sickened by the ruling. We're upset, amazed, and hurt. On behalf of my immediate family, all of whom have died, on behalf of the Jewish people, facing exponentially growing antisemitism, this is a terrible ruling."[11]

Considered the greatest art theft in history with 650,000 works looted from Europe by the Nazis, many of which were never recovered, has led to decades of restitution legal battles and provenance arguments. Bruno Lohse, who had been Hermann Göring's art agent in Paris during the war, admitted that he used Göring's art-collecting activities in the 1950s to help wealthy Germans build their collections with stolen art. Lohse's art network extended to Switzerland where he used a

THE DEVIL WEARS ROTHKO

Zurich lawyer named Frederic Schöni to create a foundation in nearby Liechtenstein to conceal artworks—many of them stolen. In 2000, two of Canada's most prominent galleries listed more than 120 works of art in their collections that may have been stolen from their original owners by the Nazis during the Second World War so that people around the world, especially European Jews and their descendants, can examine and possibly claim the works. And in 2022, museums in New York City that exhibit artworks looted by Nazis during the Holocaust are now required by law to let the public know about its dark provenance.

However, in some cases, museums have refused to identify certain works as stolen if they had been gifted. An example was the Picasso painting *The Actor*, once owned by Jewish businessman Paul Leffmann who fled Germany. Leffmann sold the painting to a Paris art dealer for $13,200 in 1938 to fund his escape. The art dealer, Paul Rosenberg, consigned the work with Knoedler in New York City, who sold it to a collector for $22,000 in 1941. The collector donated the painting to the Metropolitan Museum in 1952.

Leffmann's great-grandniece, Laurel Zuckerman, sued the Metropolitan Museum in 2016 for the return of the painting, claiming it was a bargain-basement sale price that reflected the family's desperation to flee Europe. The museum countered that the price was actually high for an early Picasso at the time. A US Court of Appeals eventually dismissed the lawsuit in 2019.

We have no idea how many Knoedler transactions involved stolen Nazi art, but undoubtedly the gallery was a gateway from Europe for the looted plunder. And none of these murky transactions bothered Michael Knoedler, Armand Hammer, or the succeeding gallery management.

CHAPTER 6

ANN FREEDMAN: BORN TO SELL

DURING MY COURTSHIP OF Ann Freedman to appear in my documentary, and then throughout the eight to nine months of my working on the film, Freedman never arrived empty-handed at our lunches or post-work cocktails.

She would often clutch a massive file-folder of photocopied articles, letters, and quotes, or a Freedman Art envelope jammed with "evidence" that either supported her position that she had been conned, or feature stories on other forgeries, where other people had also been conned.

One of the more bizarre pieces of paper she shared with me was an outline for an unpublished novel about the art world written by art critic Gregory Battcock, a key figure of the New York art scene of the 1960s and 1970s. Battcock wrote, as follows:

THE DEVIL WEARS ROTHKO

The art world, in each and all of its many parts...
is corrupt in the following ways:

a) It's managed completely by the rich as a plaything.

b) It likes to appear concerned with the poor, social problems, etc., but is not and usually acts against social interests.

c) Many "prestige" institutions, museums, galleries, etc., are really around in order to increase the value of paintings for the private gain of collectors, investors, and sometimes, artists.

d) Many of the rich, society people who control things have no real background in art, or anything else, the picture of superficiality and "good" manners.

e) The "auction houses," again run by the banks, really, are staffed by wise-ass society girls, otherwise unemployable, overeducated, and flunky art historians.

I'm not sure how any of this supported Freedman's view of her precious world or was designed to give me a more sympathetic take on her story. When I was making my first documentary on the art world, *Blurred Lines: Inside the Art World* (Netflix, 2017) with collector Jonas Prince, art critics called the art shows "a NetJets parking lot" and "Comicon for billionaires." Freedman found those quotes disrespectful.

And beyond the endless letters of support by art world figures, there were pithy quotes she had her daughter print out for

me, such as this from Oscar Wilde: "A good friend will always stab you in the front," or this from author, Amit Kalantri: "A stab from a friend cuts deeper than a stab from a foe."[12]

One of my favorites from the towering inferno of notes she gave me was an excerpt from a book, written by clinical psychologist Martha Stout, that Amazon describes as "an excellent book that gives insight to what a sociopath is, how to spot one, and most importantly, how to protect yourself from them."[13] Freedman gave me a hand-written passage from the book: "Fear-based super egos stay behind the dark curtain accusing us."[14] What? Perhaps it would have been fortuitous for Freedman to read this book before she met the crime wave known as Bergantiños and Rosales.

So, who is Ann Freedman and where did her journey begin?

Ann Louise Fertig was born in 1949 in Scarsdale, New York, daughter of Mr. and Mrs. Felix C. Fertig. Her father was a vice-president of Williams & Co., a New York real-estate firm. "I grew up with a measure of comfort of wealth and my parents exposed me to culture early on. I remember going to MoMA, the Whitney, and Guggenheim and being smitten. I took art classes as a child and lots of arts and crafts at summer camp in Maine for seven years," Freedman said.[15]

She attended Washington University in St. Louis as a painting major, earning a bachelor's degree in fine arts in 1971. She told me it was her dream to be an artist but quickly realized in art classes that her skills were simply not good enough.

Freedman said: "I understood that…my own making art was very limited because I didn't have talent. Again, it was cathartic, even therapeutic. I took some private lessons after school. But I knew who the real artists were. And I didn't just want to be a

student of art. I wanted somehow to touch the artists who were making art. So, I did not want to get a job in a museum 'cause that would have been in some back room filing things. I wanted to be in the front lines meeting people who were looking at art, meeting the artists, and being there with the art. I didn't want a clerical job or administrative job. I wasn't good at that. And I was going to teach art and the job fell through here in the city."[16]

One of her professors suggested that she get a job in a gallery in New York City and to begin her career there.

"And so," Freedman continued, "I turned to my best friend, I guess, in college at Washington University in St. Louis. And I said, 'I need to get a job. I'd love to work in a gallery.' And that happened. I was living at home with my parents in Scarsdale and I said, 'I'll work for nothing just to get my foot in the door.' I was told that the Emmerich Gallery, André Emmerich Gallery, would be looking for a receptionist in the fall, September."

So, on July 19, 1971, Freedman took a train to New York right after graduation and secured her first job at the Emmerich Gallery working as a receptionist. It was there that she was immediately introduced to the heady society of art. "And I graduated college in, what? End of May. So, I said, 'I'll start right now in June.' And I literally started beginning of July. And for no salary. It was the first time that they had had anybody work at the gallery that wasn't hired by André Emmerich."

Freedman wasn't asked to do anything except make coffee type labels that went on the back of paintings, answer the phones, do a little bit of clerical work, and of course, meet and greet people. "I couldn't type at all, so, it took me three times as long to get that done. But meanwhile, I was on the front lines.... I loved it. I opened the gallery early and stayed late."[17]

Emmerich Gallery was run by André Emmerich, a pedigree gallerist whose grandfather was an art dealer who acquired art for wealthy industrialists such as J.P. Morgan. Emmerich and his Jewish family fled from Germany to Amsterdam when he was seven, and then immigrated to Queens, New York in 1940.

Emmerich opened his first gallery in 1954, the André Emmerich Gallery, at 18 East 77th Street. He initially specialized in contemporary American and European works, eventually displaying leading artists who employing a wide variety of styles, including abstract expressionism, op art, color field painting, hard-edge painting, lyrical abstraction, minimal art, pop art, and realism, among other movements. He would later open another gallery in Zurich, Switzerland. Emmerich operated successfully for the next four decades before selling the gallery to Sotheby's in 1996.

What propelled Emmerich's success was his friend, artist Robert Motherwell, who introduced him to a group of eccentric painters we now know as the New York Abstract Expressionist School, featuring (aside from Motherwell) Jackson Pollock and Mark Rothko. The gallery represented many internationally known artists and estates, including David Hockney, Hans Hofmann, Helen Frankenthaler, Jules Olitski, Jack Bush, and Ed Moses. Many of these artists would later be represented by Freedman herself at Knoedler.

Freedman received her education at the gallery and watched incredible art sell for millions. She would study Emmerich and the other dealers as they passionately described every aspect of a specific art from brush stroke to composition and the artist's vision and state of mind while creating a work.

THE DEVIL WEARS ROTHKO

Every piece of art came with a back story that was rich in detail and Freedman lapped it up. She even spent hours of her free time doing her own research. She told me: "I instinctively related to art." She even bought her first painting, a Hofmann, as a "wedding present" from the gallery for $6,000. "We had no assets, car or jewelry, but I was infused with the pride of having a great work of art."[18] Freedman sold the work later, when dealing with mounting legal issues, and although she would not tell me what she sold the piece for, it is fair to say, considering the size and condition of the painting, it was in the millions.

Freedman hated being called a receptionist and changed her title to gallery research manager, as she called herself, in a *New York Times* marriage announcement to her husband Robert Freedman in 1972.

Freedman knew she was wasting her time answering phones and getting lunch for the other sales staff who were making a fortune in commissions. She would leave her desk and start selling art to anyone who walked in, much to the disdain of the sales staff. And she was good at it. Freedman said: "My enthusiasm for the art was contagious and won people over. I was relentless. Emmerich started seeing more and more invoices on his desk that he could not have imagined." At night, she would attend art shows and auctions, and started to develop relationships with collectors. She told me: "There was resentment and they wanted me to stay at the reception desk and greet people."[19] After six-and-a-half years, it was time for her to move on.

In 1977, at age twenty-nine, Freedman was offered a job at Knoedler as director of contemporary art by Armand Hammer himself. He had bought the gallery six years earlier in 1971 and hired Lawrence (Larry) Rubin to be president of the gallery.

She initially resisted, not wanting to leave. But it was artist Helen Frankenthaler, wife of the legendary artist Robert Motherwell, who said: "You will grow, you will challenge yourself. Knoedler represents great artists." At the time, Knoedler and Wildenstein were the two oldest and most prestigious galleries in New York.

In no time, Freedman began to outsell everyone and eventually claimed the main office of the gallery's gilded-age Upper East Side mansion as her own. She was on fire. "There was a sense of some disbelief, if not resentment," she said. "No one paved the way for me to sell, but I sought out the opportunity and never looked back."[20]

People noticed. "I had never seen anything like it before or since. She could sell the proverbial snow to Eskimos," Will Ameringer told *Vanity Fair*. He worked with Freedman in the 1980s and now has his own gallery. He added: "Once the client was in her office/showroom, there was no getting out without buying a painting."[21]

Michael Shnayerson, a *Vanity Fair* journalist whom we interviewed for our film told us that, as Freedman rose to become Knoedler's director, she had her admirers. Roger Kimball, editor and publisher of *The New Criterion*, said: "She is a woman who cares passionately about art and artists." But other competing gallerists found her cold and abrasive. Michael David, a former artist with Knoedler, told *Vanity Fair*: "I think that was how she defined herself. She was great at what she did, but she had an edge. She took no prisoners, and she could be vindictive."[22]

Freedman responded in the same article: "Being vindictive is not on my radar screen in my personal life or…as a serious dealer for close to four decades." Ameringer called her a fabulist

THE DEVIL WEARS ROTHKO

who believes her own stories. "She could point to the blue sky and tell you it was red, and she would believe it."[23]

Freedman responded: "I talked to the best people I could. I would get opinions from some of the most credible experts."[24]

When Freedman joined Knoedler in 1976, Rubin, who had been there since 1973, was now president of the gallery. Rubin was very well respected and had a sterling reputation in the art world. Born in Brooklyn in 1933, Rubin began his gallery career at Rome's Galleria Schneider in 1959. After studying art history, he had a meteoric rise in the art world that would include directing or owning five galleries in Paris and New York.

In 1961, he opened his own gallery in Paris, Galerie Lawrence, with the first European solo exhibition of Frank Stella. He would go on to help compile a *catalogue raisonné*—a thorough, comprehensive listing of an artist's all known works—of Stella's canvases from 1958 to 1965.

Rubin returned to New York and opened a gallery, continuing to represent Stella as well as other artists. His brother William Rubin served as director of the painting and sculpture departments at the MoMA in New York.

In 1973, Armand Hammer persuaded Rubin to work at the prestigious but financially-struggling Knoedler. Hammer moved the Knoedler Gallery into a stunning Italian Renaissance-style townhouse on East 70th Street and spent millions transforming it into a multi-level gallery that housed a rotating collection of the very best in pedigree art for sale.

Over the next two decades, Rubin turned the gallery around by developing its lucrative mid-century and contemporary art wing and exhibiting many of the abstract expressionists

he had previously represented, including Stella, Diebenkorn, and Rauschenberg.

Although very different in style and temperament, Rubin and Freedman worked well together. One veteran art world insider told me that Rubin found Freedman's selling tactics to be pushy and relentless. He described her as "the Picasso of passive aggressive."

But somehow, they managed to make it work. Freedman said: "We worked together for seventeen years and had lunch three or four times a week." Rubin had the connections to the artists and could seduce wealthy collectors. Freedman arrogantly told me: "Rubin had a great eye, but the early bird catches the worm. Larry was enjoying the sales I made, and it was clear that I was doing more than him."

In 1994, Rubin decided to retire. He announced that Knoedler would be run by two co-directors: Freedman and an outsider named Donald Saff, who was a publisher of Rauschenberg and Roy Lichtenstein. His vision was that Saff would run it, and Freedman would go on being the super salesperson. "He was clearly reducing my role," said Freedman.[25]

She was devastated.

By now, Michael Hammer taken over the gallery after his grandfather's death in 1991. Freedman figuratively put a gun to his head and essentially told him that if she didn't become head of the gallery, she would leave and take her clients with her. Hammer gave in, as he knew nothing about running a gallery, and certainly didn't know their clients.

Freedman was named the gallery's sole new director. In Freedman's words: "I met with Michael, and he made an immediate decision to have me run the gallery."[26] To paraphrase a

THE DEVIL WEARS ROTHKO

legendary film: She made him an offer he couldn't refuse. Rubin was escorted out. They never spoke again.

Holding the seat of infinite influence, Freedman was an overnight rock star and the face of the Knoedler Gallery for nearly thirty-two years. The gallery continued to soar, racking in millions in sales generated from her rolodex that included the music world's David Geffen, hedge fund boss Steve Cohen, and the investor/philanthropist Taubman family, as well as every imaginable museum insider. She made Knoedler the art world's hottest gallery. She was powerful, ruthless, and hated. Many privately questioned her deals, but no one dared confront her. She was unstoppable.

What made Freedman so good was that she studied every deal point. Yes, she pissed off the other gallery sales staff, but she was outselling them, and most of the other galleries in New York as well. The result was that artists came to her asking her to represent them. She ultimately reversed the gallery's fortune with a new direction, selling contemporary art versus the old masters, who had previously defined the Knoedler for the past century. Freedman loved that artists such as Motherwell, Olitski, Stella, Gottlieb, Howard Hodgkin, and Diebenkorn chose Knoedler. "I was doing well for them, they trusted me and many of them stayed with me for twenty-five years," she said.

"I didn't want to be famous," Freedman added. "I didn't court fame like Peggy Guggenheim, Betty Parsons, or Mary Boone" (who later went to prison for tax evasion).[27]

Freedman loved the vast and priceless Knoedler gallery library. Its own librarian would prepare detailed research reports for her and help add rich detail for collectors. She loved the academics of art and would produce massive exhibitions such as

the 150th anniversary of the Knoedler in 1996, and a patronage show involving the history of collecting at Knoedler, and another show celebrating its 160th in 2006. Being accepted by the art community was irrelevant to her game plan. She did court the media and looked to make friends beyond her relationships with her artists and the collectors who were prepared to spend millions. When she arrived at prestigious art shows at The Armory in New York or Art Basel in Switzerland, the waves parted for the diva.

However, with just a year under her belt as the ultimate boss, and after decades of unstoppable success, it began to look as if Freedman had hit a wall. The tides were turning in the art world and the Knoedler was no longer a hot commodity.

Several cash-cow artists including Rauschenberg, Motherwell, and LeRoy Neiman led an exodus from Knoedler after disagreements with management. Fierce competitors such as the now-famed Gagosian chain of galleries, auction houses, and other galleries had started selling contemporary art and attracting young artists that had pushed Knoedler to the curb.

Freedman had managed to miss the boat on the next wave of artists whose works were being gobbled up by a new generation of very wealthy collectors.

Freedman was floored at the stagnation that fell upon the gallery. She could never have predicted the turn would be so Shakespearean. But the storm clouds had arrived in the once sunny skies over Knoedler and she needed a miracle to save the gallery and her own ass.

Hammer did not share his grandfather's love of art and thus, wasn't particularly attentive to what was happening. He had worked for his late grandfather before overseeing multiple

THE DEVIL WEARS ROTHKO

Hammer foundations and numerous businesses that included Hammer Galleries, and a television and film production company. He was more interested in private planes, expensive cars, and fake tans. The gallery accountants had warned Freedman that Hammer was using the gallery as his own piggy bank to fund his lifestyle. "I did not work on commission, only my salary and bonus," Freedman explained. "And I had no real sense of the gallery accounting floor or overhead. I did know when we had the odd lean year, but I had no idea what the owner was taking."[28]

Rumors were also circulating that Hammer was toying with shutting down the gallery and selling the Upper East Side townhouse in what could be a $50 million payday. Knoedler had become yesterday's news and Freedman was no longer controlling the street.

The gallery needed to find a source of income to replace its lost cash-cows. Furthermore, the big auction houses, Christie's and Sotheby's, were increasingly dominating the business of selling established artworks. Hammer pressured Freedman to find new streams of revenue and attract collectors. The gallery was now part of an older generation that had been overshadowed by more fashionable businesses downtown—galleries such as Gagosian and Mary Boone—which had prospered throughout the 1980s by selling contemporary works to new Wall Street money.

The art market crashed in 1990, but signs of recovery emerged beginning in 1994. The market for contemporary art was beginning to overtake the prices commanded by impressionist and modern art.

Freedman needed a miracle. Enter stage right: Carlos Bergantiños and Glafira Rosales.

CHAPTER 7

BONNIE, CLYDE, AND A MASTER FORGER: A HOLLYWOOD CASTING DREAM COME TRUE

SO, HAVING SET THE table for the insanely intoxicating and yet scandalous art world, the often-gluttonous collectors, and lurid history of fake art, let's now get back to our story and meet the villains.

As a reminder, here is our principal cast:

- Jose Carlos Bergantiños Diaz, criminal mastermind
- Glafira Rosales, co-conspirator, Bergantiños's girlfriend
- Pei-Shen Qian, master forger
- Anne Freedman, Director, Knoedler Gallery

Jose Carlos Bergantiños Diaz agreed to be interviewed for the film we were making. The man we would meet in Lugo in May 2019—nearly a decade after he fled to Spain to avoid prosecution in the infamous art forgery scandal—did not appear as a

THE DEVIL WEARS ROTHKO

criminal mastermind of any kind. Time and health were not on his side. He looked more like a disheveled Bob Hoskins versus the art thief Pierce Brosnan in *The Thomas Crown Affair*.

We met in the office of his lawyer, J.A. Sánchez Goñi, who was there to ensure that his client didn't incriminate himself any further. Thankfully, Goñi was addicted to cigarettes and kept leaving, allowing us to ask questions and get some real answers. Bergantiños arrived late, wearing a vicuña cashmere gray coat, a Prada suit, a deep burgundy tie, and on his right hand, a silver cross-shaped ring.

He spoke with difficulty due to a stroke he claimed he suffered. However, he was not shy in telling his story. One has no clue how to separate fact from fiction when dealing with a con man, but nonetheless, Bergantiños wove his yarn.

He was born in Parga, Spain, in the svillage of Lugo, a charming medieval walled-in city. At times, he sounded boastful and yet depressed. He told me his childhood was hard. He was the middle child of three brothers but his sibling of significance for this story was Jesus, seven years his senior, and with whom he would develop the art forgery scheme. His father was unemployed, and his mother, he claimed, had great painting skills and ran the household. He was forced to get a job at age nine as a bellboy in a spa to help support the family.

Desperate to get out of Lugo, he took various jobs at restaurants in Madrid. He then met a bullfighter who took him to Mexico where he fell ill and was taken to a hospital. The medical student who took care of him was Glafira Rosales. "She saved my life, and we fell in love," he claimed.[29]

Rosales, born to an indigenous mother and rancher father, was from Guanajuato, where she grew up in a home without

75

electricity or running water, along with her eight siblings. Her father was strict and abusive, and she left home at sixteen to begin nursing studies. Bergantiños described her as "a great woman. Very intelligent. I still admire her and love her."

For Bergantiños, America was where his dreams could be fulfilled and he and Rosales went to the border, passed the Rio Grande, and stayed in Nuevo Laredo, just across Laredo, Texas. He told me: "We spent hours on trains, buses, and bribed the Mexican police to let us slip over the border."[30] They arrived in Houston where Rosales found a job as a waitress, and he worked as a dishwasher.

Bergantiños told me he always dreamed of living in New York City. He saw pictures of Times Square and Rockefeller Plaza. Most of all, he said he wanted to be rich. After a year of washing dishes and waiting on tables, the couple moved to New York.

His first job in the Big Apple was delivering seafood to upscale restaurants. Given his perishable cargo, Bergantiños was always frustrated with brutal city traffic, so he bought a second-hand ambulance, turned on the siren, and sped through red lights. He called his new venture Emergency Seafood.

Bergantiños's entry to the art world came simply by delivering caviar to Christie's and Sotheby's. After his deliveries, he would wander into the bid rooms during auctions and was captivated by the well-heeled crowd spending millions on incredible modern art. While his fingers smelt like fish, his head was spinning as to how he could get into the action and make some money in the art world.

An old friend from Madrid who was now an art patron in New York City introduced Bergantiños to a few galleries that were exploding with a new breed of wealthy collectors. While

THE DEVIL WEARS ROTHKO

Rosales, exhausted from her shifts at a diner, slept next to him in the suffocating heat of their one-room apartment, Bergantiños plotted his entry into the art world.

In 1991, they would have a daughter, Isolina (Soli), who today, astonishingly, runs an art gallery: Soli Corbelle Art. According to its website, it has locations in Los Angeles, Spain, and Mexico, where it claims to sell original works from many of the same artists her parents were accused of forging. Her online biography states that she grew up in a household of "art collectors" and at the age of fifteen, she "garnered" experience with several auction houses such as Sotheby's and Phillips. Oddly enough, while I was making this film, I received an email from an irate person in Los Angeles, with a lurid story claiming to have been defrauded by Soli.

Martha Henry, a New York art advisor and former gallerist, told a journalist that she remembered meeting Bergantiños at auctions, openings, and parties. She said he was suddenly everywhere and telling her and others he was interested in buying art. She also met someone she perceived to be "a quiet housewife."

Henry terminated her friendship with Bergantiños when she found herself being sued in 1997 over a supposedly fake painting that came from him. Sadly, Henry would get conned again in 2008 by a man named Clark Rockefeller, falsely posing as a scion of the famous family.

Determined to be a player in the art world, Bergantiños took a course at New York University called "How to Be a Successful Art Dealer." He opened accounts at the main auction houses and started buying work. His strategy—be noticed and be recognized as a player—worked to a point, but not without some scandal.

77

In 1995, he was sued by Christie's for nonpayment on a painting. The process server in that case was chased away when Bergantiños came out of his house with a shotgun. Christie's barred him for life from entering their premises. Scandal and lawsuits followed him and yet no one bothered to investigate his background before doing business with him. He had been accused of forgery in Spain and was involved in lawsuits in the Dominican Republic, where he purchased a second home and two paintings: a Leger and a Picasso.

Wanting to establish a base for his art schemes, Bergantiños and Rosales started their own gallery business, King's Fine Arts. They began by selling Latin American and Spanish artists but weren't making money. He told me, "I wanted to play in the big league" and with that, he needed to sell big art. Enter the artist that would change everything.

Long before Pei-Shen Qian would meet Bergantiños and get involved in his scheme, he was living in China during the Cultural Revolution, where he discovered he was born with a skill to paint. He would paint endless portraits of Chairman Mao for schools and factories. He was stifled by the rigidity of Chinese art and was yearning to be more expressive such as the art he saw in the modern art books his family sent him from Taiwan. He dreamed of being famous in post-revolutionary Shanghai. He was a high school math professor by day and painted by night. His art was getting some attention as his style was inspired by the modern art he was intoxicated by. But he fantasized about finding fame in New York, just as Rothko and Pollock had.

In 1981, he arrived in Manhattan with a student visa, despite being forty-seven years old, and enrolled in The Art Students League of New York. The legendary school, founded in 1875,

THE DEVIL WEARS ROTHKO

was a massive influence on innovative artists, abstract expressionists, pop artists including Donald Judd, Knox Martin, James Rosenquist, Cy Twombly, Frankenthaler, Lichtenstein, Rauschenberg, Rothko, and Pollock. Qian wanted to soak in everything about the art world.

A friend of his and fellow student, artist Zhang Hongtu, told me that Qian was obsessed with the freedom of modern art. "The first time he saw one of Monet's *Water Lilies* in the MoMA, he cried," Zhang told me, and that when Qian saw Warhol's version of Mao, his "head exploded." Ai Weiwei, the Chinese contemporary artist, told me at a cocktail party one night that he had great sympathy for Qian's involvement in the forgery scheme. "He was victimized and should not be blamed," the activist said. "He was desperate."

Qian painted and painted, finishing hundreds of canvases without successfully getting a gallery to take him on. He started working as a janitor, in construction, and painting tourists' portraits in Times Square.

On a cold fall day in 1992, Bergantiños walked by Qian on the street and was floored by the quality of his work. Right there, he offered him $200 as a test to see if he could imitate various artists. Bergantiños was thrilled with his work, calling it "identical." He began ordering dozens of Keith Haring and Jean-Michel Basquiat paintings, among many others, specifically telling Qian what artists he should copy. Qian loved the attention and was flattered by Bergantiños's praise. He would work through the night in his tiny, window-covered garage in Queens, making each piece his masterwork. He had dozens of art books, and he would study each stroke and style to make a perfect copy. However, these were not copies of paintings, they were to be sold as "newly discovered" originals.

Bergantiños and his brother Jesus would find the necessary materials to ensure their products corresponded to the right time of the work—from the wooden fiber board used by abstract expressionists to the aged frames they found at antique furniture stores or flea markets. Bergantiños would then send Rosales to pick up the art from Qian's house. Qian's neighbors remembered seeing an expensive Mercedes pull up to his very modest home and see either a well-dressed man or woman walk away with large canvases wrapped in brown paper. Bergantiños and Jesus would then treat the works to make them look older. They used tea bags to create a more aged look, then leave the paintings outdoors to weather the canvases further. They then used a hair dryer to make the paint crack.

For the next fifteen years, Bergantiños would buy about a hundred paintings from Qian that were forgeries, including in the style of Pollock, Rothko, Franz Kline, and De Kooning, among others. What drove Qian to keep making these fakes we will explore later. However, given his feeling of being "unjustly neglected" by the art world in New York, you can't help but think that he derived some pleasure and even a sense of revenge in eventually fooling so many art experts and collectors.

As Qian was making fake art for the couple, Bergantiños wanted to test the waters by selling a few fakes to lower-profile galleries for discount prices. When he succeeded in selling a few lesser-known works for $10,000 to $15,000, he felt he was ready to play in the big league.

He created a new company for his venture called Glafira Rosales Fine Arts LLC. He was careful to launch this new company in her name.

THE DEVIL WEARS ROTHKO

He spent hours rehearsing with Rosales, scripting her. She was about to walk into one of the most famous galleries in the world with a fake under her arm. Rosales would later claim that Bergantiños would choreograph everything by building up her story, her style, and ensuring that she had previously attended auctions and shows, so that she would appear as someone who was not a complete unknown.

CHAPTER 8

THE CON IS ON

THE MONEY THAT PEI-SHEN Qian received for each painting was multiplied thanks to a fortuitous encounter. The painter was visiting an art fair when he came along one of his works for sale for a much higher price. Livid, he demanded more. He went on to charge up to $7,000 per painting.

It was a cold day in February 1995 when Rosales, aged forty, held her breath, probably said a prayer, and walked through the prestigious doors into the stately townhouse foyer of the Knoedler Gallery, located off Madison Avenue in New York's posh Upper East Side.

Freedman told me that although she didn't know Rosales and hadn't previously met her, Rosales had been in the gallery before and had given other works for considerations to be sold through her connection with a close Freedman friend, Jaime Andrade. Andrade or Jimmy or Hymie (Freedman referred to him by various names) was described by her as a "major part of the Knoedler family." She called him a "guy Friday" who seemed to do odd jobs for the gallery and was somewhat of a connector.

THE DEVIL WEARS ROTHKO

Andrade is an interesting character in this story as he is the conduit of Rosales and Freedman. He was born in Ecuador, spent time in Colombia, and arrived in New York in 1963, where he began working as an assistant to gallerist David Herbert at the Feigen/Herbert Gallery on East 81st Street. Andrade and Herbert also opened a private gallery in Andrade's apartment on East 70th Street, where he began to sell art.

Andrade's relationship with Herbert is worth exploring as many pertinent details seep into the Rosales scam later. Andrade was well aware of his mentor Herbert's history and reputation as a pedigreed art dealer. Herbert had worked for the legendary dealers Betty Parsons and Sidney Janis where he developed relationships to the first-generation abstract expressionists Motherwell, Pollock, Rothko, Kline, Smith, and Clyfford Still.

In his first years as an independent dealer, Herbert helped launch the careers of artists such as Warhol, Ellsworth Kelly, Louise Nevelson, William Scharf, and Leon Polk Smith. Andrade had a front-row seat and had great stories to tell about those years.

In 1967, Andrade went on to work for the Lawrence Rubin Gallery. When Rubin became director of Knoedler & Company, Andrade went with him, beginning as his assistant. He was employed there for more than forty years. His knowledge of art was impressive, and he developed strong relationships with collectors. At the gallery, he did everything from hanging paintings to entertaining the collectors.

So, when Andrade told Freedman he had a friend who had a painting to sell, she was eyes wide open. She trusted Andrade implicitly and it was not the first time he made certain introductions to the gallery over the years. Freedman said he had an ear

to the street and the scene. She told me that Andrade "would cash her cheques and had full access to her home without her being there."[31]

Freedman also disclosed something to me that would only be revealed once the scandal broke, in that the gallery was not on solid ground financially. She was scraping the resources together to do an anniversary exhibition and collection and the gallery suffered a recent Nazi-looted art suit involving a Matisse painting (as discussed previously) that was "very costly," she told me. The financial hit to Knoedler was estimated by *The Art Newspaper* to be about $2 million. Bizarrely, she believed the gallery would have won the suit had it gone to trial, but the trial was scheduled to be in Seattle, and she felt the gallery needed her and would have suffered in her absence.

So, with Andrade's sterling recommendation and the exciting news that Rosales had a Rothko painting to sell, she happily met with her. Freedman found Rosales to be "well-dressed and very soft spoken." The Rothko work on paper was oddly wrapped between pieces of cardboard. She escorted Rosales and Andrade to the third floor, a private space, where Andrade unwrapped the Rothko.

Freedman's eyes lit up and she was immediately taken with the piece. She described it as "absolutely beautiful." She asked Rosales where the piece came from and who owned it.

Rosales took a breath and casually and confidently spun the story that she had rehearsed over and over with Bergantiños.

She claimed to represent a foreign collector who "was of Eastern European descent, maintained residences in Switzerland and Mexico, wished to remain anonymous, and had inherited the works…from a relative." As she saw Freedman become more

excited, even with her reserved poker face, she told Freedman there were many other paintings in the collection. Freedman labeled the relative "Mr. X" and the anonymous seller "Mr. X, Jr." Had Freedman hit the motherlode of undiscovered collections? She told me this happens all the time—"paintings in the barn, undisclosed assets"—referring to the $25 billion Barnes Collection of art that would tour internationally in the 1990s to shore up the finances of a cash-strapped foundation.

Freedman felt the story was credible. She told me: "You often see museum publications with many works labeled 'private collection.' The chain of ownership or provenance is often incomplete. So, nothing initially worried me about this painting."[32]

Fun fact: The same fake Rothko is now hanging in Freedman's lawyer's office, along with a Pollock that hung in Freedman's apartment for fifteen years, with a misspelled signature. Beneath the Pollock, Nikas hung a framed *New York Times* article with the headline: "Note to Forgers: Don't Forget the Spell Check."[33]

Freedman further examined the painting and the dated signature on the back. She declared it "good." At this time, there was no official Rothko *catalogue raisonné* that had been published, but it was in the works under the leadership of Dr. David Anfam and the National Gallery of Art. Anfam is a widely respected art curator, writer, and consultant, and one of the major authorities associated with abstract expressionism, including Rothko.

Anfam was working on the definitive *catalogue raisonné* that would be a comprehensive, annotated listing of all the world's known Rothko paintings, including title and title variations, dimensions, date of the work, current location/owner at time of publication, provenance, exhibition history, condition of the

work, literature that discusses the work, and potential essay(s) on the artist.

Freedman discovered that Anfam was in New York and invited him to Knoedler to see the Rosales Rothko. She claimed that he said the work was "beautiful" and that she should let the National Gallery know as there would be a subsequent *catalogue raisonné* of works on paper. That was solid gold for Freedman. She said: "David blessed it and that was enough for me."[34]

With that Rothko, Freedman and Rosales forged a business relationship. After all, Rosales had told Freedman she had many more pieces of art to show her.

One could only imagine the conversation that Rosales had with Bergantiños when she got home that night, after locking in one of the most respected art galleries and dealers in the world. The prices that the couple charged Freedman would escalate over time when they discovered how much Freedman was selling them for. In the beginning they would sell or co-sign a work for as little as $80,000 for a Lee Krasner (*Untitled*, 1949). Knoedler sold it later that month to American investor Jay Shidler for $1 million. Later, as Freedman was selling works, Bergantiños, who was monitoring the prices that Freedman was getting, got bolder and would ask—and get—anywhere from $475,000 to $1,250,000 for a Kline work that Freedman then flipped for $3,375,000 in 2008 to Jamie Frankfurt, an art consultant who then placed it with a client.

Following the first Rothko that Rosales brought in, Freedman put its provenance on Knoedler letterhead, making it look very official:

THE DEVIL WEARS ROTHKO

> Mark Rothko
> *Untitled*
> 1959
> 29 ½ x 22"
> CA 22708
> Provenance
> Acquired directly from the Artist
> Private Collection, Mexico, and Switzerland.

She would then go to work by building up the paperwork trail with expert opinions and, more importantly, exhibit the work in very public and prestigious shows to build its credibility. The above Rothko was exhibited at the Seventh Regiment Armory Show and that detail was listed in the provenance. Again, for many, Knoedler saying it was real made it real.

Whether she could or couldn't ultimately sell that Rothko, she traded one of her prized Diebenkorn pieces she had bought directly from Knoedler for the Rothko and kept it for herself. It may have been a mistake potentially worth millions had she held on to it, pending the size and vintage of what she traded.

Regardless, Rosales and Bergantiños found their golden goose and a willing pawn—a pawn that one journalist described "was on a mission. And, in the process, selling a lot of art."

And so, for the next fourteen extraordinary years, Rosales brought in thirty-two paintings to Freedman who then sold them to collectors. Bergantiños had Qian paint a total of sixty-three fakes with Rosales also selling to Julian Weissman, a former director of Knoedler (who operated his own gallery) multiple fakes worth $17 million, including three Motherwell paintings, and another twenty-three fakes that Bergantiños sold elsewhere. Knoedler started selling the works for about $100,000 apiece

until reaching the record of $17 million for an alleged Pollock. Freedman drew out the list for me on paper, indicating that she bought three of the fakes. Five remained unsold and nine pieces she claimed she didn't sell herself. Other reports suggested the gallery sold closer to seventy fakes.

You will see the following numbers restated later, but in print they are staggering:

- The fake Bergantiños and Rosales art sold to collectors for a total of $80 million.
- Knoedler's estimated profit was $33 million.
- Bergantiños's estimated profit was $40 million.
- Qian was paid less than $250,000 for the sixty-three paintings.

What is beyond remarkable are four highlights:

1. This was a long con spread over a decade, not unlike Bernie Madoff's that lasted seventeen years or possibly even longer. You would have thought that Bergantiños and Rosales would cut bait and get out of Dodge after a few cons, but the money was too good, and Freedman kept buying the fakes.
2. The quality and enormity of the forged artists they kept bringing in.
3. The collectors and experts they fooled.
4. Close to a dozen artists had been forged by one artist!

Bergantiños knew enough about how voracious collectors were and how hot the market was, so he could instruct

Qian on what to paint. The collection of artists represented the following:

- Robert Motherwell*
- Willem de Kooning
- Jackson Pollock
- Mark Rothko
- Clyfford Still
- Franz Kline
- Lee Krasner
- Richard Diebenkorn
- Barnett Newman
- Andy Warhol
- Francis Bacon
- Jules Olitski

(*Three sold to Julian Weissman Gallery.)

Rosales would consign the works to Freedman one at a time, for an agreed-upon price, with Knoedler keeping anything of the profit margin they earned. Freedman even bought three paintings from Rosales for her personal collection through a cash transaction or by trading real and valuable art for fakes.

As the paintings flowed into Knoedler, Freedman claimed to have pushed Rosales for a more transparent and less opaque story on how she discovered the collection. Over time, Rosales, with the help of Bergantiños, added more detail to the original story. A new twist was that the married Mr. X and David Herbert, the real-life gallerist who conveniently died in 1995, knew each other in the 1950s and were lovers. Herbert introduced Mr. X to the abstract expressionist artists, where he purchased paintings for cash. The works were then hidden until Herbert's death to

protect Mr. X's homosexuality. Mr. X had a wife and two children. He had to decide—would he give up the gay world in New York and return to Switzerland with the paintings in hand?

Freedman drank the Kool-Aid, adding: "The fear was that, if the paintings came out while Herbert was alive, he might have been extremely upset, and revealed the identity of the owner. There's no question that the paintings would have been paid for with cash, taxes not paid, assets not declared, and you can go to jail for that. Even after Mr. X Sr. died, the paintings stayed hidden, in the hands of his son—Mr. X Jr. until David Herbert died in 1995. Only then would they be sold quietly, one by one," and to overcome the weak provenance.[35]

The story was good. Herbert had existed and other dealers remembered him being part of a gay art world circle. He would dine out frequently with Andrade. But very few believe that Herbert would sell major works on the side. One dealer said: "Paintings didn't just disappear. They would keep records of what they sold, especially of major paintings."

Freedman told one journalist: "My ongoing diligence met more than the gold standard; there is plenty of evidence of that. I always felt that each time I got a work in, and I was able to place it or sell it, that that would enable me to meet 'Mr. X Jr.' I would ask to get on a plane to meet him and Rosales never said never; she just said, 'Not now.'"[36]

There were times that Rosales might have felt that Freedman was getting skittish or nervous about the backstories she fed her, so she would offer some new, imaginary detail. She told me that Rosales called to tell her she had a car accident and a Still painting had burned up, but that she had managed to save a paint fragment. Freedman sent the fragment to Anfam, the

THE DEVIL WEARS ROTHKO

esteemed art specialist, who by now was charging Freedman fees to authenticate art and gave the opinion that the fragment was "visually very convincing."

As mentioned previously, to further bolster her claims of saying the paintings were "right," Freedman would hang paintings at the Knoedler booth at the Armory show (hosted by the Art Dealers Association of America) attended by the *crème de la crème* of art dealers. Freedman insisted not one dealer said: "Take that down off the wall. It's a fake."

Behind her back, and perhaps mostly out of jealousy caused by Freedman's buzzworthy discoveries, dealers were skeptical that none of the works had any records. Freedman ignored it, telling me: "I find professional jealousy to be not very charming."

But Freedman carried on telling the media: "They were very credible in so many respects. I had the best conservation studio examine them. One of the Rothkos had a Sgroi stretcher. He made the stretchers for Rothko. They clearly had the right materials."[37]

Aside from hanging the art at the right shows in Miami and New York, the Rothko went to the Beyeler Foundation, where pedigreed and legendary Swiss collector Ernst Beyeler called the painting "a sublime, unknown masterwork." Meanwhile, the Barnett Newman went to Guggenheim Bilbao for the tenth anniversary exhibition and prestigious art magazines such as *Taschen* would feature them on their covers. Freedman said: "The most knowledgeable in the art establishment gave me no reason to doubt the paintings."[38]

Freedman's other tactic was to retain the most prestigious art scholars and art consultants, solicit their opinions and attach their positive comments to the provenance file on each painting.

This emboldened Freedman's view that the art was real and let her keep selling despite the eventual red flags that popped up.

Freedman would routinely conscript or pay fees to a who's who of experts including art historian Laili Nasr, who was making a supplement to the Rothko *catalogue raisonné*; Christopher Rothko, the artist's son; art historians Irving Sandler, Dore Ashton, Stephen Polcari, and Anfam, the author of the *catalogue raisonné* for Rothko's works on canvas; and E.A. Carmean Jr., a former curator at the National Gallery of Art who was being paid $50,000 a year primarily to research the provenance of Rosales's works. From 2001 through 2009, Carmean was paid a total of about $438,000 to review and offer written opinions of authentication to support the Rosales paintings.

Both Polcari and Carmean expressed the most definitive opinions of the art, and unlike other experts whom Freedman merely showed the works to in passing, put their solid gold opinions in writing: "I am convinced of their quality and authenticity," Polcari wrote in full assessment of the "entire" Rosales collection.

Later, Carmean and Polcari would go even further, when certain pieces were questioned or could not be authenticated. Polcari called one highly negative report "amateurish...and irrelevant." And Carmean contested definitive testing done by a leading forensic analyst who in one case discovered a pigment that wasn't invented until long after the artist died. He called the reports "too broad" and "negative."

Interesting enough, many of the experts and academics, including Anfam, claimed they either were never asked to give an opinion or never saw the actual paintings in person. Anfam would later say: "You don't put people's names on lists of anything without asking their consent."

THE DEVIL WEARS ROTHKO

Another expert said he looked at a work for "five to twenty seconds."

And yet Polcari declared: "The fact is that the entire Eastern establishment believed in them. I saw the paintings."[39] Remember that Polcari is a scholar of abstract expressionism and the author of *Abstract Expressionism and the Modern Experience*.

In Freedman's defense, she did share with me emails and memos from several of the experts such as Anfam, that indeed had been written to her, either scheduling times to come see the work or negotiating their fees. In one letter, dated August 16, 1998, Anfam promised to visit the gallery in the next month and proposed a fee of £450 to consult on three works: a Rothko, a Kline, and a Still.

Freedman claimed: "I didn't put a pen and piece of paper in front of him, but he had no problem with my telling anybody that he'd seen it and thought it was 'right.'" Anfam did admit to seeing one of the later Rothkos and telling Freedman it was "pristine."[40]

Many of the artist foundations—from Pollock and Motherwell to Rothko—would later give up authenticating art after the Knoedler fiasco, as they were subjected to piles of lawsuits for errors and incorrectly writing positive opinions on fake art.

In 2006, as Freedman kept pushing Rosales to fortify the provenance and credibility of her paintings (and perhaps on Freedman's direction), Rosales wrote Nasr at the National Gallery of Art. Along with Ruth Fine, Nasr led the Rothko *catalogue raisonné*. Rosales practically begged her to include a Rothko on paper in the catalog that she claimed was seen at Dana Cranmer's studio. Cranmer was a conservator for the Rothko Foundation at that time. In her letter, Rosales listed an

exhibition history, including shows in Spain, and enclosed a transparency of the work.

Freedman believed these paintings were real and that it was her responsibility to place them into the best of collections. She saw establishing these discoveries as accepted works that would be "among her greatest accomplishments at the gallery." She wanted to create a new legacy for Knoedler, "a treasure trove of paintings to bring out into the world," as she called it.[41]

And so, with that, Freedman began selling whatever Rosales brought in.

Domenico de Sole. Photo credit courtesy of Domenico de Sole.

Ann Freedman and art expert E.A. Carmean. Photo credit courtesy of *Made You Look* film archives.

**Armand Hammer—Stockholm, Sweden.
Photo credit courtesy of Getty Images.**

**Armand Hammer and Ann Freedman. Photo
credit courtesy of Knoedler Gallery Archives.**

THE DEVIL WEARS ROTHKO

Michael Hammer. Photo credit courtesy of Getty Images.

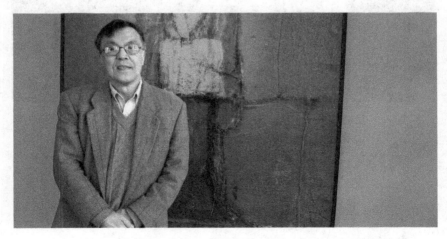

Art Forger Pei-Shen Qian. Photo credit courtesy of ABC 30.

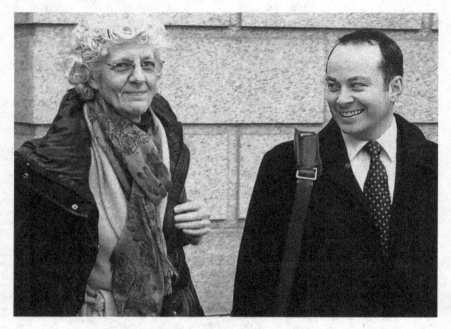
Ann Freedman and her lawyer, Luke Nikas.
Photo credit courtesy of Associated Press.

THE DEVIL WEARS ROTHKO

MICHAEL AND DRU HAMMER

CORDIALLY REQUEST THE PLEASURE OF YOUR COMPANY

TO CELEBRATE

ANN FREEDMAN'S 25 YEARS AT

KNOEDLER & COMPANY

TUESDAY EVENING, DECEMBER 10TH, 2002

COCKTAILS 6:00 TO 7:30 PM AT KNOEDLER & COMPANY

19 EAST 70TH STREET NEW YORK CITY

DINNER AND DANCING 8:00 PM AT THE FRICK COLLECTION

1 EAST 70TH STREET NEW YORK CITY

FESTIVE ATTIRE

KNOEDLER & COMPANY
— ESTABLISHED 1846 —
19 EAST 70 STREET NEW YORK NEW YORK 10021
TEL 212 794-0550 FAX 212 772-6932

**Party Celebrating Ann Freedman. Photo credit
courtesy of *Made You Look* film archives.**

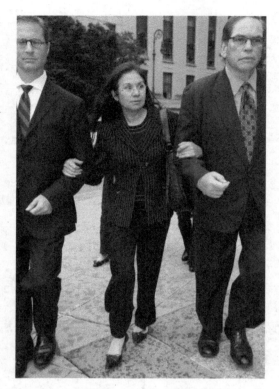

Glafira Rosales. Photo credit courtesy of Getty Images.

Josè Carlos Bergantiños Diaz. Photo credit courtesy of Melbar Entertainment Group.

THE DEVIL WEARS ROTHKO

FAKE: Untitled (1956)—Rothko. Photo credit courtesy of Luke Nikas.

CHAPTER 9

BORN AGAIN, TO SELL

AS SHE BEGAN SELLING one Rosales painting after another, Freedman was the toast of the town and the envy of the art world. Art experts, conservators, and museum professionals were lining up to gush over what looked like the discovery of the decade, a true collection of masterworks.

The paintings from Rosales were enormously lucrative for the gallery. Among the sales were a "de Kooning" that went for $4 million, a "Rothko" for $8.3 million, and a "Pollock" for $17 million. (I put these artists' names in quotation marks because, of course, these works were nothing of the sort). Freedman would take the Rosales backstory and build a market for each of the paintings as they came in. She was unstoppable and would later say: "If something had been off or wrong on any one of the paintings, I would have put on the brakes."[42]

When Rosales brought in paintings from Diebenkorn's *Ocean Park* series, Freedman was floored and excitedly invited Richard Grant, Diebenkorn's son-in-law and head of the Diebenkorn Foundation, to look at the paintings. Diebenkorn's widow and

THE DEVIL WEARS ROTHKO

daughter had advised her that they had never seen the series and had no record of them. And yet Knoedler sold five of them. When Grant discovered that Freedman sold a Diebenkorn to the Kemper Museum of Contemporary Art in Kansas City, he approached her with his concern about the painting being a fake, but she did not respond to his calls. Freedman then quietly replaced the one she sold to the museum with one of her own, calling it a "gift."

From 1998 to 2000, Freedman's selling machine powered on, selling paintings including two Rothkos and a large Pollock to collector Frances Hamilton White for $3.1 million, and a Still to Nicholas Taubman for $1 million.

There may not have been a huge slam-on-the-brakes moment yet, but one was around the corner.

In late 2001, Jack Levy, Goldman Sachs's co-chairman of mergers and acquisitions, fell in love with a Pollock, the first of four Rosales would bring in, and agreed to pay $2 million for it. Levy was not an art novice and had previously acquired art from Knoedler. Freedman claimed that she did tell him that the work, *Untitled 1949*, wasn't in the Pollock *catalogue raisonné* and that its provenance "was yet to be fully sourced...the owner's identity unknown." She also told him that the work was undoubtedly genuine.

Using his banker's forensic instincts, he agreed to buy it only if the work was authenticated by the International Foundation for Art Research (IFAR), the main source for authenticating works by Pollock and other abstract expressionists. But IFAR could not conclusively attribute the work to Pollock. IFAR has been around for more than fifty years. It is a non-profit educational research organization that works at the intersection of art

103

scholarship and art law in the public interest but was founded to deal with complicated issues of attribution and authenticity.

Sharon Flescher, the former executive director and editor-in-chief of the *IFAR Journal*, told me that "It's foolish to rely solely on the pedigree of the gallery; you must always go beyond the paint and that is what Jack Levy asked us to do."[43]

At the end of 2002, IFAR issued a report saying they couldn't accept the piece as a work by Jackson Pollock. Flescher brought in specialists to look at the work and they determined it was something on canvas mounted on Masonite, and signed J. Pollock '49. It looked good and it had the Knoedler pedigree. Also, the work came to IFAR with an Alfonso Ossorio provenance, plausible according to Flescher, "Because he was a friend and patron of Pollock. So, on the surface, it was a plausible provenance. There wasn't any documentation to back it up, so we were never clear despite my asking quite a few times for clarification, what Ossorio's role was."

However, a deeper dive revealed serious issues. Flescher explained: "What we noticed was that it was new paint on old canvas and that it was mounted, not simply on the wrong side of the Masonite. But we compared it physically to an actual Pollock painting of the same year in…1949, also a canvas on Masonite on a real Pollock. [It] had aged completely differently because Pollock had put some sizing on his Masonite, and that sizing had darkened over the years. And the Masonite of this one had not. Stylistically, there were many concerns about the way the paint was applied, about that greenish-brown wash that was applied underneath, the background wash, the underlying—no one had ever seen—even the people who liked the work questioned that."

THE DEVIL WEARS ROTHKO

IFAR attached sixteen pages of documents to its report showing why the provenance was inconceivable and actually said that in the report—that the provenance defied credulity. They used very careful wording in that report because there were a couple of positive opinions, but the negative opinions far outweighed the positive ones. It just didn't meet the bar for acceptance into the *catalogue raisonné*.

"We said we couldn't accept it, which in the art community is generally understood as, it is a fake," said Flescher.[44]

The report was sent to Levy, and he went to the Knoedler Gallery and got his money back. According to Flescher, the work went back on sale at the Knoedler Gallery, and the price went from $2 million to $11 million. This was after Freedman went back to Rosales demanding a new provenance and where the story changes to involve David Herbert, a readily accepted character in the art world.

All the subsequent works sold had the other provenance—the later provenance—"which was just as concocted, frankly, as the provenance submitted to us, and just as refutable with research," Flescher said.[45]

When I told Freedman that I was interviewing Flescher for the film, she scowled and called her bitter and unpleasant.

Meanwhile, the selling continued and proved to be enormously lucrative for the gallery and both Rosales and Bergantiños. The money poured in from a "de Kooning" that went for $4 million, a "Rothko" for $8.3 million, and a "Pollock" for $17 million, with Freedman utterly convinced about the paintings. "I lived with them, and in the context of my personal collection," she said.

BARRY AVRICH

As Knoedler was raking in millions a year from art that in some cases had been marked up 700 percent, Freedman was earning a commission, in some cases, of $1 million a year. Freedman reputedly "baptized Mr. X with the nickname of Secret Santa, her invisible friend." And when Freedman asked to meet Mr. X, Rosales said he wanted to continue under anonymity and that her insistence would upset him. Rosales told Freedman: "Don't kill the chicken with the golden eggs."[46]

Rosales did tell Freedman: "He's happy with you, Ann, with what you're doing."[47]

Beyond the puzzling curiosity of whether there was an actual Mr. X, it also appeared that Freedman was not that interested in killing the other golden goose either, by knowing much more about Rosales. Freedman would later say that she was more interested in the art than hiring investigators to look into Rosales.

And yet Freedman was like a proud mother, excited beyond measure each time Rosales would allegedly return from Mexico or Switzerland with another work under her arm. She told me they would celebrate over lunch and wine at a nearby favorite Upper East Side haunt. Freedman said that all she knew about Rosales is that she loved ballroom dancing and her daughter, Isolina, who now goes by the name Soli-Diaz Corbelle, who was studying to be a violinist and eventually became a gallerist, worked as an intern at the Knoedler art library. Makes me wonder if Rosales schooled her daughter on how to keep an eye on Freedman, and report back with any concerns.

In the meantime, Bergantiños and Rosales, raking in tens of millions and paying Qian paltry sums, were wiring the money into accounts in Spanish banks and laundering other funds through a now bankrupt financial institution in the Dominican

THE DEVIL WEARS ROTHKO

Republic, where Bergantiños had a home, and coincidently was on the board of directors of the bank.

In 2005, the couple purchased a $2.5 million, five-bedroom villa on Sands Point, Long Island, one hour from Manhattan, and said to be the inspiration for F. Scott Fitzgerald's *The Great Gatsby*. They filled the home with authentic art by Warhol, Miró, and Krasner, and had a Mercedes with a driver. Neighbors thought they were quiet, "super-millionaires." Bergantiños also used the funds to earn his pilot's license and take music lessons. He told me he saw himself as a "Renaissance man," cultured and talented. He proudly said his daughter, born in 1991, played for Pope John Paul II and performed concerts at the Lugo Cathedral in Spain.

While Bergantiños and Rosales were spending and spending, Michael Hammer (you remember him), the allegedly hands-off owner of Knoedler, was enjoying the fruits of Freedman's labor. His holding company, 8-31, which owned Knoedler and Hammer galleries, paid him a salary of $400,000 a year, plus a 20 percent share of the profits. Hammer also had an unlimited American Express credit card, which 8-31 paid for. Hammer charged $1.2 million to the card during the Rosales paintings period. He routinely charged trips to Paris with his then wife, plus several cars, including a $482,000 Rolls-Royce, which was sold in 2008 for $452,000 (money that Hammer kept for himself), and a $523,000 Mercedes for Hammer's exclusive use.

The only one that was not spending money and living the high life, aside from the art forger Pei-Shen Qian, was Ann Freedman. Despite the $10.4 million she had made off of the sale of the Rosales works and her $300,000 a year base salary, Freedman never moved from the apartment she shared with

her husband, who worked in commercial real estate, nor did she spend lavish money on anything beyond modestly adding to her art collection. Sadly, that collection included several fakes she bought or for which she traded real art.

Her walls were covered in art including a Pollock and Rothko. The prices she paid, as reported to a journalist, were staggeringly low: $200,000 for the Rothko, $300,000 for the Pollock, and $20,000 for the Motherwell, worth $1 million in 2007. Freedman said: "I bought it at 'a quiet time' in the late painter's market and paid a dealer's rate."[48]

I wonder if she was either just a simple, modest person without the same avaricious, luxurious needs that Bergantiños and Hammer had, or if she felt that one day this house of cards would collapse, and she would have to pay the money back. She certainly did have the money and art to eventually settle cases and pay for lawyers when blood began flooding the streets. But before there was blood, there were dozens of more sales.

In 2002, as a curator at the Beyeler, Oliver Wick showed Rosales a Rothko that Knoedler later sold to the Hilti Foundation in Liechtenstein for $5.5 million, and another Rothko that would be sold three years later.

In December 2004, Domenico De Sole and his wife Eleanore walked into Knoedler on a mission. De Sole, impeccably dressed and right out an Italian movie, was born in Rome and studied law at Harvard. After becoming a partner at a Washington DC firm specializing in tax law, De Sole helped Gucci with its corporate restructuring and became CEO of Gucci America.

He reportedly saved Gucci Group from near bankruptcy and turned it into a luxury conglomerate. If you saw the (not great) film *House of Gucci*, De Sole was portrayed by the British

THE DEVIL WEARS ROTHKO

actor Jack Huston. After bringing designer Tom Ford to Gucci, De Sole then spun him off and became chairman of Tom Ford International. In 2015, De Sole became chairman of the international auction house Sotheby's until its sale in 2019.

De Sole told me they had started collecting art and were looking for Jim Scully artwork. An old friend of theirs from Miami who had built a great collection from Freedman and Knoedler told him, "Go see her and see if she has a Scully available."

De Sole said, "And we'd never laid eyes on her before. We did not know her."[49]

He said they were "blessed to own a Rothko work on paper," which he conveniently had the National Gallery authenticate for him because they were doing a *catalogue raisonné* on paper. De Sole said it was his wife Eleanore who made it her mission to build their collection and that she made the decisions.

Freedman didn't have a Scully, but she had a Rothko and a Pollock. Eleanore was floored: "To see a Rothko and a Jackson Pollock in a scale that's manageable that's really quite beautiful." But it was Rothko that Eleanore now wanted.

De Sole said to Freedman: "'Tell me about this Rothko.' And she told me the story of the so-called Swiss collector, and she made very clear to me that she knew the Swiss collector—the son of the Swiss collector—and she told me that this was a great Rothko. She said that Christopher Rothko, the artist's son, had authenticated the painting. And that she cannot disclose the name of the Swiss collector because he wants to maintain anonymity which, you know, that happens a lot; some people don't want their name to be disclosed for a lot of reasons. She was very specific of including Christopher Rothko, and the other names

109

like David Anfam. And a bunch of other names who said the Rothko was real."

De Sole added: "We just listened. And we're looking at these two paintings. And we're not talking about the Pollock, and Freedman says, 'You can have them both, I'll give you a deal.'"

De Sole then brought in respected art advisor Jim Kelly whom he knew through his business partner, Tom Ford, and who had helped the couple put their collection together. He told Kelly that Freedman was asking $8.3 million, and he wanted to know if it was a reasonable price.

Kelly flew to New York twice to see the Rothko, talked to other experts—Rothko experts—and gave the piece a greenlight.

De Sole said: "I had no reason to believe someone was lying to me at Knoedler, so I did not take further steps to prove it was a real Rothko. I respected the brand of Knoedler,"[50] which he was told was "the most trusted, oldest, most important gallery" in America.

Before the sale of the Rothko went ahead, the De Soles requested the details of their meeting with Freedman be put in writing. Freedman wrote that the Rothko had "been viewed by the following individuals with special expertise on the work of Mark Rothko," going on to list the eleven experts Freedman supposedly named in their meeting.

And with that, De Sole spent $8.3 million on a "Rothko" painting, *Untitled (1956)*. He spent six times more than he had ever spent on a piece of art and enjoyed it for almost seven years in his stunning Hilton Head, South Carolina home, where the couple loved showing it off. Kelly earned a commission of $100,000 for his services and Rosales was paid $950,000. Knoedler had scored a more than an 800 percent mark-up. De

THE DEVIL WEARS ROTHKO

Sole even gave permission for his acquisition to be exhibited in the "Rothko Rooms" at the Beyeler Foundation.

Meanwhile, Freedman chose not to buy the two larger Pollocks from Rosales for herself (the one Goldman Sachs' Jack Levy had returned and a silvery one Rosales brought in, around 2002). I should mention here that Freedman and Knoedler would sometimes buy a piece from Rosales rather than on consignment and sit on the work for three or four years, then make a killing.

This was the case with renowned Canadian theater impresario and highly respected art collector and scholar David Mirvish. He and Freedman had become very close friends. They dined and traveled together frequently and even went to major art shows together. He may be better known for his work in the theater, but he lived and breathed art. You can see how both academics would be attracted to art and each other.

Freedman convinced Mirvish to start investing in the Rosales collection. It is uncertain as to whether she was cutting him into her piece or cutting out Knoedler, but Mirvish knew a bargain and an upside when he saw it. He had been buying and selling art for more than thirty years. He agreed to buy three Rosales Pollocks, and invest in others, including the silvery Pollock that would sell years later.

Mirvish bought *Untitled (1949)* in 2003, under an intricate deal where he borrowed half the cost from the Canadian Imperial Bank of Commerce, and the other from Knoedler Gallery with a promise that he and the gallery would split the proceeds of its resale. By 2007, he'd bought another Pollock from Knoedler—for $4 million, with the gallery again loaning him half that sum— and invested $1.6 million in a third. All three works were then put up for sale for profit.

Mirvish was no art amateur. He opened an art gallery in Toronto across the street from Honest Ed's, his father's huge retail empire in 1963 when he was still a teenager, and built a substantial art collection of his own. He once planned to build his own museum with architect Frank Gehry.

Throughout the years, Mirvish asserted the works' veracity. Luke Nikas, Freedman's lawyer, said in an email: "This is a simple contract case. Mirvish paid money to buy or invest in paintings and Knoedler would sell them." Yes, that was true and wonderful, until the paintings were revealed as fakes.

Mirvish was furious and immediately stopped talking to his close friend Freedman. He was embarrassed and Freedman was devastated to lose his friendship. She endlessly tried to call him but to no avail. When she asked her close friend Ron Spencer, a lawyer who ran the Pollock-Krasner Foundation, to step in and help restore the relationship, he rebuffed her in an email that said: "This experience has been very negative for me. My wish to remain distant from Ann has not changed."[51] Freedman was deeply hurt by the email and would ask me every time I saw her for news on Mirvish. When I asked him to be interviewed for the film, he responded with: "My mother always said, if you have nothing nice to say, don't say it."

I'm not sure if his mother actually said that. However, was Mirvish just another pawn that fell prey to the fakes, or did he turn a blind eye to red flags such as low prices and a slippery provenance? Did he really follow Freedman into the abyss or was he driven by greed on what he could make on the art? Whatever the truth, Mirvish is an art scholar and collector; it's hard to believe he didn't share his suspicions with Freedman. But perhaps it's not that hard to believe she didn't make him aware of

THE DEVIL WEARS ROTHKO

the various red flags and objections that surfaced along the way. Again, the profits were obscene and Mirvish was sufficiently seduced to not ask too many questions. Then again, no one had ever asked too many questions.

Regardless, in November 2007, Knoedler had a client for the silvery Pollock in which Mirvish had invested. Wealthy hedge fund manager Pierre Lagrange agreed to buy the Pollock for $17 million. The deal was negotiated through long-time art dealer Jaime Frankfurt, who earned a commission of $1.7 million. Frankfurt claimed that Freedman told him: "There's going to be a supplement to the *catalogue raisonné*. I'm actually in touch with the people at the Pollock-Krasner Foundation, who are going to be taking over the reins of the foundation."[52] The Pollock-Krasner Foundation was established in 1985 at the bequest of Lee Krasner, an American abstract expressionist painter and the spouse of Pollock. The foundation has awarded more than $87 million in grants. For a time, they authenticated work. Tim Taylor, Lagrange's English dealer, said that in a subsequent meeting in London, Freedman told him the same thing.

Freedman would later deny saying that, claiming: "Frankfurt had merely to call the Pollock-Krasner Foundation to learn that the foundation had stopped authenticating Pollocks in 1995."[53]

Whatever. Lagrange had his Pollock and Knoedler had made a margin of millions on the piece.

That same year, Frankfurt introduced Freedman to John Howard, the head of an investment firm, and sold him a de Kooning artwork for $4 million, telling him the provenance "was impeccable" and she knew the seller directly and had just bought a Motherwell painting from him directly. A few months later, billionaire casino mogul John Fertitta bought a Rothko for $7.2

million that was brokered by Freedman and Knoedler through dealer and past Beyeler curator Oliver Wick.

As a side note, when the Beyeler exhibited a painting purportedly by Barnett Newman on loan from Knoedler, it was Wick who forwarded Freedman a letter from three experts on the artist's work, telling the museum they thought it was a fake. While Freedman still believed in it, the Beyeler took down that painting.

While Freedman thought Rosales was exclusively bringing her precious discoveries, of course Bergantiños was having her sell art elsewhere. If you are a con artist, you generally have more than one shell or card game going at the same time.

Enter Julian Weissman. Weissman was an independent dealer who had worked for Knoedler in the 1980s and had represented Motherwell when the artist, born in Washington state, was still alive. It makes sense that Andrade must have introduced Rosales to Weissman as well as Freedman. Rosales had paintings from Motherwell's stunning *Elegy* series and Weissman was beyond ecstatic to get into business with her.

Motherwell was only twenty-one when the Spanish Civil War broke out in 1936. Its atrocities made an indelible impression on him. He conceived of his *Elegies to the Spanish Republic* as a grand reflection of human suffering and a symbol of "the inexorable cycle of life and death," according to leading art curator Nancy Spector.

Motherwell wrote: "They are essentially the Spanish black of death contrasted with the dazzle of a Matisse-like sunlight."[54]

Weissman's first customer was Sheikha Paula Al-Sabah of Kuwait. The sheikha claims that she flew from Kuwait to

THE DEVIL WEARS ROTHKO

Weissman's Lower Manhattan gallery in 2004 to see what she believed to be a painting from Motherwell's *Elegy* series.

Weissman told her the work at issue came from an anonymous Swiss-Jewish owner, whose father bought it from Motherwell directly. The sheikha loved the piece and bought it immediately through Dar Noor Ltd., a British Virgin Islands corporation she controlled. Weissman was ecstatic and thrilled that Rosales had other *Elegy* Motherwell paintings for him. He would then sell a Still painting from Rosales to auto parts tycoon and former United States ambassador to Romania, Nicholas Taubman, for $4.3 million. Weissman was unaware that Rosales was selling the "collection" elsewhere.

In 2006, Weissman contacted art advisor Marc Blondeau, whom he had known since 2001 from a meeting at the Basel art fair in Switzerland. For nearly a decade, Blondeau had been buying paintings from Weissman, on behalf of Killala Fine Art, a European art gallery. Weissman told him he had a stunning Motherwell to sell him. The piece, *Spanish Elegy 1953*, was a small oil painted on canvas. Blondeau was excited and flew to Weissman to see the piece. Weissman was asking $650,000 and told Blondeau the same story that Freedman was pushing, namely, that the piece was purchased directly from Motherwell by the owner in 1959. He also added that he could reveal the name of the owner.

Blondeau had a buyer but told him that his buyer, Killala, would not purchase the piece unless both Weissman and the Dedalus Foundation (formerly known as the Robert Motherwell Foundation established by the artist in 1981) certified the Motherwell as authentic.

In 2007, Jack Flam, the president of Dedalus, and Morgan Spangle, the foundation's executive director, went to see the painting at Weissman's gallery. Spangle was a veteran dealer who was formerly director of the iconic Leo Castelli Gallery in New York. Their mission was to authenticate the Motherwell. Weissman had other Motherwell paintings that he had not told Flam about yet. "He wanted to sell this painting, so he wanted us, he wanted to kind of test the waters," said Flam.

Flam added: "We went to see it, four of us went to see it from our committee, and to be honest it didn't look—in my gut it looked kind of weird; it was warped, there was too much oil on the paint or too many drip marks, but it looked just like the stuff that was in the database from 1953. It's an odd-looking painting, that it was probably okay because it looked like other stuff we had in the database. When I say other stuff, I mean five other paintings in our database."[55]

After the visit, Weissman told Blondeau that the foundation was pleased with the work and excited about a "new discovery" and subsequently issued a "Letter of Authenticity."

I'm not sure what was making Blondeau so skittish about the Motherwell. But he then demanded that Weissman get a letter from the foundation confirming the painting would be included in the foundation's *catalogue raisonné*, which had been developed since 2002. The foundation confirmed it would do so.

That was gold. Weissman had everything he could possibly need to ensure this Motherwell, and potentially the others that Rosales had, were indeed authentic. Blondeau bought the painting. The purchase agreement warranted that the painting was a work of Robert Motherwell.

THE DEVIL WEARS ROTHKO

In the fall of 2007, Freedman called Flam and told him she had another Motherwell *Elegy*. Same story for Flam—paintings were coming from a private collection to which she supposedly had exclusive access. She never mentioned the name Rosales. Flam remembered: "The collector was a very mysterious person who is either Swiss or Mexican, or a Holocaust escapee. There were now different versions of the story. Qian's fakes are really good fakes. I've seen a lot of Motherwell fakes. These are the best Motherwell fakes we've ever seen."

Spangle and Katy Rogers, who was the project manager for the Motherwell *catalogue raisonné*, went to see Freedman's Motherwell paintings. "They came back with a photograph, and it really looked wrong. And really looked out of balance. We were concerned. And we were concerned that we had uncovered fakes. We did feel there was a conspiracy. We did not, at that time, suspect that Knoedler was involved in the conspiracy or Julian Weissman," said Flam.[56]

Flam called Freedman demanding a meeting. Two days later, on December 12, 2007, Flam and Rogers walked into her office. The beginning of everything was about to spin out of control.

CHAPTER 10

A HOUSE OF BEAUTIFUL CARDS

THERE IS SOMETHING DISTINCTIVE between an individual's private self and the character they present to the world. Freedman worked very hard to construct a public-facing façade that had her in the starring role of the New York art scene. She used her fame and the art to capture the definition of the American dream for old and new captains of industry alike. She put a Gatsby-esque sheen on collecting at a high level. But if Freedman had any inclination that the house of cards was about to fall on her, she never took off her poker face to the world for a minute.

In late 2007, as more Motherwells from Rosales—all presented as part of his famed *Elegies to the Spanish Republic* series about the Spanish Civil War—came to Flam's attention, he began to have his doubts. He knew Freedman had other Motherwells and arranged a meeting with her on December 12, 2007.

"We laid out the case for these paintings being fake," said Flam. "We thought we were doing her an enormous favor.

THE DEVIL WEARS ROTHKO

And she had told us that there were not only Motherwells but there were Rothkos and Pollocks and de Koonings. And one of the things with a collection like that, if one painting is wrong, they're all wrong."

Flam told her that nothing has a provenance. "I mean, it's astonishing. They're all fake if one's fake," he said.

Freedman took offense to Flam's comments, started arguing, and brought up the David Herbert story—how Herbert was close to Motherwell. Flam told her that Herbert wasn't even in Motherwell's address book.

"She's good at a poker face," Flam said. "The only time the poker face broke was when we told her that the other paintings had come from Julian Weissman. And that's when I realized she didn't know that Julian was getting other Rosales paintings."

Flam said that Herbert had worked for the Sidney Janis Gallery for a while when Motherwell was being represented by Janis and had sold a Motherwell painting. "David Herbert wasn't even on the guest list for Motherwell's opening at The Museum of Modern Art from the 1965 retrospective," he pointed out.[57]

Flam pushed Freedman to reveal who the intermediary was. Who was the collector? What was his name? Freedman insisted she couldn't tell him and left Flam's office angry and frustrated.

Flam claimed he wanted to help Freedman through this, and he wanted to see her Motherwell. He went to her office and met with her and Pierre Janssen, her second-in-command at the gallery. He looked at a painting from a Motherwell *Elegy* that she owned, and also the *1955* painting that she had on consignment from Rosales.

Back in 2006, Flam saw one of Rosales's fake Motherwells, which eventually sold to collector Jay Shidler, in Freedman's

office. Freedman told Flam that Motherwell had gone to Mexico as a guest of Mr. X in 1953, and that's when the latter purchased the painting. Flam countered that there was no evidence Motherwell ever went to Mexico that year. Flam also told Freedman the signatures had an "exaggerated consistency," and Motherwell had never titled a painting *Spanish Elegy*.

In examining two works, Flam was "even more convinced" they were not authentic, as the support was warped but the paint film was pristine. In addition, the whites, which were supposed to be fifty years old, hadn't yellowed.

Freedman responded by reiterating the Herbert story. Flam shot back that he wanted the two Motherwell paintings forensically tested. It was Freedman that offered up James Martin and Orion Analytical, considered that era's best in the world at authentication. Flam got in touch with Martin whom he'd never met.

Undoubtedly, feeling the pressure mounting and looking for Rosales to shore up a distressed provenance foundation, Freedman got her assistant and researcher, Melissa De Medeiros, to fax a rather desperate sounding memo to Rosales prior to leaving on a trip to Italy. In the letter, she writes:

> I am aware of much, it not all, that has transpired.
> I understand that you must be under enormous
> pressure, but I want to express my heartfelt wish
> to appeal to you not to withdraw your trust and
> longstanding communication with us. We are
> all colleagues in this matter, which ultimately
> impacts not only you, but every single one of us at
> the gallery. As the kind woman I know you to be,
> whom Jimmy (Andrade) loves and in whom we

have the most profound trust, I beg of you to be
in touch again.[58]

It is hard to go ascertain Freedman's state of mind at that time, but it is obvious she is begging for help as she clings to the edge of an impossible story and quite implausibly believes the Rosales paintings are still real.

A few months later Freedman sent Flam a letter that Rosales had written to the gallery four months earlier on Knoedler letterhead. The letter said that Rosales was the legitimate representative of this collector. And while the Motherwells were being examined by Orion Analytical, Freedman claimed she had other experts on the other artists. For example, Eugene Thaw was examining the other paintings and told her that the Pollocks were real. Thaw was a prestigious and respected art dealer and collector.

"She said that people who were experts in de Kooning had said the de Koonings were real," said Flam. "People who were expert in Newman had said the Newmans were real. So, I went around and started talking to these people. I told E.A. Carmean, who's a close associate of Ann Freedman's, who was on her payroll as a consultant to the gallery, and I told Carmean they were fakes," Flam concluded.[59]

Flam went to see whether Thaw would be willing to swear an affidavit to his findings. Flam claimed the videotaped affidavit had Thaw saying the paintings he saw were fakes. Then Flam went to see Heidi Colsman-Freyberger, who was the co-author of the Barnett Newman *catalogue raisonné*, and she said the paintings she saw were fakes. Flam thought she even told Freedman that she didn't think the Newmans were real.

So, Martin and Orion Analytical completed the testing in late December 2008, sent the results to Knoedler, and told an anxious Flam he'd been commissioned to examine these paintings by Knoedler. Because of that, Martin said he couldn't tell Flam anything that Knoedler didn't want him to know.

Knoedler had told Martin the works dated from the mid-1950s, but the damning report stated that "some information arising from analysis and research of materials used is inconsistent with the understanding that the paintings were made and purchased in the 1950s."[60]

The report also stated the works had traces of two red pigments that hadn't been used until the 1960s, and an electric sander had apparently been used on the canvases.

Martin would later examine fifteen other works brought to the gallery by Rosales, including the painting bought by the De Soles. He said that some of the anomalies he found didn't require special forensic instruments and were sometimes visible to the naked eye—such as a misspelled signature of Pollock's name—and could have been found with techniques used by any conservator.

The bottom line: Martin and Orion Analytical built a ground line of what the characteristics of real Motherwells from that period are: "What kind of paints, what kind of pigments, what kind of grounds, what kind of canvass, what kind of surfaces, grounds, etc. used," said Flam.

Freedman was not happy. "When you're doing research, you're like Christopher Columbus," she said. "You're not sure when you're going to find land."[61]

On January 25, 2009, Carmean, the former National Gallery of Art curator heading up Knoedler's research, faxed Martin a

THE DEVIL WEARS ROTHKO

marked-up copy of his report with revisions Carmean wanted him to make before a meeting at Dedalus the following Friday. Martin said that Carmean "had asked me to delete many of the most relevant conclusions and say I hadn't reached conclusions…I refused to do that." He also asked Martin to add a note that said: "At this point in analysis and research, no conclusions can be drawn regarding these two works."[62]

Freedman was now in damage control mode.

Flam was also getting anxious. Remember, he had authenticated a Rosales Motherwell, and his reputation was now on the line. Rosales had sold the Motherwell painting to Weissman for $225,000 which he flipped to Blondeau for $650,000. Blondeau then sold the painting to his collector, Killala, for $1 million. Within sixty days, one painting had gone from $225,000 to $1 million.

Now, Flam realized that everything the Dedalus Foundation had worked on could be ruined. Rosales had been revealed as the intermediary, so Flam hired a private firm to investigate her. The report quickly linked her to Bergantiños, who had been accused of trafficking in stolen paintings in 1999 and had a sketchy past.

Flam then called a meeting with Freedman at the Knoedler, with Martin and Carmean listening in by phone, to discuss his report. The director of Dedalus, Morgan Spangle, joined as did Dedalus's chair Richard Rubin, the older brother of the man Freedman used to work for at Knoedler, Larry Rubin.

The third part of the report, which had Martin's opinion, was redacted. He only saw the forensic evidence. And there were all sorts of irregularities that questioned the works.

"We wanted her to X-ray the paintings," Flam said. "She wanted us to find out whether Motherwell had a studio assistant and whether that studio assistant had ever used a sander, etc."

Freedman claimed Rubin "accused me of running a factory. What? I helped him out when he needed some appraisals on Motherwells. He had come to me years ago when I chose Motherwells from Dedalus to bring to Knoedler to sell."

Flam left the meeting somewhat panicked and sent a long memo to everybody at the get-together, including Carmean, with questions that needed to be answered.

Flam never heard from Freedman again.

He sent her a note, perhaps to initiate a response, telling her if she wanted these paintings included in the *catalogue raisonné*, then she could submit them to the Robert Motherwell *catalogue raisonné* project, because she had never formally submitted any of these paintings.

Flam then got a letter from collector David Mirvish supporting Freedman and the research she had done to authenticate the Motherwell paintings. Flam responded by telling Mirvish: "She should submit the paintings to the committee and the committee will pass on them."[63] That could not have done much for Mirvish's comfort level.

And with that, Flam determined there was a massive fraud being perpetrated. In February 2009, Flam and Dedalus foundation sent the Weissman Gallery a letter saying that "based on new information," the foundation was withdrawing the letter of authenticity for the Motherwell that Weissman had purchased from Rosales, and it would not be included in the *catalogue raisonné*. The letter didn't reveal what the new information was, or that it had previously said the painting was authentic. Weissman

THE DEVIL WEARS ROTHKO

sent the letter to Blondeau. Blondeau and his client, Killala, were floored and spent the next two years to no avail trying to get answers from Weissman and Flam on what had transpired.

Flam then took his findings to the FBI. Flam said: "I did not tell her I was going to go to the FBI, in part because it would've accomplished nothing. I mean, it seemed to me so clear that she knew, or should've known, that these paintings were fake that my saying I'm going to go to the FBI, what good was it going to do?"

Freedman said, after hearing that Flam had gone to the FBI, "Jack was aggressive. He could have had a sit-down with me to talk about his concerns about the art. He confronted me in front of others at the Dedalus meeting while I'm there. All I asked, please let me prove these works right. I believe them. I believe E.A. Carmean, who knew Motherwell better than Jack Flam. Nobody knew Motherwell like E.A. Carmean except one other person. But those two people, E.A. Carmean, author and art critic Dore Ashton, and then let's put Helen Frankenthaler, his wife of thirteen years, who saw Motherwell hanging in my home and said, 'Yup, that's Motherwell.' So, I had reason to feel convinced. But no, it was so warlike behind my back to take me to the FBI."[64]

The FBI's art crime team have for years operated largely under the radar. Their work really broke into public view in 2022 when they raided the Orlando Museum of Art, where agents seized twenty-five works that the museum had said were created by Jean-Michel Basquiat. But their work really began in 2003, around the time of the war in Iraq. Many pieces had been looted from the Baghdad Museum and from some of the other cultural institutions in Baghdad. The FBI was called in to create a team

of agents that could assist by trying to help identify artwork and antiquities that were being stolen. The hope was that the bureau could help return anything that had been stolen and had left the country. Following that, agents worked on the Rudy Kurniawan wine-fraud case.

Once the case was assigned to a New York team specializing in art crimes, the attorney-general began a grand jury investigation to get testimony from people and find documents.

Jason Hernandez, former Assistant United States Attorney for the Southern District, said: "We began by collecting documents, so you issue grand jury subpoenas so that you can find emails, sales records. And speak to experts to get their opinion on what they think about whether a piece is, is real or not.

"Typically, don't want to let the targets, the people who you're investigating, know that you're investigating. You don't want them to destroy evidence and especially if they have passports from other countries," said Hernandez.

Once the case began, Hernandez arrived at Glafira Rosales pretty quickly. They determined that it was a one-person operation, that Rosales didn't have a real art background, and that she must be getting the paintings, if they're fake, from someone else. "We determine that there's at least one other person involved," said Hernandez. "You know from gathering records that there's money being sent overseas to bank accounts, at least one of which is not in her name, so you know that there's potentially someone on the money side in Spain or somewhere else."

Hernandez was also able to determine rather easily that Rosales had had a boyfriend, with a shady past himself, who was also involved in art. They surmised there was some sort of

THE DEVIL WEARS ROTHKO

connection because money was being sent overseas to Spain in bank accounts to Jesus, Bergantiños's brother.

"We determined that Bergantiños wasn't in the country when the investigation was heating up," Hernandez said. "He was in the Dominican Republic, he was in Spain, but he was very rarely in the US. The only person who was reliably in the US was Glafira Rosales. The plan was now to keep things quiet for as long as possible, get a criminal complaint and then have Rosales arrested. And then ask the judge to not give her bail."

Two years after Pierre Lagrange hung his new, $17 million-painting in his extravagant Kensington home, hell was about to be unleashed on the art world.

By the summer of 2009, the FBI had issued subpoenas to Rosales and Knoedler Gallery, and was curious to know more about the David Herbert collection.

Nikas, Freedman's lawyer, said: "There was nothing on the public radar about the Knoedler Gallery case. The sole public press, the sole story that you could look up and read about, and that I did see, was that Knoedler Gallery and Ann Freedman had parted ways. And that Knoedler Gallery was shifting as a result of that leadership."[65]

"When Michael Hammer acquired an interest in Knoedler Gallery, Ann Freedman had been working there for some time," said Charles Schmerler, the lawyer representing Hammer and the Knoedler Gallery. "Ann and Michael always had a very cordial and very civil, and very professional relationship. Michael trusted what his grandfather had done at the gallery. He had absolutely no reason not to believe that Ann Freedman would continue the good work that had been done at the gallery previously. But these paintings came in and Ann had to make a

market for them. For better or for worse, that's what art dealers do. If you want to go to Art Basel and figure out how some guy sells a Volkswagen bus full of bananas for ten million dollars, it's 'cause he's makin' a market in it whether you like it or not."

Take that, plus feeling the pressure of the FBI scrutinizing his lavish world, add a touch of other related potential accounting adventures, and you'll understand why Freedman was escorted out the door on October 16, 2009, just as her former boss Larry Rubin was fifteen years earlier. Eleven days later, *The New Times* and *Art News* reported, "The resignation of Ann Freedman and the appointment of Frank Del Deo as president and director. Freedman joined Knoedler in 1978, and during her 31-year tenure, served as director of contemporary art. She was appointed president and director in 1994."[66]

Freedman was devastated. "I always felt I would spend the rest of my life at Knoedler, like mother and child," she said. Hammer and his wife Dru had thrown a lavish party honoring Freedman's twenty-five years of service just seven years earlier. The Knoedler spin was that she was on leave for medical reasons related to a recurring bout with cancer. Freedman was furious and sent a letter to friends and colleagues in November 2009, stating: "I wish to dispel a rumor now circulating that is upsetting. I am not resigning due to a recurrence with lung cancer.... I look forward to forging a new path in the world of art." Her friend and head of the Pollock-Krasner Foundation added: "The investigation was not the cause of her resignation. She is opening her own gallery on the Upper East Side."[67]

In an email from Freedman to her friend and art expert Stephen Polcari, she described being forced out, and how it "hurt like hell." She did not mention the grand jury subpoena,

THE DEVIL WEARS ROTHKO

after which the remaining Rosales works in Knoedler's inventory were marked NFS ("Not for Sale"). In the meantime, a tsunami of lawsuits were on the horizon for Weissman, Freedman, and Knoedler.

CHAPTER 11

I WILL SET YOU ON FIRE: A COLLECTOR'S SCORN

IN 1995, THE FINANCIER Pierre Lagrange set up a hedge fund in London. He made a fortune and began looking for serious art to build his collection and furnish his stunning home. Freedman sold him a Pollock with an assurance that it would be included in the updated edition of Pollock's *catalogue raisonné*, regardless of the fact that the artist's foundation's authentication board had been disbanded since 1995. In 2010, when Lagrange told his wife he was gay, she filed for divorce, and he now needed £190 million to settle the divorce. When he tried to sell the Pollock through auctioneers, Christie's and Sotheby's both declined to sell the work and discovered it was a fake. He flew to New York and took Freedman to the Carlyle Hotel where he got up on a chair and yelled at her: "I will set you on fire." More on that later.

In February 2011, frustrated by Weissman and Dedalus, Killala Fine Art sued them both over the fake Motherwell they purchased in 2007. Killala argued that "it is left with a worthless

picture," which it bought after Dedalus—which Killala said is "dedicated to authenticating Motherwell's works"—claimed the work was authentic. Dedalus defended the suit, insisting that it gave a "conditional opinion letter," not a warranty; that it expressly stated it has no liability; and that it does not run an authentication "business." Dedalus then sued Weissman, accusing the gallery of "deceit and dishonesty" because they did not reveal they had acquired the work from a dealer linked to someone "accused publicly...of allegedly trafficking in forgeries." Weissman, it was alleged, claimed its provenance was a Kuwaiti princess, who is a known collector. The two dealers split the $425,000 sale commission.

Perry Amsellem, lawyer for Dedalus, said: "They bring a suit. They bring eight claims against Julian Weissman. And thankfully they sue Dedalus with the one claim for promissory stopple. A fancy term saying, you made representations to us that it was real. I sat down with Dedalus and said, you've been waiting for years now to tell your story, here's your opportunity. So, we respond in May 2011 with a 90-page crossclaim against Julian Weissman."

Dedalus, for the first time in this sordid history, brought a lawsuit against Glafira Rosales, added in the original complaint in July 2011, and connected her to the art fraud that Dedalus had discovered in connection with Weissman, Knoedler, Freedman, and Rosales in the center.

"They had every opportunity, Knoedler and Freedman, to interplead prior to the lawsuit being settled in 2011, the Killala lawsuit," Amsellem continued. "And defend their reputation, claim that they were being defamed, doing whatever they want, but they chose not to. They sat on the sidelines."

A settlement was reached by October 2011 with Weissman paying $650,000 to Killala, Rosales paying $165,000 to Dedalus and $600,000 to Weismann, and then Weissman paying $34,778 to Dedalus. Essentially, Dedalus had all its fees paid by defendants.

Weissman's lawyer, Glenn Colton, told the media that his client had been influenced by ill health and financial difficulties to settle, rather than by evidence that the painting was a forgery. He complained that his client had not been permitted to review the forensic report and question its findings.

"We made sure that the settlement was public so that you could go online actually, and look at it," said Amsellem.[68]

A lawyer for Rosales said: "The allegations had unfairly hurt Ms. Rosales. Since the Motherwell matter was made public, her ability to engage in this business—even with pieces beyond reproach and with absolutely sterling pedigree—has been severely circumscribed and damaged."[69]

Then, suddenly, the earth shook.

On November 30, 2011, Patricia Cohen from *The New York Times* reported that the Knoedler Gallery was closing after 165 years.

The gallery issued a statement: "It is with profound regret that the owners of Knoedler Gallery announce its closing, effective today. This was a business decision made after careful consideration over the course of an extended period of time. Gallery staff will assist with an orderly winding down of Knoedler Gallery."

Cohen reported: "News of the institution's demise was met with surprise at Art Basel Miami Beach, an art fair where leading artists and gallery owners from around the world have gathered this week."[70] And she recapped recent highlights including

THE DEVIL WEARS ROTHKO

Freeman's departure, the sale of the gallery's landmark Italian Renaissance-style town house for $31 million to mogul Leon Black, and the "embarrassing" civil lawsuit involving the Dedalus Foundation that named Knoedler and Freedman, and accused them of selling forged paintings by Motherwell, while she was president of Knoedler, "an assertion she has denied" at the time.

Cohen said: "This was an earthquake to those in the industry too. And you'd think, you know. As sort of this bitchy and jealous and backstabbing...and rumors and this, and gossipy. People were still shocked when that article came out."

Schmerler, Hammer's lawyer, told me: "In about 2010, Michael Hammer made a decision that it was likely that they would move the gallery to a new location, begin to cut costs, reduce overhead and to continue the business in a slightly different way. And there were meetings held with the executives of the company at that time who supported that decision. And so, for a good period of time, it had been Michael's intention to, not wind down the business at that point, but to operate under some different financial constraints. Given that there was nobody left to run the company, and no one to sell the art, Michael made the decision at that time that the gallery needed to close, and the building was shut at that time. It was not as has been reported or has been indicated previously by some people, a sudden decision to close the gallery. It was not a decision that was made at all in reaction to the Glafira Rosales scheme."

Freedman too was knocked off her feet with the closing. "Knoedler closed its doors during an exhibition and there were people going to see that exhibition. As I remember, the artist was Charles Simonds. It was rather surprising that in the middle of

an exhibition without—so I was told—warning, the gallery just shuts its doors," said Freedman.[71]

A FEW DAYS LATER, Cohen reported that Rosales and others including Knoedler were being investigated by the FBI. The next day, another earthquake hit.

A few months prior, Lagrange had flown to New York demanding his money back from Freedman for the fake Pollock he now knew he had, even though she was no longer there.

She arranged a meeting at the Carlyle Hotel, steps from the Knoedler where he had bought a Pollock for $17 million from Freedman, through his art consultants. Lagrange arrived with his lawyer, Matthew Dontzin. Freedman, hoping to keep things bright, said: "I've been looking forward to meeting you."

"I want my money," Lagrange said.

"Let's see what we can do to help one another in this," Freedman replied.

"I want my money!" Lagrange said more loudly. "And I want it now."

Over drinks at the Upper East Side's Carlyle Hotel, Freedman tried to calm him down and offered to find another buyer for the painting he had paid $17 million for. He was horrified. He yelled: "It's a fake!" He was sitting on a report that had shown that some of the paint used was discovered in 1957—a year after Pollock died. Frustrated with Freedman, the flamboyant Lagrange allegedly got up on a table in the small bar and yelled: "I will set your hair on fire!"

Lagrange had a different recollection. "I wasn't banging my fist on the table," he insisted. He was more shocked than angry. "It's quite extraordinary to hear her version of the truth. She

THE DEVIL WEARS ROTHKO

contradicts herself; then, even when you point it out, she doesn't waffle."[72] Lagrange recalled Freedman saying: "The painting is perfect."

"I said, 'It's so perfect I can't sell it.'"

Lagrange was outraged by Freedman's suggestion that she could find another buyer. He told her: "You can't sell it pretending there's no problem. Even if I get my money back, it's completely unfair to the other collector."[73]

Lagrange left frustrated and sued Knoedler. Dontzin, Lagrange's lawyer, told *The New York Times*: "It's a sad day when a venerable gallery goes out of business when confronted with the fact that it sold its clients a $17 million fake painting, rather than stand by their client."[74]

Knoedler denied the claims. The notion that they misrepresented the painting was "completely baseless" and the decision to close the gallery was not sudden.

The case would be quickly settled with exact terms that were not revealed, but essentially, Knoedler agreed to give Lagrange his money back. This was not an easy settlement as the gallery owned only 50 percent of the Pollock (*Untitled, 1950*) as Freedman had off-loaded the other 50 percent to Mirvish, who had almost certainly made a big profit when the painting was sold to Lagrange. Mirvish preferred not to give back his half.

"Mirvish was a stunner," Dontzin told the media, "On the invoice the painting's provenance was stated as 'the artist (via David Herbert). Private collection. By descent to present owner.' It failed to mention that the present owners were Knoedler and Mirvish."[75]

There were more legal tidal waves on the horizon as the media made this art scandal front-page news. In 2012, Cohen

ran a front-page story headlined: "Suitable for Suing." It documented in detail the lawsuits that were piling up in the Knoedler case, against both the gallery and Freedman.

Freedman was at Art Basel in Switzerland. The story floored her. She told me it was: "Painful. Truly painful, front page, *Sunday Times*, during the hottest, I don't mean temperature, I mean you know, active time in the art world, everybody congregating. And I am front page.

"I went back to the hotel room," Freedman continued, "and I made a few phone calls. I didn't, you know, I didn't go under the covers, so to speak. I was shocked. I had just the day before been at the fair walking down the aisles and seeing people and socializing, obviously looking at the art. I did not go back to the fair that day. I met with someone in the art world for coffee, I think. I was traveling with a colleague from Knoedler in the past. And it was sort of a blur of just speaking to people who had questions. I answered as best I could. I didn't know what was coming. Well, I knew I was going to need legal help. I went to see a lawyer at Boies Schiller, one of the top partners and he'd had experience in art litigation," she said.[76]

A cast of who's who of collectors began suing Knoedler and Freedman, one after another, including:

- John Howard sued Knoedler, Freedman, Rosales, and Bergantiños for $4.5 million, citing fraud on a fake de Kooning painting.
- The Martin Hilti Family Trust sued the same as above for $5.5 million over a fake Rothko.
- Frances Hamilton White and David Mirvish filed separate suits over fake Pollocks with White suing for $3.1 million.

THE DEVIL WEARS ROTHKO

- Nicholas Taubman sued over a fake Clyfford Still.
- Frank Fertitta sued art dealer Oliver Wick over a fake Rothko for which he paid $7.2 million and claimed to have been sourced from Freedman.
- The Manny Silverman and Richard Feigen galleries were sued as intermediaries in a sale to the New York collector Stephen Robert of a painting purportedly by Still, for more than $1 million.
- Martin and Sharleen Cohen sued over a fake Rothko, which they bought through the Michelle Rosenfeld Gallery.
- William Lane sued over a counterfeit Rothko he bought through the Gerald Solomon gallery for $320,000.
- The first case against Knoedler by Pierre Lagrange was settled (as mentioned earlier).
- David Mirvish sued Knoedler after investing in three Pollocks, but did not sue his former friend Ann Freedman.

The Mirvish suit was intriguing. One scholar said that it was only Freedman and Mirvish who believed the art was real. His lawsuit was filed after Knoedler closed its doors and Mirvish sued for breach of contract now being out two Pollocks and never having been repaid his stake in the third.

Mirvish would say: "Leading scholars and experts believed in these works, as did I." His suit contained many references to his own expertise, saying that his independent judgment was that the works were authentic.[77]

The plaintiffs in almost all the lawsuits contend that Freedman ignored clear warnings such as works at below-market prices. An expert in dealer practices, Martha Parrish, said: "When that happens, a reputable dealer would run like hell."[78]

Freedman would continue to defend her position: "Art often enters the market through divorces and inheritance, which can be messy. Some people want top dollar. Others just want to be rid of their art. When you separate yourself from something, that takes on a different value than if you want it." Freedman added that during her career, it has not only been Rosales who said to her, "I don't want this work of art...give me something for it."

Even with the IFAR report, which rejected the provenance for the forged Pollock painting supplied by Rosales, Freedman's belief in the painting did not waver, citing a "recent history of bad feeling between IFAR and Knoedler."

Regardless, Freedman was feeling the fire: "I certainly wasn't numb to it. It was painful. It was hurtful. It was angering. I felt all those emotions, but I never stopped moving. I felt that, the conviction of believing in these paintings. I believed that the paintings were right at that point in time. I wanted to do everything I could. Too many people needed to learn a lot about the art world," Freedman added.[79]

Despite all of this, nothing could prepare Freedman for another angry collector still to come. And that collector wanted the trial of the century.

CHAPTER 12

A POUND OF FLESH BY DESIGN

THERE WAS NO CHANCE in hell that Domenico and Eleanore De Sole would follow the words of John Steinbeck: "I shall revenge myself in the cruelest way you can imagine. I shall forget it."[80] There was simply no forgetting the wrong heaped upon them.

De Sole recalled hearing his wife scream. His wife was sobbing and shaking uncontrollably.

It was December 2011, and they were in Palm Beach. Eleanore was reading *The New York Times* on her iPad. She came across a news item that said Freedman and the Knoedler Gallery had settled a case related to a fake painting.

The buyer was Pierre Lagrange and he had purchased a Jackson Pollock that came from an anonymous Swiss collector, connected to an art advisor named David Herbert.

The Herbert and anonymous collector story was the *same* story Freedman had told the De Soles about their Rothko. About five years after buying their Rothko from Freedman, De Sole

had wanted to ensure their Rothko was authentic and asked Freedman to get a current appraisal.

At that same time, Freedman was feeling the heat from Flam, who told her that the Motherwells were fake. "And yet with that knowledge, with all the other knowledge that she had, she never disclosed anything to us," said a disgusted Eleanore. "Just sent a signed letter saying, 'This is the value of your Rothko.' In fact, the value had gone up."[81]

De Sole studied the *Times* article and determined that the Lagrange litigation, and facts of circumstance of that purchase, were totally identical to their circumstances. He called Jim Kelly, his art advisor that blessed the painting. Kelly told him: "No, that's not possible. Ann Freedman has the greatest reputation."

De Sole then called Freedman. He remembered the call well: "She continued to lie, 'The painting was the right painting and was a real Rothko.' And then she said, 'In any event, give me a few days and I will disclose the name of the Swiss seller, the son of the original collector, I will disclose the name.' And I say, 'Okay, just, you better call me right away.' And she never called me back. I never saw or heard from her until the trial and then I hired a lawyer."

When he bought the original painting, De Sole insisted on an invoice with the price, and a warranty of authenticity, in which Freedman supplied a multi-page document listing every expert who had seen and authenticated the painting. De Sole said: "It was simply my sense as a businessman in saying, 'Well, I'm spending $8.3 million, I know it's the greatest gallery in the United States, the oldest, but I really do believe it's important to have this documented.'"

THE DEVIL WEARS ROTHKO

Freedman added the sentence: "You have the full commitment of Knoedler and myself that strongly restated that this was a real Rothko," De Sole added. "And I had the guarantee of Knoedler and Ann Freedman."[82]

De Sole, looking to solidify his case before the lawsuit, sent the Rothko to Orion Analytical, the same firm that had issued a negative report on the Motherwell.

"The report comes back and the painting is a fake," De Sole recalled. "Some vinyl, some of the paint that was used, was never used by Rothko until the late '60s, so it was very clear from the report that the painting was a fake. I was quite furious."

De Sole added: "The unwillingness of both the attorneys for both Ann Freedman and Hammer to offer a rational settlement was pretty stunning. They refused."[83]

De Sole told the media: "When Orion's report, which I believed and trusted, came back that the Rothko was a fake, Freedman, Knoedler, and Hammer were insistent that this was not the case and that it was authentic. My point of view was, 'Fine, if it's authentic, give me my $8.3 million back and I'll walk away.' Now you can sell this authentic Rothko for more than twice as much, $18 million, or whatever and you can make a huge profit.' When they absolutely refused to do that I knew that, one, the Rothko was definitely a fake, and two, they knew for sure that it was a fake."[84]

De Sole was hardly being flippant about Rothko prices. In 2016, a Rothko, *No. 10 (1958)*, sold for $81.9 million at Christie's New York, establishing the second highest auction price for the artist ever. Seven Rothko paintings have been sold at auction for more than $50 million apiece. So, De Sole's Rothko, purchased in 2004, if real, was worth considerably more.

On September 13, 2012, Domenico and Eleanore De Sole filed their complaint against Ann Freedman, Knoedler Gallery, Michael Hammer, 8-31 Holdings, Jose Carlos Bergantiños Diaz, and Jaime Andrade. The complaint alleged fraud and RICO conspiracy (Racketeer Influenced and Corrupt Organizations). The addition of Andrade was very interesting as it was the first time his name was suggested as part of the conspiracy. He was the one who introduced Rosales to Freedman and was now being sued for "aiding and abetting fraud."

Freedman's reaction: "I can't get into the minds of Domenico and Eleanore De Sole, only to say that their behavior was excessively angry. Spilling their anger all over the place over me or about me. They wanted the drama. They helped create it. Domenico De Sole was a collector. He had an advisor. A well-known advisor [Jim Kelly] and I even more so believed in the seriousness of Domenico and Eleanore's interest in art. I didn't sell them their first painting and again, they had an advisor."

Freedman's observations about the couple during the trial were more clinical. "I think that was actually what the De Soles wanted—a very public display. I think they were obsessed with my every reaction. I think there was just incredible animus."[85]

Before the trial began—nearly four years after filing suit, there was much ado in the world of Glafira Rosales, Ann Freedman, and the Knoedler Gallery.

On May 21, 2013, Rosales was arrested at her home on Long Island, New York. She was accused of failing to disclose offshore bank accounts and filing false tax returns. Preet Bharara, the US Attorney for the Southern District of New York, accused her of hiding $12.5 million from the sales of counterfeit artworks. It was the tip of the iceberg.

THE DEVIL WEARS ROTHKO

By July 2013, Rosales would be charged with knowingly selling fake artworks in a $30 million scheme, selling more than sixty works of fake art to two Manhattan galleries. Her charges now included money laundering and tax crimes related to the art fraud scheme.

Bharara said: "The indictment depicts a complete circle of fraud perpetrated by Glafira Rosales—fake paintings sold on behalf of non-existent clients with money deposited into a hidden bank account. The one thing about this story that is true is that this alleged fraud will be prosecuted."[86]

According to the allegations contained in the indictment and the complaint filed in Manhattan federal court, the charges were very damning:

- The paintings Rosales sold were fake, that is, not by the hand of the artists that she represented them to be.
- Rosales knew the paintings were counterfeit and that the statements she made about their provenance were false.
- The purported Swiss client, on whose behalf she claimed to sell most of the paintings to the Manhattan galleries, never existed.
- The purported Spanish collector, on whose behalf she claimed to sell the remainder of the paintings to the Manhattan galleries, never owned the paintings.
- Instead of passing along a substantial portion of the proceeds of the sale of the various paintings, she kept all or substantially all the proceeds, and transferred substantial portions of the proceeds to an account maintained by her then-boyfriend.
- Rosales concealed and disguised the nature, location, source, ownership, and control of the proceeds of sales

of the fake works by causing the Manhattan galleries to transfer substantial portions of the proceeds of the sales to foreign bank accounts, and by transferring and causing to be transferred proceeds of the sales from foreign bank accounts to accounts maintained in the United States.

- Rosales filed tax returns that falsely claimed she had not kept all, or substantially all the proceeds from the sale of the purported clients' paintings, when, in fact, she kept all or nearly all the proceeds. In total, she failed to report the receipt of at least $12.5 million of income for the years 2006 through 2008.

- In addition, Rosales received most of the proceeds from the sale of the paintings in a foreign bank account that she hid from, and failed to report to, the IRS (Internal Revenue Service).

This case was handled by the Complex Frauds Unit and led by Jason Hernandez, Assistant US Attorney for the Southern District. Hernandez said that for months after she was initially arrested, Rosales sat in jail waiting for her trial and would not confess to anything: "She doesn't fit the profile of what you might think would be an international art criminal," he recalled. "I knew what might get her to open her mouth and spill was the strength of the case that we had, which was at that point, primarily a tax case."[87]

Hernandez knew that Rosales had fake paintings, but they had to prove that the paintings were fake, beyond a reasonable doubt, and needed to prove that Rosales *knew* that they were fake. There were red flags but probably not enough to get a criminal conviction. At least, not yet.

THE DEVIL WEARS ROTHKO

Hernandez didn't know who made the paintings, but he knew he could get Rosales on tax charges. "I took what Glafira told everyone in the world who she was, and I kind of followed the money from what she said she was," he said. "She said she was a broker. Brokers typically keep 10 percent and they remit 90 percent to their clients, so I followed the money. The money goes from the galleries in New York to bank accounts in Spain. It should then go 90 percent to the family that she says owns the paintings.

"Very quickly," Hernandez continued, "I was able to figure out that she's keeping all the money and that tells me two things: number one, there is no family, there is no one behind Glafira Rosales, this is all her, so she's lying already about where the paintings came from; and secondly, that's also income to her, millions and millions of dollars of income. So, we investigated whether she reported her foreign bank account, we investigated whether she reported it as income, and she didn't."

So, after being in custody for months and facing potentially years in prison on tax charges, Rosales hit a breaking point. Hernandez said: "She knew that she wasn't going to hold the bag for everybody and that she could be very helpful to our investigation. She's going to lose her tax case; she's going to go to jail."[88]

Rosales confessed to the scheme and told Hernandez who made the paintings and explained how they altered the paintings to make them look older, how they created the false provenance, and laid out everyone's role in the scheme.

Once Rosales identified Pei-Shen Qian as the artist, authorities got a search warrant and found a ton of evidence including envelopes marked, Mark Rothko nails, books on all the different

artists, and paints that matched exactly the fakes that he was producing for Rosales and Bergantiños.

"His studio was a compact studio but clearly someone who had a real passion for painting," recalled Hernandez. "Lots of materials and books, dog-eared pages to Rothko, de Kooning, and all the different abstract-expressionist artists. Sadly, Pei-Shen had fled to China and once he's in China there's really nothing [that] can be done. China's not going to extradite a Chinese national to the US."

Rosales also said Qian knew where his paintings were going. He was signing them in the names of the artists and had conversations with Bergantiños about upping the price on what he was getting paid for these paintings, after he saw that they were going for millions of dollars. So, he was negotiating for a higher rate for himself.

Rosales confirmed that Bergantiños gave Qian guidance and said, this is what we want, this artist, this era. Qian made the painting and then it went to Bergantiños, and he did things to the painting to make it look credibly old.

"So, they worked hand and glove," said Hernandez. "They needed Pei-Shen's artistry but then Bergantiños had to put the finishing touches on it to give it the appearance of age and credibility. But they were all both intimately involved in creating the provenance and in handling the money and perpetrating the fraud."

"As far as Bergantiños was concerned, he felt he was untouchable because they're Spanish nationals and we have to go through an extradition process in Spain," Hernandez continued. "Spain has decided that they would not be extradited, which is disappointing. I didn't know he had fled to Spain. I learned about

THE DEVIL WEARS ROTHKO

it from a Google News alert instead of getting a call from our government. It's disappointing because I didn't think they were going to really face any justice in Spain."[89]

With the Rosales confession in September 2013 came a guilty plea to nine counts, including conspiracy to commit wire fraud, money laundering, filing false federal income tax returns, and willful failure to file Report of Foreign Bank and Financial Accounts. The total maximum term of imprisonment was ninety-nine years. Rosales also agreed to forfeit $33,200,000, including her home in New York, and to pay restitution in an amount not to exceed $81 million.

After her confession went public, the art world was stunned for a moment and somewhat vindicated, given what so many had suspected for a decade. What happened after was a flurry of lawsuits against Freedman and Knoedler that were mostly filed and then settled—with the notable exception of the De Sole suit.

Freedman said: "I think that Knoedler realized that they needed me. I wanted to stay and solve these issues with the clients. And let me just talk about the big elephant in the room— settlements were about what I could do to heal with people whom I wanted their trust. I paid as much, if not more, than I made on any transaction. I did not have a problem giving back money."

But beyond giving money back, for Freedman, the Rosales confession was devastating. She said: "They're trying me in the press! It was very frustrating, and I didn't give any interviews. However, Patricia Cohen at *The New York Times*, would quote something not in quotes but infer that I've said something. I would say Glafira's confession was a kick in the stomach. A confession is a very...definite answer. I felt horrible. But I didn't feel

alone. I wasn't alone in believing in these works of art. It wasn't Ann Freedman against the world. A colleague of mine, a well-known one, said 'Ann, everyone was willing. The art world was willing.'"[90]

In 2013, while embroiled in seven lawsuits, Freedman swung back at an accuser by filing a defamation suit against art dealer Marco Grassi, who was quoted in a *New York* magazine article, saying that Freedman had failed to perform "due diligence" in authenticating the paintings supplied by Rosales.

His exact quote was: "This has ruined one of the greatest galleries in the world. It has trashed a lot of people's money. It seems to me Ms. Freedman was totally irresponsible, and it went on for years. Imagine people coming to someone and saying every painting you sold me is a fake. It is an unthinkable situation. It is completely insane. A gallery person has an absolute responsibility to do due diligence, and I don't think she did it."

After filing the suit, Grassi backed down and issued this statement: "Regretfully, I made these comments without having full knowledge of the facts about Ms. Freedman's diligence, including the many years of research conducted about the provenance of the works or the many scholars, museums, conservators, and dealers to whom she had shown the works. I therefore retract my comments and apologize for any harm they may have caused."[91]

As far as the FBI goes, Freedman was not off the hook just yet. Once Dedalus alerted the FBI and began its investigation, a grand jury was empaneled and sent grand jury subpoenas to assist the FBI and the US Attorney's Office for the Southern District of New York. They began questioning a big group of witnesses but, at this point, there was still no criminal prosecution

of anyone including Freedman and Knoedler, or any witnesses, or even Rosales, before the first lawsuit was filed in 2011.

But according to Nikas, Freedman's lawyer: "It was clear from the beginning that the FBI, the US Attorney, was investigating and it was clear that they wanted to know what Ann had done. They sent the grand jury subpoena that listed Ann as someone they wanted documents from as related to the art authentication that had been sold. Ann believed that when you put those documents in front of those people, they would admit they wrote them, they would stand behind them, and they would support her," said Nikas.

So, Nikas and one of his partners found themselves on the other side of the table in the US Attorney's office facing two FBI agents, Hernandez, who would have been the prosecuting attorney had he decided to prosecute Freedman, and the co-chief of the Complex Frauds Bureau.

It was now time for Nikas to explain his case to them. Nikas said: "It was reasonable for them to think they were going to prosecute somebody. I had a sense that they were fair, [that] they were willing to listen."

In a meeting that would last several hours, Nikas, using a very large presentation that offered extraordinary detail, step by step, as to why Freedman had acted properly, and what her story was. It was as if Nikas was doing a dry run before any potential jury, civil or criminal.

Nikas claimed there were no follow-up questions, no response ever: "It was the last time I ever spoke to anyone in that room."[92]

Freedman recalled being interviewed by the FBI twice: "You're in a small room. Three FBI agents and my lawyers are there. I don't remember much prep at all. But I answered every

question. I didn't feel that fright that I would be arrested. No. The plaintiffs at that point were accusing me of knowingly selling fakes. I did not knowingly sell fakes."

While these interviews occurred prior to Rosales confessing, Freedman said she was somewhat surprised that Rosales did not try to implicate Freedman in the scheme: "She had every opportunity to say anything she wanted to," Freedman said. "Might have made her case even better for her. But she knew I needed to show the paintings to experts, to museum professionals, to my colleagues, to bring them to art fairs. She didn't ask me many questions, so it wasn't as if I had to explain to her what I was doing."

While Nikas settled the various cases against Freedman, he also prepared for what was shaping up to be "the trial of the century": De Sole *v.* Freedman et al.[93]

CHAPTER 13

THE TRIAL OF
THE CENTURY

HERE IS AN *AMUSE-BOUCHE* prior to the trial everyone in the art world was waiting for—the biggest names in the New York art world fooled for nearly fifteen years, $80 million spent on fake art created by a brilliant Chinese immigrant in his garage in Queens, and a 165-year-old institution disgraced and suddenly closed forever.

The criminal masterminds, Jose Carlos Bergantiños Diaz, his brother Jesus Angel Bergantiños Diaz, and Glafira Rosales, were all indicted. The forger, Pei-Shen Qian, fled to China, maintaining he knew nothing about the criminal enterprise, saying: "I made a knife to cut fruit, but if others use it to kill, blaming me is unfair." Glafira Rosales was left holding the bag, pleading guilty, and awaited sentencing.[94]

While Freedman claimed that none of the others suing threatened to go to trial, the De Sole trial was about to begin and perhaps answer two major questions: How such a dramatic con could have been sustained for so long, and did one of New York

City's most prestigious art institutions and veteran art dealers knowingly sell fakes as originals?

Freedman now went from declaring: "I wanted to go forward with my life and prove these paintings to be right or at least I would do everything I could to prove what the paintings were, and I believed they were right," to "My lawyer said, and clearly felt, we could win this, and I am the central victim here."[95]

De Sole, unlike the other collectors who chose privacy by settling their claims, relished his day in court. He claimed that Knoedler, in its last fifteen years, was a racketeering operation, and he was suing for damages, amounting to triple what he paid for his Rothko, or $25 million.

The legacy media were pumped, calling it: "One of the greatest scandals the art world has ever seen."[96] And if Freedman was concerned that she was truly being poisoned by the media, she was not far off. Just about every journalist was taking aim at her in the days leading up to the trial. Michael H. Miller, *The New York Times* journalist, said: "Either she was complicit in it, or she was the one of the stupidest people to have ever worked in an art gallery." Michael Shnayerson, who covered the scandal for *Vanity Fair*, said: "Ann drew her share of heat, because she frankly wasn't liked and any art dealer who would be foolish enough to sell works, especially Abstract Expressionist works, without provenance, would deserve the opprobrium that the world would heap upon her." Cohen of *The New York Times* added: "I don't think Ann Freedman's defense that she just put the work out there and showed it to everybody exonerates her from any responsibility or that she was in no way complicit in the selling of these paintings."[97]

THE DEVIL WEARS ROTHKO

As a side note, Freedman told me that she had a tremendous dislike for Cohen, not because of her voluminous coverage of the scandal, but because she felt Cohen was not up to her standard of being an art world expert. She felt Cohen made errors in her articles when describing certain art works. She claimed that when Cohen got the dimensions wrong in her reporting on a Pollock, Freedman was successful in getting her removed from covering the art world.

Regardless, Freedman stayed focused on her day in court and prepared to win the case against her.

When making the film, I had the opportunity to go inside the trial and interview not only the De Soles and Freedman, but also their lawyers and the legal counsel representing the Knoedler Gallery. It provided invaluable insights into their strategies and approaches.

For the defense, Nikas represented Freedman. Nikas now had his own firm but had carved out an impressive reputation as a litigator and co-chaired his firm's art litigation practice. He represented some of the most prestigious artists, museums, galleries, and collectors. He was already well known before representing Freedman, having worked on high profile cases involving Warhol and Picasso. But it would be the Knoedler case that would make him world famous, even landing him an interview with Anderson Cooper on the CBS news magazine *60 Minutes*.

While filming Nikas, we noted how carefully he choreographed the location, including having fake Motherwell and Pollock paintings in the frame. He told me he just liked the paintings. He admitted that "sitting on this side—sitting on the defense side—I knew there were a couple of weaknesses."

153

For example, there are a lot of cases and people are asking for a lot of money—triple damages (three times the amount of each individual painting). There was no way they could recover a fraction of that, even if they won. A second risk: Once you start telling people the story and they realize there's another side to the case, then maybe someone will listen to the (other) negative side. "Maybe they can prove it," Nikas said. "Maybe a jury will go there. And throughout the entire case, I thought, if I press on the collectability, can they collect a judgement if they won. If I press on the narrative, ultimately, I'll get people in a position where they're willing to settle."

Nikas spared little expense in preparing for the case.

"I did multiple focus groups where I tried the case before mock juries," he explained. "I tried the case to understand how people think about this. How do people think about a situation where a work of art is being sold for $8 million, for $17 million, and they think that their kid could paint it? How do they think about caveat emptor (let the buyer beware)? How do they think about seller responsibility?"

Nikas added: "How do they weigh all these factors? And my plan was that, by the time the trial came, I knew exactly what the jury would be thinking at every single step of the trial, about every single piece of evidence that would go in, and that ammunition in the trial, and in the negotiations before and then after the trial, was priceless. My strategy before going to trial was always, getting the best result being to settle as many cases as I can, at as good a price I can get for Ann."

Ultimately, by the time Nikas got to trial, five suits had settled, the sixth one was going to trial, and there were four waiting to be heard.

THE DEVIL WEARS ROTHKO

"The focus groups tell us this, that after the opening statements, this is a horse race," he said. "They say, when we listen to one side, the plaintiff's side, it's incredibly damaging. We're gonna go that way. And then they listen to my side, and they say, there's another side to this story.

"Then, the witnesses are gonna come in, and fifteen, twenty who are not going to support Ann, and they're gonna swing to the plaintiff's side. Then Ann has to answer about ten questions on the stand—powerfully, persuasively, truthfully, in a way that's credible. And if she does that, that wins the day."[98]

Nikas has the benefit of having certain insights into the psyche of the collectors who were angry and felt they deserved to be heard as a result of negotiating nearly eight cases where Knoedler settled either alongside Freedman, or in a few of the cases, shortly after her. Nikas said: "Ann had no issues giving up her commissions."

In most cases, Knoedler took the position that it was a defunct gallery that has no assets. The holding company that owns Knoedler, 8-31, doesn't have sufficient assets to pay what these plaintiffs are asking for. Nikas felt from a legal standpoint that there's no way the plaintiffs would be able to pierce through Knoedler, pierce through 8-31, and find assets behind all the corporate structure. "And that's not a satisfactory answer to a lot of people," he said. "They were angry."

Aside from convincing the jury, Nikas knew he had to study, in depth, the plaintiffs and understand whether their case and testimony would resonate. "Do people care about rich people getting ripped off?" he wondered. "Should they have known better?"

"Eleanore and Domenico De Sole purchased a Rothko, thought to be a Rothko, from Knoedler Gallery," Nikas continued. "Domenico De Sole is currently the chairman at Sotheby's and is employed as an executive at Tom Ford. At the time, at Gucci. The De Soles are very smart people. They had a significant collection of art. Domenico De Sole is a graduate of Harvard Law School. He's a very sophisticated man. And they have an impressive collection of art. We knew she [Eleanore] would testify, that she was angry, heart-broken, sad. [So], we did try to settle on multiple occasions."

Nikas began trial preparations a full year before the trial happened. He said: "The very first day I met Ann Freedman was a day where I thought, how would I tell this story—her story that she's telling me right now? How would I channel that in a way that's persuasive to a jury? How do I win? And every single day more documents came in—tens of thousands of documents. Every single day more testimony came in. We deposed over fifty different witnesses in the case. Every single day I did a focus group or a mock trial. And so, the trial preparation, the formal trial preparation, started about a year in advance. But the thinking about what this trial is going to shape up to be started five years, six years before.

"We know they're going to try to front load all of these experts who looked at the works and will certainly not support Ann," Nikas added. "We knew their story about red flags. I knew that every single written piece of paper I filed at the court was going to be focused on caveat emptor. Caveat emptor—buyer beware."[99]

Nikas felt the headline was: "When you go in and you're a sophisticated collector, and you're buying works at this

level—millions of dollars—you have an obligation to due diligence. This was about Ann believing what she saw was real."

For the plaintiffs, Domenico and Eleanore De Sole were represented by Emily Reisbaum, Aaron Crowell, and Gregory Clarick from the firm Clarick Gueron Reisbaum LLP. Reisbaum is a no-nonsense litigator who had previously served as an Assistant US Attorney for the Southern District of New York.

In preparing for the case, Reisbaum studied all the related provenance documents Freedman had attached to the Rothko. "We saw all the paperwork they had been given from all the experts who she said had authenticated the work," she said. "And then we started calling those people and finding out they had never authenticated the work. So, we were doing our investigation. Well, it wasn't a red flag for Domenico and Eleanore, and they had no reason to doubt what Ann Freedman reported to them.

"We determined that for the decade, Freedman and Knoedler were really in the business of selling fakes," Reisbaum continued, "selling these fakes that came through Glafira Rosales, with the provenance the folks at Knoedler had concocted, in our view."[100]

Reisbaum had sent the Rothko to James Martin at Orion Analytical, and his analysis suggested that the painting was not authentic. It had not been painted with materials that were commonly used at the time. Reisbaum ultimately secured Martin's access to many paintings in the Rosales collection. She was able to piece together that works that were reportedly from different periods of time had basically used the same canopy. "So that sort of linked them all together as coming from the same source," Reisbaum said.

On one of the paintings, Knoedler also used Orion Analytical's services. "This was a source for them on testing," Reisbaum said. "But they didn't like their results and fought tooth and nail to get the results changed."

The lawyer acknowledged that a settlement was discussed: "We reached out to the lawyers for the defendants privately. And we wrote them a letter. We sent them Jaimie Martin's report. We said that 'You guys, you have a problem on your hands here. Let's work this out.' And when that wasn't going anywhere, we filed a complaint publicly."

De Sole said their offers were "absurd."

Reisbaum, like Nikas, began the discovery phase of the case, deposing all the witnesses, and gathering all their documents.

"We just uncovered every rock in the case," Reisbaum said. "We then deposed Freedman and it was a long deposition. And you know, she was very well prepared. She had her story. And that's the story she told. And for Rosales, she took 'the fifth,'" Reisbaum recalled, referring to the amendment of the US Bill of Rights that entitles a witness to be silent, rather than incriminate themselves. "She was already at risk. There was a translator there. And every question she just took 'the fifth,'" she said.

Reisbaum also felt that Hammer and Knoedler were complicit. "Our view is that it was, you know, from the top," she said. "Glafira Rosales didn't know David Herbert. That whole story was Knoedler's doing. And the Swiss collector and all of that was right out of Knoedler." Here is reminder for those trying to follow the genesis of the complex provenance: We know that Jaime Andrade (Knoedler gadfly) introduced Rosales to Freedman, Andrade had once worked for the art dealer David Herbert and knew the artist Alfonso Ossorio, and it is definitely plausible that

THE DEVIL WEARS ROTHKO

Andrade coached Rosales and helped her craft the ever-changing story, as he alone knew the inner workings of the art world, the characters, and Freedman's state of mind.

Reisbaum continued: "Freedman helped Glafira along with this whole idea of Glafira telling her the story, changing every time from Ossorio to Herbert to Mr. X. All the stories kept changing constantly as the years went on as there were provenance issues. Ann told Domenico and Eleanore that Mr. X and Mr. X's son had been a client of Knoedler's. That didn't come from Glafira Rosales."

Reisbaum added: "They spent a fortune on their defense. I hear that they did all sorts of mock juries, testing, testing, testing. I think they had somebody playing me. We did none of that."[101]

The Knoedler Gallery, Michael Hammer, and 8-31, the Hammer holding company, were represented by Charles Schmerler. When I interviewed Schmerler, he spent a lot of time educating me and defending the pedigree of the Hammer name, and their passion, history, and commitment to collecting art. He added that Hammer didn't even live in New York and spent no time there. So, any suggestion that he was involved, or a conspirator was "unreasonable and untrue."

"When Michael discovered what was going on, he immediately took all of the steps to undo the wrongs and take down any of the fakes from sale, he took every step to make it right," Schmerler claimed. "Anything that happened at Knoedler is not in any way attached to the legacy of the Hammer family."[102] That was good spin, and although he tried to distance Hammer from the day-to-day operations of Knoedler, he was about to be blindsided during the trial with some damning testimony.

BARRY AVRICH

Although Freedman would consistently say she was not an accounting person, and that she had no idea about the financials of the gallery, Schmerler found that claim untenable.

"You have to be an idiot if you are running a gallery, and you say you are not involved in the day-to-day business and know what you sold something for and what the margin was," Schmerler said.

The trial began in Southern District Court in Manhattan on a Monday in January 2016. It would be the season's hottest ticket.

The front row was packed with a who's who of the art world, including art dealers and appraisers and reportedly one very pregnant art advisor, who canceled a sonogram so she wouldn't miss anything. Undoubtedly, many of the art dealers who attended or watched the trial from afar had to know they too were most likely guilty of selling fakes.

Setting a dramatic background in the courtroom was the fake Rothko of the De Soles. The painting, which hung in the De Soles' Hilton Head house for years, protected by an alarm and expensive glass, was now being handled like a worthless piece of cardboard.

Before the trial began, Nikas had tried to file a summary judgment in his client's favor, arguing that it was De Soles' responsibility to do due diligence—his "buyer beware" strategy.

He lost.

Judge Paul Gardephe stated that the De Soles were not required to make "extraordinary" efforts to discover the truth.

Many experts now refuse to offer their opinions for fear of legal jeopardy if they are sued. In one case, the Andy Warhol Foundation spent $7 million on one lawsuit ("Brillo Box Scandal"), then closed its authentication board. As a side note,

THE DEVIL WEARS ROTHKO

legislation to protect authenticators has been proposed in New York, but it has not yet been enacted.

However, the stakes would be sky high, should the jury decide that the De Soles should have done more to investigate. The message to collectors will be, you had better treat art purchases like financial investments.

Also at stake: Were the De Soles justified in relying on Freedman? The De Soles claimed they are entitled to trust a gallery like Knoedler to provide accurate provenance. Nikas said the De Soles are sophisticated collectors, that De Sole would become the chairman of Sotheby's and was in the luxury retail business that is rife with fakes. It was his sole obligation, Nikas insisted, to determine authenticity.

The media spared no detail in painting deeply cinematic descriptions of the eccentric cast in the courtroom:

- "Clarick, a compact bald man, was chipper in the courtroom, usually managing an awkward smile no matter the circumstance."
- "Crowell had the unique ability to ask a witness a question if he really was just curious and wanted to know the unexpected answer."
- "Reisbaum was the most relaxed and casual of all the lawyers."

In her dramatic opening statement, Reisbaum laid out the six "red flags" that formed her argument in the De Soles' case against Knoedler:

1. Freedman knew nothing of Rosales before she came into Knoedler, and had no reason to trust her.

2. No one had ever seen the art Rosales was bringing in, without receipts, sales records, or photographs; essentially, there was no provenance.
3. The art was offered at "bargain-basement prices," allowing Knoedler to earn massive profits in selling them, in some cases more than 700 percent.
4. The way Knoedler paid Rosales for the art: partly by wire transfer, partly by cheque, and partly with a cash payment usually just under $10,000, the federal bank reporting requirement.
5. Knoedler and Freedman "actually made up the story about where the works came from."
6. From the very first piece that Rosales brought into Knoedler in 1994, experts had suspicions about the collection.

The bottom line for Reisbaum was convincing the jury that Freedman, who had not been indicted criminally, and Knoedler were in a conspiracy with Rosales.

Domenico De Sole loved Reisbaum's opening statement. "It was like watching a movie, she was brilliant," he said.

Reisbaum showed the jury some Rothko paintings and then said: "Freedman was lying. We will give you the evidence that will show you she was lying to the De Soles about everything she said."

Bottom line, De Sole also had the sales receipt from Freedman herself declaring the Rothko to be real with a pile of "experts" supporting that assertation.

Next up, the opening statement for the defense.

The media described Nikas' style as "dramatic and brooding that contradicted his boyish face." He told the jury that

THE DEVIL WEARS ROTHKO

Freedman traded genuine works from her own collection for some of the Rosales works and purchased others, including a purported Jackson Pollock (with the misspelled signature, "Pollok") that hung in her apartment for fifteen years. No one that was a conspirator in fraud would do that. Her excitement for the Rosales works was evidence that she believed in them. To try to prove that De Sole had a weak case, Nikas played an animated video showing a house crumbling down because of its weak foundation.

Nikas would speak confidently for ninety minutes and even showed a clip from the film *Pollock* (2000) to demonstrate that the artist and his fellow painters kept poor records of their work and had no idea where much of it was. Hence, he said, it was credible that the Rosales work was not published in the painter's *catalogue raisonné* that was first published, as a four-volume set, in 1978.

The Knoedler lawyer Schmerler was described by the media as someone that looked like the actor "Edward G. Robinson and came across as a plainspoken everyman that a juror might want to have a beer with." In his opening statement, he said: "I want you to put aside the fancy art words like 'connoisseurship' and 'catalogue raisonné' that the supposed experts use."[103]

Strangely, Schmerler revealed bullet points of the case by employing a video scoreboard that made loud buzzing noises with each new fact. It was as if he was hosting a game show. It pissed off the judge who yelled at Schmerler: "Please cut out the sound effects."

Freedman told me she thought it was humorous that during a trial about fakes, Schmerler wore a fake hairpiece.

BARRY AVRICH

Nikas also knew how to play to the jury and create doubt within the ocean of red flags. He said: "We have all seen movies where we thought one person was the villain or the saint, and then at the very end there is a revelation that the villain was the saint. Don't get ahead of Ann Freedman's knowledge at the time. Always come back to home base: Rosales pled guilty to lying to Knoedler Gallery. Don't make Ann Freedman pay for Rosales's crime, because Ann believed her." Nikas concluded by saying that De Sole had to prove that Freedman acted with fraudulent intent and not just negligence. Nikas then showed another cartoon of a stick figure climbing up a tall mountain, and atop the mountain was the word "fraud." Schmerler added: "They want you to believe that Ann Freedman fooled the entire world."[104]

Nikas underscored the main point, that Freedman had vetted the Rosales paintings with leading experts—conservators, historians, connoisseurs—all of whom supported the works. He added the De Sole painting was even briefly exhibited at the Beyeler Foundation, a private museum in Switzerland where it had its own wall.

Nikas stared at the jury and said: "This is when the whole art world says it's impossible that these works are forgeries."[105]

What ensued was a parade of witnesses and experts.

Watching the De Soles became an entertaining sport. Eleanore was less expressive than her husband who would make faces and play to the jury and gallery with a "Can you believe this crap?" demeanor. Eleanore simply wore a cynical look on her face when Knoedler's lawyers tried to discredit a witness. Sometimes, she would cry. Freedman, on the other hand, was described as "stone-faced and dressed as if attending a funeral, in black, beige, or gray."

164

THE DEVIL WEARS ROTHKO

Freedman made no attempt to make eye contact with anyone, but felt the De Sole heat directed toward her. "I kept staring at her with daggers in my eyes," admitted Eleanore.

De Sole testified that Freedman told him and his wife that eleven experts had authenticated the Rothko. His legal team specifically instructed him to use the word "authenticate," arguing that the work was presented as authentic without disclosing where it came from.

The convoluted provenance Rosales had presented to Freedman is what was told to De Sole, but Freedman never mentioned the name "Rosales" throughout the negotiation and sales process.

Former Knoedler employees Melissa De Medeiros, who was Freedman's assistant, and Edye Weissler, the gallery's librarian and archivist who worked for Knoedler from 1998 to 2012, also gave evidence. Edye testified that she worked for five days doing research at the Washington, DC and New York offices of the Archives of American Art and Yale's Beinecke Library. They found no connection between Mr. X and deceased collector David Herbert or any documentation that proved the paintings were purchased by a Swiss collector with the help of either Ossorio or Herbert (the story Rosales created). Both employees testified that no such documentation was ever found. And yet Freedman would use the names of Herbert, Ossorio, and Mr. X on Knoedler invoices. De Medeiros said that Rosales would usually bring a few paintings a year to Knoedler, and the staff would get the rolled-up art from the back seat of her Mercedes. Weissler said that "tossing a multi-million dollar painting in your car wasn't our customary white glove treatment."

De Soles testified that he told Freedman he wanted the details of the provenance story with its eleven expert opinions put in writing. Freedman agreed and supplied a letter. Both sides felt that letter was gold in proving their respective cases. While De Soles claimed the letter implicitly suggested that Freedman had experts authenticating the work, Nikas and Schmerler said, no, it only meant that Freedman had shown the work to the experts without authentication.

De Sole was furious at that point and looked at the jury with an incredulous look. "Freedman kept lying and lying, the list of experts were right there in writing; Laili Nasr, the expert working on a supplement to the Rothko *catalogue raisonné*; Christopher Rothko, the artist's son; art historians Irving Sandler, Stephen Polcari, and David Anfam, author of the Rothko *catalogue raisonné*, and E.A. Carmean, the former curator at the National Gallery of Art. Did she think we were idiots?" asked De Sole.[106]

Both Polcari and Carmean specifically wrote: "I too am convinced of their quality and authenticity."[107] Polcari even wrote an essay commissioned by Freedman about the entire Rosales collection including his opinion of what would turn out to be a fake Motherwell.

Freedman had believed that her list of "experts" would save the day and vindicate her, but one by one they turned on her with stunning testimony. Anfam testified he was never asked to give his opinion on the Rothko and that he never saw it in person—only in a picture, after the De Soles purchased it. He further testified that Freedman including him on her list was "outrageous. You don't put people's names on lists of anything without asking their consent," Anfam said.[108] You could hear a gasp in the courtroom.

THE DEVIL WEARS ROTHKO

The jury heard how Freedman's biggest supporters—respected scholars Carmean and Polcari—were beyond effusive about the works, despite warning signs. Polcari called the Pollock assessment "amateurish and irrelevant."

Irrelevant? Carmean, perhaps in devotion to Freedman (or his retainer), called Orion Analytical's testing of the Rosales works as "too broad" and "negative."

Then, Sandler testified that he was unaware that his name was being used as an expert opinion: "I looked at the Rothko in Freedman's office for five to twenty seconds," he said, but was unsure if it was the De Sole Rothko. He added: "I do not authenticate works of art. I never have and I never will."

Christopher Rothko also said he does not authenticate his father's work. But he did see the De Soles' Rothko and called it "pristine." He did not say whether it was real or not.

Nikas and Schmerler argued that De Soles had placed "blind trust" in Knoedler without bothering to read Freedman's letter or contact the experts themselves. It sounded ridiculous to assume that De Sole had Christopher Rothko on speed dial and that, as someone who demanded the letter confirming the experts in the first place, would not read the letter.

De Sole countered by saying: "If I bought a sweater from the Ralph Lauren store, I wouldn't ask if the sweater was a real Ralph Lauren. A similar analogy was brought over and over in that, if you walked into Tiffany's, you would not ask for the provenance of the diamond. You trusted the blue box it came in."[109]

Schmerler said: "De Sole wants you to believe that Knoedler should have hired a guy with a special microscope and the truth would have magically [appeared]."

BARRY AVRICH

Next up was James Martin from Orion Analytical, who also tested about fifteen Rosales works, including the De Sole Rothko.

Martin testified that certain issues with the paintings were obvious (such as a signature misspelling Pollock's name). He thought other flaws were also obvious, and could have been identified, despite other experts such as former conservator for the Mark Rothko Foundation, Dana Cranmer, testifying that she didn't think the De Soles's Rothko was a forgery. Martin added that the splatters of paint across various Pollock canvases he looked at led him to believe they were fakes. "It didn't seem likely to me that in a hermetically sealed environment that Freedman said the works were kept in, there were people walking around splattering red paint, one painting to another, that would be akin to an auto body shop."

Martin said that Carmean, on contract with Knoedler, asked him to revise the report on the fake Motherwell, including striking out Martin's conclusions that rejected the Motherwell. He further asked Martin to add the language: "At this point in the analysis and research, no conclusions can be drawn." Martin testified that he refused. He said to Carmean: "I believe you are asking me to alter my findings." This whole episode was a career embarrassment for Carmean and ultimately ended what had been a prestigious career as an art historian and curator. He ended up leaving the art world and becoming a lay canon in the seminary world.

Jack Flam, president of the Dedalus Foundation that published the Robert Motherwell *catalogue raisonné*, testified that the Mr. X story given to him by Freedman was rich in detail but kept changing. "First, it was that Herbert and Mr. X, a sugar

tycoon, were in a homosexual relationship together. Then it changed to the two men being just acquaintances," Flam said.

Flam admitted he saw one of Rosales's fake Motherwells in Freedman's office in 2006. Freedman told Flam that the Motherwell had been sent to Mexico. Flam told Freedman that that there was no record of Motherwell works having been sent to Mexico then. Flam then said that when he looked at the other Rosales Motherwells in 2007, "They were probably fakes."

Flam testified: "Stylistically, the Motherwells did not hold water. We believed that they were not authentic, the consistency of the signatures on the paintings was such that it looked like they used a template."[110]

He added that Freedman refused his conclusion, telling him the provenance was "impeccable." This must have irked Freedman who had to feel that Flam was on a mission to bury her.

The lawyers on both sides of the case found Flam's testimony frustrating. I could sympathize with them in that during my interview with Flam, he tended to take you down so many side roads to make a point. It was his passion for trying to be detailed and accurate, but the lawyers found it annoying. At one point, Schmerler cut Flam off and said: "Why don't I just go ahead and object now?" Gregory Clarick, a De Sole lawyer, cut him off as well before Flam could tell another unrelated back story.

Schmerler pushed Flam to admit that, when he saw the first Rosales Motherwell fake, although he was an expert in Motherwell, he did provide a letter of authentication. Flam vacillated, saying giving a definitive opinion could differ from painting to painting. Flam then became frustrated with Schmerler and said: "Do you want an honest answer, or do you want a pre-fabricated answer of what you are expecting?"

Sounding like Tom Cruise in the film *A Few Good Men*, Schmerler yelled back: "All I want is the truth." Flam shot back: "I'm trying to tell you the truth. You seem resistant to it." (At least Flam didn't tell the lawyer he couldn't handle the truth).[111]

Regardless, Flam was poison to the Knoedler and Freedman defense. He testified that the Freedman experts (including Robert Hobbs) that called the fake Motherwells among the artist's "greatest works" were beyond "hyperbolic."

Flam testified that when he investigated two of the Motherwell paintings in person in 2008—one supposedly from 1953 that Freedman owned and another from 1955 that was for sale—he found flaws, such as having the title of the series *Spanish Elegy* written with the artist's signature on the back of the canvas. Flam testified that Motherwell never used the phrase "Spanish Elegy" as part of his signature. Flam added the painting's support was warped, "which should have caused cracks in the paint itself, but the paint appeared to be in perfect condition." Freedman refused his suggestion to get the paintings to Orion Analytical for testing.

John Elderfield, a former curator at the Museum of Modern Art in New York, testified that in 1994, he told Freedman that two Rosales Diebenkorn works appeared "dubious, bland, and flat." He added that he brought Diebenkorn's widow into Knoedler and she told Freedman: "It would take a lot to persuade me that these were done by my husband." Nikas objected by saying that the two Diebenkorns were never at Knoedler at the same time, and that Elderfield's story was simply untrue.

There was no avoiding the emotion that the De Soles brought to the courtroom. It was almost cinematic. De Sole played the passionate Italian man, wronged by evil villains, often adding

THE DEVIL WEARS ROTHKO

commentary when he felt something was inaccurate. Eleanore would punctuate her testimony with tears.

Adding to the drama was the fake Rothko that sat in the courtroom as a daily reminder to the jury. It had to make Nikas uncomfortable, appearing like a chalk outline at a crime scene.

Although De Sole had paid more than $8 million for the painting, he told the jury: "It's worthless!" At one point during the trial, there was a humorous moment where experts were unsure if the fake Rothko was placed upside down or not.

The lawyers for the defense would try to set up De Sole, saying that he should have known better as a former Harvard-educated lawyer. "Mr. De Sole, you should have known, you're a lawyer," they'd say. And De Sole would respond: "I'm not a lawyer. I sell handbags."

Reisbaum said: "I think the play was to try and make the De Soles look unsympathetic to the jury and didn't work. I think it backfired; they were sympathetic."[112]

Next up, a close look at the financials of the Knoedler, and testimony that detailed how reliant the gallery was on the flow of the Rosales fakes. Reisbaum had Roger Seifert, an independent accountant, testify that when he pored over Knoedler's accounting records, he said that without selling the forgeries, the gallery would be "millions of dollars in the red." He found that the gallery earned a net income of $69.8 million from the Rosales paintings and had the gallery not "discovered" the Rosales art, it would have lost $3.2 million. Freedman's share of the gallery profits was raised from 16 percent to 25 percent in 2002, and then to 30 percent in 2008. Her take from the De Sole Rothko was $1.9 million.

Ruth Blankschen, a former accountant for Knoedler and chief financial officer of Hammer's 8-31 Holdings company, added that Hammer, although allegedly rarely involved or in New York, was paid $400,000 a year, plus a 20 percent share of the combined profits of 8-31's subsidiaries, which included Knoedler and Hammer's own gallery. Once Freedman left and the Rosales paintings stopped coming in, the gallery lost more than $1.6 million a year.

Schmerler said those findings were of a "hypothetical business" and that it failed to consider the eventual sale of the Knoedler Gallery townhouse. Seifert shot back: "$18 million proceeds from the sale would cover a lot of the sin."[113]

What wasn't hypothetical was Blankschen's testimony. She testified that Freedman made about $10.4 million from the Rosales sale, in addition to her $300,000-a-year base salary.

Blankschen said that between 2001 and 2012, Hammer ran up $1.2 million in expenses on the gallery's American Express card. That included trips to Paris, a $482,000 Rolls-Royce, which was sold in 2008 for $452,000 (money that Hammer kept), and a $523,000 Mercedes. For a gallery that was in trouble, the Rosales fakes were fueling Hammer's lavish lifestyle. Judge Gardephe suggested that any reasonable jury might see this as "co-mingling" between his personal and business expenses.

When the defense tried to suggest that Hammer was in Paris for Knoedler meetings, Blankschen said there were no such meetings.

One of the more dramatic moments came when Martha Parrish, a gallery owner who also commissioned to draft ethical guidelines for the Art Dealers Association of America, testified

THE DEVIL WEARS ROTHKO

that if any dealer should encounter a scenario such as the Rosales fakes, any reputable dealer should "run like hell."

Nikas objected and filed a motion to have her testimony dismissed, which was denied.

Frank Del Deo, who was promoted when Freedman was escorted out, gave dramatic testimony about Knoedler's final days. Freedman left the gallery in 2009, supposedly on medical leave. The jury was shown an email from Freedman to Polcari, in which she said she was forced out, and how it "hurt like hell." But Del Deo said what was happening at that time was that the gallery received a grand jury subpoena, and the FBI were investigating. Del Deo said he met with Hammer who told him the gallery townhouse was sold for $31 million, 50 percent less than the $60 million Hammer was seeking and well below market price. Then he closed the gallery for good.

The jury was shown the email that Knoedler sent out and it read:

> It is with profound regret that the owners of Knoedler Gallery announce its closing, effective [November 30, 2011]. This was a business decision made after careful consideration over the course of an extended period. Gallery staff are assisting with an orderly winding down of Knoedler Gallery.

Freedman's own account she shared with me on her final days added more color. She claimed that in August 2009, as things were unfolding with the investigation, she was handed a Code of Business and Ethics to sign. She refused. Hammer then asked to meet with her, and she was brought into a private room at

the gallery where she was questioned for six hours by a law firm conducting an internal investigation. Two days later, she was told that Del Deo would become the new gallery director. Freedman asked to become executive director but was refused. A few weeks later, she was served with an FBI grand jury subpoena.

Approximately thirty days later, on October 16, Hammer told her she needed to take a thirty-day "personal leave," and not talk to anyone. Two weeks later, Freedman was told the contents of her office had been boxed up and were being sent to her apartment.

In November 2009, Freedman (now gone from Knoedler) was still selling art. She concluded a sale of a Frankenthaler (1976) to collectors John and Jane Ellison for $1.2 million. The painting was owned jointly by Knoedler and David Mirvish. They split the net profit of $1.1 million evenly. The painting was authentic.

De Sole told me at this point in the trial that he felt Freedman and Knoedler's defense was weak. "Their witnesses were a complete joke and embarrassing. I thought they were reaching for straws and had no facts to support their defense. I was shocked that the courtroom was packed every day."

The court broke for lunch after Blankschen exited but the courtroom was riveted in anticipation of Hammer and Freedman's upcoming testimony. There were no empty seats. This was the show that everyone had wanted to see.

After lunch, Hammer walked into the courtroom looking like he could be Siegfried or Roy. Eleanore De Sole said: "He had on a royal blue velvet jacket, tan pants in February in New York, [with] deeply tanned and whitish gold flowing hair. I knew this would be interesting."[114]

THE DEVIL WEARS ROTHKO

After about an hour, all the lawyers retreated to the judge's chambers. A few minutes passed and then they all returned. Judge Gardephe said to the jury: "Due to some unexpected developments, I am releasing you today."[115]

De Sole said it was as if the air had been let out of the room.

The next morning, the lawyers once again went into the judge's chambers and then returned to the courtroom. Hammer and Freedman would not be testifying under oath. The lawyers said that all the parties had settled. The terms were not disclosed but De Sole's lawyers said they were "extremely satisfied."

De Sole later said: "It was clear that their case was getting weaker and weaker and yet the settlement offers were not there yet as we were dealing with three parties—Freedman, Knoedler, and Hammer. Finally, the combined offer made sense and we accepted it."[116]

Reisbaum told the media: "I think after the couple of weeks of trial, the defendants saw what was happening, finally, I guess. And we really settled when they were ready to settle."

Nikas's version to the media was: "The experts had previously supported the Rosales works but were trying to backtrack in order to save their reputations." He added that "the De Soles would have bought the painting, without a list of experts, such was their trust in Knoedler." He felt that "either Knoedler and Ann acted in good faith, or they were the worst criminals in the entire history of criminality."[117]

The New York Times journalist Michael Miller, who covered the trial, said: "I don't think that there was really any hope of Ann Freedman and Knoedler Gallery ever winning. And I think Ann Freedman didn't want to testify. And you know, the most memorable image of the trial was of the fake Rothko, which would

175

get propped up on an easel, pretty much once a day during testimony. And it would sort of get handled around like it was an old pizza box."[118]

Miller added: "We got back from lunch; the courtroom was packed. Everybody wanted this. Everybody wanted Michael Hammer and Ann Freedman to explain themselves because they hadn't done that sufficiently. Ann Freedman saying, 'Well, I'm a victim too.' It was disappointing that they didn't have to answer for it."

For Freedman, it had to be somewhat of a relief to put the trial behind her. But she would not lose her steely bravado. "I don't think De Sole wanted the defense to testify," she insisted. "They could have settled after I took the stand. They all had advisors, and they didn't want to listen too much of what I had to tell them. They wanted the piece, they loved it and for the art consultant, it's let's get the sale done here."[119]

The trial was over and one of Freedman's closest friends and supporters, art expert Marjorie Cohn, told me that she believed that Freedman was "only guilty of pride and avarice, but she had plenty of starch in her spine and vindication for her is still looking at fine art."

Freedman was definitely still looking for and selling art. Within two years of leaving Knoedler, amidst scandal and a tsunami of lawsuits, Freedman opened a new gallery just three blocks from the Knoedler. With her pride intact and never one to hide, she called her new gallery Freedman Art. The three-floor gallery was designed by her friend Holly Hunt and her opening show featured her loyal friend, the artist Jules Olitski, who had works that were previously forged and sold by Rosales, and works from her other loyal supporter, artist Frank Stella.

THE DEVIL WEARS ROTHKO

I asked former US District Attorney Jay Hernandez if he would ever buy a painting from Freedman. He laughed and said: "Hard no."

Eleanore De Sole found it "infuriating" that Freedman was still selling art. "I have a friend who bought a piece of art from her in her new gallery, and I said, 'Are you aware of the story behind Ann Freedman?'"

Cohen from *The New York Times* said: "The trial is over, lawsuits are being settled, but I think, there's probably people out there who bought these paintings and did not get reimbursed for them."

Cohen is right in that in more than forty fakes sold, there were only eleven lawsuits filed and settled, leaving close to three dozen collectors who did not come forward.

Interesting to note: The statute of limitations in New York for a plaintiff wanting to sue in similar cases, according to Hernandez, is either six years from the date of representation, or two years from when the fake is discovered. So, either the clock ran out for the many others, they were embarrassed to come forward, or they have no idea they have fakes hanging on their walls.

CHAPTER 14

THE AFTERMATH

WHEN I MET FREEDMAN for the last time at The Mark, before we began post-production on the documentary, *Made You Look*, she walked into the hotel's Jean-Georges Restaurant carrying a Freedman Art tote bag stuffed with more newspaper clippings and articles about yet another forgery scandal where someone was duped.

She wanted to ensure I had what I needed to begin editing the film. She quizzed me endlessly about who said what. I told her nothing. I reminded her that at our very first meeting, the objective of the film was for her to tell her side of the story, and not to vindicate her. I am not sure she ever heard that point.

She pulled out a piece of paper and in typewritten bullet points, she boldly summarized her experience:

- Not a single judgement against me
- No indictments
- Two FBI investigations that yielded nothing
- No more liability
- Not a single plaintiff could charge me

THE DEVIL WEARS ROTHKO

- No exposure
- Government case was closed.

Even though the trial was long over, she also presented me with a July 2002 memo from Ernst Beyeler, the famed art dealer and collector who founded the Beyeler Foundation. The memo expressed how the De Sole Rothko had been "very much admired as a centerpiece." Freedman was underlining her vindication to ensure the movie had the right ending.

She then presented me with a list of quotes, as she did in our first meeting:

- "You have enemies? Good, that means you stood up for something, sometime in your life." —Winston Churchill
- "I am not a vengeful woman...the bastards will get theirs without me doing anything about it and it will be fancier than anything you could have dreamed up." —Dorothy Parker
- "Once we see something and accept it as true, it's really hard to falsify the belief." —Rosanna Guadagno, Psychologist

Freedman also brought me a highlighted memo in which mogul art dealer Larry Gagosian, by far the largest dealer in the world, tells his staff: "If you would like to continue working for Gagosian, I suggest you start to sell some art. If you are not willing make that kind of commitment, please let me know. I put in eighteen-hour days. The luxury of carrying under-performing employees is now a thing of the past." Freedman's point was that all galleries were under a lot of pressure to sell a lot of art.

We then did one last shoot where our camera tracked her as she slowly walked past what was the Knoedler Gallery. The

building now had large scaffolding in front of it, as it was being massively renovated to be the private residence of Leon Black.

We did two or three takes as Freedman would walk and gaze up at the building, her home for more than thirty years, the place that sullied her pristine reputation. I'm not sure what I expected from Freedman—either more emotion or some sign of sorrow. There was nothing. On each take, she simply stopped, shrugged as if it was no big deal, and continued walking.

She did tell *The Art Newspaper*: "We all need to get over it. I've had a debacle to deal with…I'm not hiding it, but you go on…. You have to have a good conscience to keep going."[120]

We said goodbye to each other for what would turn out to be the last time. The film, slated to have its world premiere in front of sold-out audiences at the 2020 *Hot Docs Festival* in Toronto, became a virtual screening because of COVID restrictions.

Our plan was to fly Freedman in for the film but that was now impossible. She asked us for a link of the film, and we said no. The film ended up screening as part of the *Hamptons International Film Festival* in 2020, where I did a post-screening interview moderated by Alec Baldwin, who had been a victim of art forgery. He was anxious to tell me his story and was now dubious of all art dealers.

In 2010, Baldwin bought a painting by Ross Bleckner, *Sea and Mirror*, that he was lusting after for years from dealer Mary Boone for $190,000. Baldwin took delivery of the painting, uncrated it, and found it didn't look right and that something was off. Boone told him that the artist had personally cleaned the canvas. He accepted the response. Six years later, Sotheby's confirmed that the *Sea and Mirror* was a forgery.

THE DEVIL WEARS ROTHKO

Both the artist and Boone admitted the painting was a copy. Baldwin filed a civil suit in New York State Supreme Court against Boone and her gallery, alleging that she had intentionally defrauded him. Boone tried to claim that Baldwin himself was in on the scheme but that backfired on her. She settled out of court but was later jailed for tax evasion.

Baldwin loved *Made You Look* but was critical of Freedman whom he felt came across like "an old schoolteacher that needed to be disciplined herself." He would bark at me in his traditional macho way, "You should have been harder on her, she was guilty."

Freedman finally saw the film when a friend showed her a copy on an iPad. She left me a voicemail: "Well, well, that was the quite the editing job." And that was it. Her implication was that I edited her interviews with certain people that didn't quite support her not being complicit in the scandal. I left her one last voicemail reminding her that the film, soon to be streamed on Netflix, beautifully expressed her side of the story. It was not a bat mitzvah film.

The aftermath of our cast of characters is as fascinating as the caper itself.

Freedman opened her own gallery three blocks from the shuttered Knoedler, and has been selling art with same fervor for the last decade. Gone are the heady, power days where the sea divided as she walked down the aisles of the prestigious art fairs and auction houses. Gone as well are the power lunches and holidays with billionaire collectors and famous artists. Her gallery walls are mostly covered with emerging artists and the odd secondary market blue-chip art that she is selling on behalf of someone's estate. On several occasions when I visited her,

she would try and sell me a piece that someone had consigned with her.

Although the glory days are behind her, and she is very aware that her reputation has been stained, she keeps going. She is not unaware that people talk about her when she shows up at an exhibit opening or even a local restaurant, but it does not seem to bother her. Freedman recalled meeting with her friend Richard Fuld, CEO and chairman of Lehman Brothers, days after the massive $613 billion collapse of the firm in 2008, where he discussed feeling disgraced, losing his seat at the table in the financial world. Fuld was named in *Time*'s "25 People to Blame for the Financial Crisis" list and CNN's "Ten Most Wanted: Culprits of the Collapse." It is impossible to know what Freedman took away from Fuld's experience, but a year later, she would experience the same fate.

Master forger Pei-Shen Qian claimed he had stopped selling his art and told us he is now painting for himself.

Qian was indicted in 2014 on charges of wire fraud and conspiracy to commit wire fraud. At some point before that, he was questioned by the FBI and he claimed not to know Rosales or the names of artists whose work and signatures he is accused of forging. He insisted he had not faked their style. The US added lying to the FBI about producing dozens of worthless fakes that were eventually sold by prestigious galleries for tens of millions of dollars. He fled to China to avoid prosecution and a potential jail sentence of forty-five years.

Qian had both Chinese and American citizenship and there is almost no chance that China would turn over one of its citizens for American-style justice. Qian told the media, "I am the innocent victim of a very big misunderstanding and I had never

THE DEVIL WEARS ROTHKO

intended to pass off his paintings as the genuine works of modern masters. I made a knife to cut fruit. But if others use it to kill, blaming me is unfair."[121]

When I traveled to Shanghai to find Qian, I discovered that several galleries had exhibited his original works and that he was still painting. None of the galleries would tell me where he lived or connect me with him. Ultimately, we found him in a modest apartment that his daughter had bought for him and his wife. He was not happy with our camera crew. His small apartment was stuffed with dozens of paintings leaning against every wall.

He continued painting as his wife told us that he now paints for himself and no longer sells his work. His apartment looked like a factory. She said he felt deceived at how the media treated him and how the story was twisted. We asked his wife if he was somewhat proud that his work had fooled so many people. He looked up at us and smiled. And with that, his wife closed the door. Interview over.

After pleading guilty in 2013 to charges of wire fraud, money laundering, and tax evasion and spending three months in jail, Glafira Rosales was sentenced in 2017, and ordered by a federal judge to pay $81 million to victims of the fraud. She was also sentenced to nine months of house arrest and three years' probation for her part in the fraud. Authorities seized multiple properties, bank accounts including $33 million in US currency, four different bank accounts in Spain, and more than 200 works of art, including authentic paintings of Sean Scully, Jules Olitski, Ellsworth Kelly, and Andy Warhol.

Her lawyer Bryan Skarlatos said: "Glafira has taken responsibility for her role in the situation and regrets any harm that people have suffered."

BARRY AVRICH

Skarlatos told the court that Rosales had been subjected to years of abuse, suffered at the hands of her long-time partner Bergantiños. He claimed that Rosales was in constant fear that Bergantiños would take their daughter away from her and leave for Spain. He added that Bergantiños used threats to force Rosales to keep up the fraudulent scheme for more than a decade and a half.

Skarlatos added that Rosales was now "working as a bus girl in a restaurant, living in a rented room, struggling to live on a minimal salary, and barely able to pay her medical expenses. And it was Bergantiños that conceived and directed all aspects of this scheme."[122]

He added a letter from Isolina, the daughter that Rosales and Bergantiños had together, where Isolina pleaded for mercy for her mother prior to sentencing. She wrote: "My father Jose Carlos Bergantiños suffers from mental health issues with erratic and unpredictable behavior. He had violent tendencies to my mother…including full physical battery. When I was 19, I found out from my housekeeper that he tried to kill her. He had complete control over her."

When I interviewed Bergantiños in Spain, he said her claim of abuse was a lie and that she was always the ambitious one, not him. He said she was the one that dealt with Qian.

While many felt the sentence was outrageously lenient, the presiding judge, Katherine Polk Failla, said she weighed Rosales's testimony heavily and noted that Rosales had cooperated with the authorities after her arrest. Rosales addressed the court and, fighting back tears, said: "I apologize to you my daughter, to my family, and to my friends, and to all those affected by my crime.

I have had many hardships but none of that excuses what I have done."[123] And with that, she freely walked out of the court.

John Cahill, the lawyer representing John Howard who had bought a fake de Kooning for $4 million from Knoedler, told the media without any sympathy for Rosales: "Rosales reveled in and enjoyed the millions of dollars she stole through her role in Knoedler forgery fraud. Not once did she do anything to help its victims."[124]

As for Jose Carlos Bergantiños Diaz's fate, he, along with his brother Jesus Bergantiños Diaz, were charged in 2014 in a forty-two-page indictment. The statement claimed the two brothers and Glafira Rosales sold sixty fraudulent artworks in a fraudulent plot, and then fled to Spain. An extradition order for both brothers was granted in early 2016, but a month later, Bergantiños convinced a Spanish judge that his health was too fragile for him to travel to the United States. When he was arrested at a hotel in Seville, he said he suffered an anxiety attack and was hospitalized. His brother had been arrested in Spain four days earlier. The US requested extradition by Spanish authorities under a treaty agreed to by the two countries in 1970, but was blocked by Bergantiños's lawyer. Sources have told me that Bergantiños allegedly had the resources to pay off the right people and stay in Spain. His lawyer, J.A. Sánchez Goñi, said: "Most of the criminal offenses were committed in Spain, so why send him back to the USA?"

When I asked him about the status of the case in Spain as Bergantiños was arrested there, Goñi said: "Currently, there is no case. He returned the money. The person [Rosales] that had debts in the US paid the debts from there. Mr. Bergantiños is innocent,

and he does not need a trial to demonstrate that."[125] With that, Goñi wanted to have lunch and terminated the interview.

In my interview with Bergantiños, he said he did not flee to Spain: "I had my home in Spain and my roots will always be in Spain. I feel at peace here."

No matter how hard I tried to get him to acknowledge his role in the art fraud scandal, he was the master of deflection. His only admissions were as follows:

- "I made mistakes in my relationship with Glafira because I let her manage the finances."
- "She lied when she told *Vanity Fair* that I put a gun to my daughter and that her parents abused her. False."
- "I understand that she used whatever testimony to defend herself. I forgive her."

And then, before trying to sell me a harmonica that he claimed was once owned by Bob Dylan, he offered me advice on buying art: "I would buy two or three upcoming artists and then sit on the paintings and the value will go up." This was from the person that was forging famous, priceless works of art by dead artists. He added: "I entered the art world where many are called, but few are chosen."[126]

We said farewell to Bergantiños along the cobblestone streets of Lugo, Spain, as Goñi was waiting to take him to lunch.

My producer wondered out loud, as we shared some delicious local pastry, as to whether the trip Spain to interview Bergantiños was worth it. After all, he showed no remorse and blamed Rosales. The man with a plan the minute he got to New York City, who traded beluga (caviar) for Basquiat, wanted to be absolved. I loved every minute of his delusion.

THE DEVIL WEARS ROTHKO

Freedman was never charged or indicted. Hernandez, who would have prosecuted the case, told me that, ultimately, he didn't think he could get a conviction. His style was to be sure of a conviction when going into battle. He said: "The gallery was always going to be the hardest part of the case. I needed to prove to twelve people beyond a reasonable doubt that Freedman and the gallery were running the scheme. Very different burden from a civil case. There were plenty of things that did not add up, but we needed twelve out of twelve people. There are plenty of people that get caught up in fraud and don't get convicted."

The debate as to Freedman's ultimate guilt or innocence will rage on for eternity. For supporters such as Cohn, Spencer (from the Pollock-Krasner Foundation), Nikas, and art conservator Dore Ashton, their views were unyielding.

Cohn said: "She was devoted to art. It's easy to be deceived. Perhaps she should have been more anxious about that there wasn't any documentation, but she consulted experts. Ann was not a criminal."

Cohn sent an email to Freedman in 2017, writing: "I can't help thinking your story needs more public understanding. The issue of why you depended on your own judgement is so subtle, too subtle for the crowd that only regards money and the desired downfall of the elite."[127]

Spencer, who runs the Pollock-Krasner Foundation, said: "Undisclosed ownership is very common. De Sole was a sophisticated buyer. To say a 'man with a collection insured for $ 26 million' is not sophisticated is absolute nonsense. Freedman's mistakes were not mistakes of intention."

Nikas added: "She did everything she should have done, exhibited the work, consulted experts who said positive things...

and then on the stand when confronted with their 'positive opinions,' they do a remarkable about-face. It was like a Jekyll and Hyde sort of way. There was no cover up here. This was a collection of works that can only be described as the equivalent of finding dinosaur bones."[128]

Freedman relied heavily on Ashton, who was a legendary art conservator, art critic for *The New York Times*, author of thirty art books, and world-renowned art expert. Ashton looked at the Pollock that the IFAR had examined, and said she had seen the work before. She added that had she been sent the Pollock, she would have said it was authentic.

Ashton sent Freedman a handwritten letter in 2013, where she wrote: "No one can be certain in these matters and an experienced, informed eye can be fooled by skilled forgeries."

In 2012, Ashton resigned from the Dedalus Foundation board as a director. She felt violated by Flam blaming her and firing artist and writer Joan Banach for not bringing up objections about the two fake Motherwell paintings. Banach had previously worked as Motherwell's assistant for ten years. Ashton claimed she was not made aware of his written authentication. Banach ultimately sued Dedalus for wrongful termination and lost. Ashton felt that Flam was looking for scapegoats for his errors.

Ashton gave an interview to a publication before she died and said: "Bob (Motherwell) would be twirling in his grave about this nonsense." She referred to the early founders of Dedalus, John Elderfield, and Jack Flam whom Motherwell had appointed, as "evil." She was unhappy with the direction Flam had taken the foundation with everyone taking a "piece of the pie." Regardless, her support of Freedman never wavered.[129]

THE DEVIL WEARS ROTHKO

On the other side of the spectrum were the critics who would never believe that Freedman was not somehow complicit in the Rosales fakes. Perry Amsellem, lawyer for the Dedalus Foundation, said: "I was surprised that Freedman was not indicted. There was enough to bring an indictment. There were letters written on Knoedler stationery and signed by Glafira Rosales, who is not an employee of Knoedler, attesting to her having title, and that the title is good. I would never buy art from Freedman."

The De Soles' scorn has been well covered but they summed up their opinion of Freedman by saying: "Ann Freedman is the guiltiest of all parties. She told me a pack of lies. She knew exactly what she was doing as did Michael Hammer. I have no doubt in my mind. I have a great bridge in New York City, I want to sell it to them for a hundred billion dollars, so just give me a call."

And Emily Reisbaum, the De Sole lawyer, said: "During the trial, when the media saw all the evidence come in so overwhelmingly as we knew it would, there was drama. That Freedman told Eleanore and Domenico De Sole that Mr. X's son had been a client of Knoedler, that didn't come from Rosales."

And Cohen of *The New York Times*, who broke the story and relentlessly covered just about every detail, told me: "You can look at spots where Freedman perhaps failed to do what she should have as an art dealer. But criminally, you have to prove intent and that is very hard to prove. It was just a little too convenient that a lot of these stories were too hard to check and when there were holes, suddenly they were plugged by some new information that Freedman provided."[130]

I interviewed the endlessly fascinating Maria Konnikova, a *New York Times* best-selling author and champion poker player

with a Ph.D. in psychology. Konnikova was an expert in the art of the con and had also interviewed Freedman. Her view of Freedman was that, in order to understand why she was "sucked in," you must understand why she was "chosen" by Bergantiños and Rosales. Konnikova felt they knew she was "vulnerable" and "was still hungry and needed this win for a lot of different reasons and the con artists will say things to her that she wants to hear."

She added: "Even when the lawsuits pour in and the evidence comes in against you, there is a moment where instead of doubting and saying 'I was wrong,' you say, 'No, I am right.' This is a psychological process called 'dissonance reduction' where you re-interpret the events. I think Ann Freedman was an unwitting puppet master and that Rosales was an expert in emotional manipulation."[131]

Konnikova quoted legendary con artist Victor Lustig, who was known for allegedly selling the Eiffel Tower twice, as saying: "'A con artist isn't a good speaker, a con artist is a good listener.' A master con artist gives you what you want and Rosales did that well with Freedman."

She concluded: "My ultimate defense of Ann Freedman is that she has all the hallmarks of a classic victim of a con artist. I believe there was no turning back because she wanted to believe so much that she was willing to believe. We basically all deceive ourselves on a daily basis."

My own perspective as someone who spent hours and hours with Freedman is that I don't believe she had any Machiavellian intent to fool the art world and deceive sophisticated buyers, in the same way that has been suggested about Qian's intentions. Freedman was aware that the gallery was in trouble.

THE DEVIL WEARS ROTHKO

Her competition had eclipsed her. Furthermore, Hammer was wavering as to the gallery's future. And then comes along what Nikas described as a "King Tut's Tomb" size art discovery, and she was seduced almost immediately.

Should she have cut and run after the fifth or sixth Rosales work, or dug deeper to discover who Rosales was partnering with, specifically, Bergantiños? Perhaps. But instead, she doubled down, kept the blinders on, and kept going. Do I believe her altruistic mission that she was driven to find the truth and history of the paintings and that she so passionately believed they were real or was she fueled by arrogance and ego?

Freedman was driven by two things: selling art and preserving her place at the front of the line to get access to art, artists, and the collectors who would do and overlook anything to get their trophies.

For her, it was never about money. She never spent any of what she earned. But it was all about the money, when it came to what she could sell the next piece for. And that is the art world. The only thing people really care about is who bought what and how much did they pay.

In 2016, Freedman broke her silence to the media and told *The Art Newspaper*: "I always thought that tomorrow I'll find a photograph of the artist's studio and see the corner of [one of the forged paintings]. When you're doing research, you're like Christopher Columbus. You're not sure when you're going to find land." She then added, with some strange sense of bravado, blended with contrition: "I am terribly sorry for anybody who [says they have been] hurt or damaged.... But let me be clear, this is [about] works of art. I didn't slay anybody's first-born."

WHEN I LAST SAW Freedman, she was preparing for what I think she hoped might be a gentle return to the art world. She had convinced her friend and fellow art dealer Robert Mnuchin, of the reputed Mnuchin Gallery in New York, to mount a stunning retrospective exhibition of the works of Robert Motherwell, and his wife and fellow artist Helen Frankenthaler. The exhibit, called *The Art of Marriage*, had its debut in 2019 and was brilliantly conceived by Freedman. She poured everything she had into it, securing paintings loaned from key collections, even getting her old friend E.A. Carmean to write an essay for a beautiful linen book that was published to commemorate the exhibition. Freedman would attend the glamourous opening but was told by her friend Mnuchin that her involvement in the exhibition would be dramatically downplayed so as to not pull focus from the event. Her only acknowledgement in the book for an exhibition that she had conceived and named was buried in one paragraph, thanking her for getting various paintings for the exhibition. Only in the footnote of curator Karen Wilkin's essay in the book does Freedman get a proper shout-out. I found that sad given the devotion and relationship Freedman had with both Motherwell and Frankenthaler. It was blatant indignity.

Sharon Flescher, the former executive director of IFAR, put together a sold-out evening featuring a provocative panel discussion in July 2016 entitled, *Lessons from the Knoedler/Rosales Affair*. She invited panelists, including moderator Patricia Cohen, John Cahill, James Martin, and others to provide their uncensored takeaways on what Flescher called a "sad episode" in the art world.

The panelists broke down what they saw as the key factors that led to widespread fraud wherein Knoedler withheld provenance:

THE DEVIL WEARS ROTHKO

- Knoedler did not disclose Rosales as the dealer.
- Did not disclose that eight works had come from the same source and then grew to forty.
- Knoedler did not disclose the IFAR 2002 report regarding the Ossorio provenance.
- They did not disclose the provenance change from Ossorio to Herbert.
- Knoedler did not disclose their lack of personal knowledge of the Swiss owner, a fact misrepresented to Orion Analytical.

Ultimately, they felt the imprimatur of the Knoedler Gallery allowed the scam to continue.

The panel warned the audience that the Knoedler scandal would not be the last forgery case to shame the art world. Martin said: "Today's forgers glean technical information on the internet and submit fakes to laboratory testing to produce fakes aimed at thwarting scientific detection." One of the panelists, Robert Storr, a Yale professor and previous MoMA curator, said: "I can't actually say that I am sorry for the hedge funder who lost $17 million buying something he didn't investigate from somebody who really didn't play fair with him. He can afford it. But we can't afford to have the public lose faith in museums and of artists."

I would love to watch Lagrange and Storr have cocktails and discuss his point of view.

Adam Sheffer, president of the Art Dealers Association of America, points to the art advisors and consultants the clients hired to provide guidance and "help protect their clients.... They should have picked up the book on Rothko, if they didn't know better and do some research."

One insider told me: "The plethora of art consultants, experts, and dealers who were all fooled in this story, simply because it's always better for them when art sells."[132]

Storr added that Freedman interpreted any opinion she received to her benefit and Cohen said that Freedman testified that, "If people didn't say anything negative, she assumed that was confirmation."

Cahill summarized his view: "At the end of the day, the people taking accountability are the people selling the art. If you are dealing with a reputable dealer, getting straightforward promises and information, I think you should be able to count on that."[133]

Michael Hammer died of cancer in 2022. A year before his death, *Vanity Fair* skewered him in a profile characterizing him as a childish conniver, who used the name of his grandfather, business tycoon Armand Hammer, to make deals. Once his grandfather died in 1990, Hammer had a front seat in a bitter battle over an $180 million estate that featured warring family members, mistresses, and numerous business partners.

Hammer then deconstructed his grandfather's artistic legacy by turning over the Hammer Museum to UCLA, and, out of a move from the series *Billions*, had the Metropolitan Museum of Art remove Armand's name from the Hall of Arms and Armor, given that he refused pay off the remaining $1 million pledged.

Hammer was then the subject of endless gossip resulting from a DUI arrest, his boasting about a personalized "sex throne" with a family crest kept at the Armand Hammer Foundation headquarters, and which had a human-sized cage underneath its seat. He divorced his wife, Dru, after twenty-seven years of marriage; she later opened her own ministry after finding God on a trip to Jerusalem. Hammer followed up his puzzling reign

THE DEVIL WEARS ROTHKO

with the embarrassing Knoedler fiasco. Regardless, he remained on the society circuit until his death.

As a sidenote, Hammer's son is the actor Armie Hammer, who faced allegations of sexual abuse and cannibalism. Armie denied the criminal elements of the accusations against him, stating that he had engaged in consensual acts of bondage, discipline, and sadomasochism. In May 2023, the investigation by the Los Angeles District Attorney's office and the LAPD resulted in a decision not to file charges against him, citing insufficient evidence. He has been trying to resuscitate his career ever since.

Just as I was completing the manuscript for this book and preparing to hand it over to my publisher, I was contacted by Anastasios Sarikas, who had represented both Glafira Rosales and Carlos Bergantiños prior to and during the Knoedler debacle. When I was making the film, Sarikas had refused to be interviewed for it, so I was excited to hear from him. His initial statement to the media when Rosales was arrested was classically protective of his client. "Mr. Sarikas said the allegations had unfairly hurt Ms. Rosales: 'Since the Motherwell matter was made public, her ability to engage in this business—even with pieces beyond reproach and with absolutely sterling pedigree—has been severely circumscribed and damaged.'" Sarikas had now retired and was ready to spill, and spill he did in a very provocative interview.[134]

Sarikas told me that he had been very close friends with Bergantiños since 1992 after being introduced to him by a mutual friend that was an artist that Bergantiños was representing. They became fast friends and Bergantiños took him to his house in Great Neck, New York, that was filled with art, most of it Mexican art but the collection included some pedigree

works from artists such as Andy Warhol, Hans Hofmann, and Franz Kline. Sarikas assumed the art was all authentic. At the house, Bergantiños introduced him to Glafira, who told him that she was studying medicine in Mexico before she met Carlos, but in fact was a nursing student. Over time, Bergantiños told Sarikas that he came from a very poor Spanish family and that his mother suffered from severe mental illness and had at times been institutionalized. She had treated him cruelly and told young Bergantiños that status is everything and that "unless you come home in a Mercedes, then you should come home in a coffin." Sarikas admitted that he was charmed by Bergantiños and admired him.

At one time, Sarikas asked Bergantiños, who was funding his art collection and business, and he was told that his brother, Jesus, made millions as a civil engineer designing military bases and was happy to share the wealth. Over time, Sarikas witnessed certain mood swings displayed by Bergantiños and wondered if he inherited some of his mother's mental illness issues. He would later come to think that Bergantiños suffered from bipolar tendencies. Regardless, he represented him in several petty criminal issues that included threatening a legal process server with a baseball bat and a lawsuit with the famed Mnuchin Gallery in New York over a work by Franz Kline that was a fake and a Mark Rothko he had sold to another gallery.

In 2002, Sarikas believed that Bergantiños was grooming him to play the art dealer in the forthcoming Knoedler Gallery art scheme. He was educating him on all matters related to art and various artists. Bergantiños took him on a luxurious cruise, and that is where Sarikas started asking him questions about his art collection and was suspicious about certain pieces in it.

Bergantiños was put off with the questions, and Sarikas believed it was then that Bergantiños decided to use Glafira and not him to execute the scheme. While on the cruise, Sarikas saw the charming side of Bergantiños, and whatever port they stopped in people were drawn to him, as he would buy drinks and sit down at any piano to play impromptu song after song.

Whether Sarikas had an intuition that Bergantiños would be eventually prosecuted criminally for something one day, he dissuaded him from becoming an American citizen. In fact, when a warrant was issued for his arrest in the Knoedler scandal, Bergantiños was in the Dominican Republic and Sarikas advised him to not come home. He never did, and the arrest warrant is still active.

During the Knoedler scheme, Sarikas saw how Bergantiños and Rosales greatly elevated their lifestyle by moving into a 6,000-square-foot home in Sands Point, New York, with fancy furniture, décor, and a massive art collection.

When the scandal was exposed, Bergantiños was in the Dominican Republic, where he had a home. He called Sarikas and he was in a state of furious panic. Sarikas said Bergantiños looked like "Donald Trump on cocaine." He said to him, "Why is Obama and the Feds spending money on this versus catching real criminals? We are doing so much good." Sarikas told me that Bergantiños saw himself as a Robin Hood character that while he was robbing the rich he was also giving away lots of money to poor people and paying for many people's medical bills. Regardless, he stayed away from the US and both he and his brother Jesus were charged. It was only Glafira that was left holding the bag.

Sarikas visited Rosales in jail multiple times and at first she was shaken but stood by her story that the art was real. After losing a bail hearing, she was shocked. Sarikas was equally shocked: "How does Crypto fraudster Sam Bankman-Fried get bail and my client is refused bail for art crimes?" Sarikas said that Soli, Glafira's daughter that she shared with Bergantiños, was outraged with the bail hearing and was vicious in a verbal attack as to why he had failed to get her mother out of jail.

After sitting in jail and having conversations with lawyers, she began to feel more hopeful. Sarikas said that Rosales was befriended by a Columbian woman that was in jail for a drug deal and helped her get her "sea legs," while she waited out her destiny. I asked Sarikas about Rosales's claims that she had been a victim of cruel mental and physical abuse from Bergantiños, and Sarikas responded, "That was a convenient defense. Of course there was friction in the relationship, but I don't believe he abused her."

I was curious about Soli's art career and why she would enter that world after everything that had transpired with her parents and how exactly Soli had access to works by such prominent artists such as Basquiat, Warhol, and Hirst, as displayed on her website. Sarikas paused for a while and told me that he believed that whatever the Feds seized from the Bergantiños's Sands Point home was only a fraction of what really they really owned. The inference being that perhaps Soli might be selling some of it. This was pure speculation.[135]

When I asked Sarikas what his reaction was to Ann Freedman's claim that she was a victim in the Knoedler affair, he was dubious: "You can't be a victim if you keep your eyes closed." He referred to the earlier claim that Rosales was her

THE DEVIL WEARS ROTHKO

"golden goose" and that she "fought tooth and nail" to keep the story alive.

Since making the film *Made You Look*, hundreds of people have asked me two basic questions: first, what my advice is about buying art; and second, what was my takeaway from my film and ultimately, this book.

Well, here are your answers, and they're extremely simple: Buy a piece of art because you love it and want to look at it every day, because it makes you feel good when you come home. Don't buy art because some art consultant or gallery dealer told you it's "beautiful" or "will enhance your social status" or that it's "a great investment." And of course, if you're spending $100 on a lithograph or $25 million on a Rothko, you need to feel comfortable that it is authentic. If you're not sure, walk away.

Ultimately, the art world rarely slows down from boom to bust and boom again. And with that comes a new generation of billionaires and oligarchs that crave art and drive the market and the fraudsters. There will always be a dealer waiting to sell you art. As global art dealer Gagosian said: "I believe in popularizing art, but it's a bit of an elitist world. The sun never sets on my gallery." Gagosian told a journalist he probably wouldn't sell to a "convicted murderer," but buyers with "lesser allegations" levied against them may still be fair game. "If the money is correct, if the transaction is correct, I'm not going to be a moral judge," he said.[136]

And with that, I hope you find the art world as exciting as I do.

ENDNOTES

1. International Foundation for Art Research, "Provenance Guide," February 21, 2023, https://www.ifar.org/Provenance_Guide.pdf.

2. M.H. Miller, "The Big Fake: Behind the Scenes of Knoedler Gallery's Downfall," *ARTnews*, April 25, 2016, https://www.artnews.com/art-news/artists/the-big-fake-behind-the-scenes-of-knoedler-gallerys-downfall-6179/.

3. *Made You Look: A True Story About Fake Art*, directed by Barry Avrich (Melbar Entertainment Group, 2020), with performances by Ann Freedman, M.H. Miller, Perry Amsellem, and Patricia Cohen.

4. Ibid.

5. Leila Amineddoleh, "A Brief History of Art Forgery—From Michelangelo to Knoedler & Company," *Artsy*, January 30, 2016, https://www.artsy.net/article/artsy-editorial-the-8-most-prolific-forgers-in-art-history-that-we-know-of.

6. Rex Sorgatz, "Forgeries Gone Wild!" *Medium*, July 16, 2014, https://medium.com/message/forgeries-gone-wild-d9b4c195da5.

7. Peter C. Sutton, *Fakes and Forgeries: The Art of Deception* (Bruce Museum, 2007).

THE DEVIL WEARS ROTHKO

8 Colin Moynihan, "Court Tells Sotheby's to Reveal Its Auction Clients in 'Nazi-Loot' Case," *The New York Times*, March 22, 2024, https://www.nytimes.com/2024/03/22/arts/design/sothebys-auction-clients-nazi-loot.html.

9 Michael H. Miller, "More Details on the Closing of Knoedler Gallery," *Observer*, December 5, 2011, https://observer.com/2011/12/more-details-on-the-closing-of-knoedler-co-art-gallery-12052011/.

10 "Dealer Mary Boone to Close Her New York Gallery," *Artforum*, February 23, 2019, https://www.artforum.com/news/dealer-mary-boone-to-close-her-new-york-gallery-242385/.

11 Ryan Torok, "Court Rules Against Nazi-Looted Art's Return to California Family," *Jewish Journal*, January 17, 2024, https://jewishjournal.com/culture/367286/court-rules-against-nazi-looted-arts-return-to-california-family/.

12 Oscar Wilde, Goodreads, https://www.goodreads.com/quotes/7040-a-good-friend-will-always-stab-you-in-the-front; Amit Kalantri, Goodreads, https://www.goodreads.com/quotes/10056314-a-stab-from-a-friend-cuts-deeper-than-a-stab.

13 Martha Stout, *Outsmarting the Sociopath Next Door: How to Protect Yourself Against a Ruthless Manipulator* (Harmony Books, 2020).

14 Martha Stout, *The Sociopath Next Door* (Harmony Books, 2006)

15 *Made You Look: A True Story About Fake Art.*

16 Ibid.

17 Ibid.

18 Ibid.

19 Ibid.

20 Ibid.

21 Michael Shnayerson, "A Question of Provenance," *Vanity Fair*, April 23, 2012, https://www.vanityfair.com/culture/2012/05/knoedler-gallery-forgery-scandal-investigation.

22 Ibid.

23 Ibid.

24 Ibid.

25 *Made You Look: A True Story About Fake Art.*

26 Ibid.

27 Ibid.

28 Ibid.

29 Mónica Parga, "José Carlos Bargantiños, El Español Que Hundió La Galería Más Importante de NY: 'Tengo Defectos, Como Todo El Mundo,'" *Vanity Fair*, July 27, 2017, https://www.revistavanityfair.es/la-revista/articulos/jose-carlos-bergantinos-fraude-arte-glafira-rosales-galeria-knoedler/25266.

30 Ibid.

31 *Made You Look: A True Story About Fake Art.*

32 Ibid.

33 Patricia Cohen, "Note to Forgers: Don't Forget the Spell Check," *The New York Times*, June 11, 2014, https://www.nytimes.com/2014/06/12/arts/design/note-to-forgers-dont-forget-the-spell-check.html.

34 *Made You Look: A True Story About Fake Art.*

35 Ibid.

36 James Panero, "'I Am the Central Victim': Art Dealer Ann Freedman on Selling $63 Million in Fake Paintings," *NY Mag Intelligencer*, August 27, 2013, https://nymag.com/intelligencer/2013/08/exclusive-interview-with-ann-freedman.html.

37 *Made You Look: A True Story About Fake Art.*

38 Ibid.

39 Miller, "The Big Fake."

40 *Made You Look: A True Story About Fake Art.*

41 Ibid.

42 Ibid.

43 Ibid.

44 Ibid.

45 Ibid.

46 Miller, "The Big Fake."

47 *Made You Look: A True Story About Fake Art.*

48 Ibid.

49 Ibid.

50 Ibid.

51 Ibid.

52 Michael Shnayerson, "The Knoedler's Meltdown: Inside the Forgery Scandal and Federal Investigations," *Vanity Fair*, April 6, 2012, https://www.vanityfair.com/culture/2012/04/knoedler-gallery-scandal-schnayerson.

53 *Made You Look: A True Story About Fake Art.*

54 Nancy Spector, "Robert Motherwell: Elegy to the Spanish Republic No. 110," Guggenheim, https://www.guggenheim.org/artwork/3047.

55 *Made You Look: A True Story About Fake Art.*

56 Ibid.

57 Ibid.

58 Ibid.

59 Ibid.

60 Laura Gilbert, "Knoedler Asked Forensic Conservator to Revise 'Negative' Report," *The Art Newspaper*, February 5, 2016, https://www.theartnewspaper.com/2016/02/05/knoedler-asked-forensic-conservator-to-revise-negative-report.

61 *Made You Look: A True Story About Fake Art.*

62 Gilbert, "Knoedler Asked Forensic Conservator."

63 *Made You Look: A True Story About Fake Art.*

64 Ibid.

65 Ibid.

66 Patricia Cohen, "Possible Forging of Modern Art is Investigated," *The New York Times,* December 2, 2011, https://www.nytimes.com/2011/12/03/arts/design/federal-inquiry-into-possible-forging-of-modernist-art.html.

67 *Made You Look: A True Story About Fake Art.*

68 Ibid.

69 Cohen, "Possible Forging of Modern Art."

70 Patricia Cohen, "A Gallery That Helped Create the American Art World Closes Shop After 165 Years," *The New York Times,* November 30, 2011, https://www.nytimes.com/2011/12/01/arts/design/knoedler-art-gallery-in-nyc-closes-after-165-years.html.

71 *Made You Look: A True Story About Fake Art.*

72 Shnayerson, "A Question of Provenance."

73 Shnayerson, "The Knoedler's Meltdown."

74 Cohen, "Possible Forging of Modern Art."

75 Ibid.

76 *Made You Look: A True Story About Fake Art.*

77 Murray Whyte, "David Mirvish Acknowledges Fakes in New York Art Fraud Scandal," *Toronto Star,* September 18, 2013, https://www.thestar.com/entertainment/visual-arts/david-mirvish-acknowledges-fakes-in-new-york-art-fraud-scandal/article_84b3ab29-c05b-5e0d-9a1d-b23b7a80e4fa.html.

78 Laura Gilbert and Bill Glass, "Former Director of Scandal-Beset Knoedler Gallery Breaks Her Silence," *The Art Newspaper,* April 18, 2016, https://www.theartnewspaper.com/2016/04/18/former-director-of-scandal-beset-knoedler-gallery-breaks-her-silence.

79 *Made You Look: A True Story About Fake Art.*

80 John Steinbeck, Goodreads, https://www.goodreads.com/quotes/35070-i-shall-revenge-myself-in-the-cruelest-way-you-can.

THE DEVIL WEARS ROTHKO

81 *Made You Look: A True Story About Fake Art.*

82 Ibid.

83 Ibid.

84 Eileen Kinsella, "The Final Knoedler Forgery Lawsuit, Over a $5.5 Million Fake Rothko, Has Been Settled, Closing the Book on a Sordid Drama," *Artnet*, August 28, 2019, https://news.artnet.com/art-world/final-knoedler-forgery-lawsuit-settled-1637302.

85 *Made You Look: A True Story About Fake Art.*

86 "Long Island Art Dealer Indicted for Massive Art Fraud, Money Laundering, and Tax Scheme," The United States Attorney's Office: Southern District of New York, July 17, 2013, https://www.justice.gov/archive/usao/nys/pressreleases/July13/RosalesGlafiraIndictmentPR.php.

87 *Made You Look: A True Story About Fake Art.*

88 Ibid.

89 Ibid.

90 Ibid.

91 Panero, "'I Am the Central Victim'"; "Former Knoedler & Co. President Files Defamation Suit," *Artforum*, September 12, 2013, https://www.artforum.com/news/former-knoedler-co-president-files-defamation-suit-217883/.

92 *Made You Look: A True Story About Fake Art.*

93 Ibid.

94 Jon Swaine, "Artist at Centre of Multimillion Dollar Forgery Scandal Turns Up in China," *The Guardian*, April 22, 2014, https://www.theguardian.com/artanddesign/2014/apr/22/forged-art-scandal-new-york-artist-china-spain.

95 *Made You Look: A True Story About Fake Art.*

96 Miller, "The Big Fake."

97 *Made You Look: A True Story About Fake Art.*

98 Ibid.

99 Ibid.

100 Ibid.

101 Ibid.

102 Ibid.

103 Miller, "The Big Fake."

104 *Made You Look: A True Story About Fake Art.*

105 Miller, "The Big Fake."

106 *Made You Look: A True Story About Fake Art.*

107 Miller, "The Big Fake."

108 Ibid.

109 Ibid.

110 Ibid.

111 Ibid.

112 *Made You Look: A True Story About Fake Art.*

113 Brian Boucher, "Knoedler Gallery Not Profitable Apart from Fakes, Says Accountant at Fraud Trial," *Artnet*, February 5, 2016, https://news.artnet.com/market/lawyers-tussle-knoedler-books-fraud-trial-421265.

114 *Made You Look: A True Story About Fake Art.*

115 M.H. Miller, "Judge Abruptly Calls Recess Right Before Ann Freedman's Testimony in Knoedler Trial," *ARTnews*, February 9, 2016, https://www.artnews.com/art-news/artists/judge-abruptly-calls-recess-right-before-ann-freedmans-testimony-in-knoedler-trial-5816/.

116 *Made You Look: A True Story About Fake Art.*

117 Miller, "The Big Fake."

118 *Made You Look: A True Story About Fake Art.*

119 Ibid.

120 Gilbert and Glass, "Former Director of Scandal-Beset Knoedler Gallery."

121 Swaine, "Artist at Centre of Multimillion Dollar Forgery Scandal."

THE DEVIL WEARS ROTHKO

122 Eileen Kinsella, "Glafira Rosales Ordered to Pay $81 Million to Victims of the Knoedler Art-Fraud Scheme," *Artnet*, July 10, 2017, https://news.artnet.com/art-world/glafira-rosales-knoedler-art-fraud-1018190.

123 Ibid.

124 Ibid.

125 *Made You Look: A True Story About Fake Art.*

126 Ibid.

127 Ibid.

128 Ibid.

129 James Panero, "An Interview with Dore Ashton: Renowned Art Historian Dore Ashton Talks Art Criticism, the Art Bubble, and the Dedalus Foundation," *James Panero*, February 12, 2013, https://jamespanero.com/writing/2013/02/an-interview-with-dore-ashton.html.

130 *Made You Look: A True Story About Fake Art.*

131 Ibid.

132 Patricia Cohen et al., "20/20 Hindsight: Lessons from the Knoedler/Rosales Affair," *IFAR Journal* 17, no. 2 & 3 (2016), https://www.ifar.org/publication_detail.php?docid=1480 353262.

133 Ibid.

134 Cohen, Patricia. "Possible Forging of Modern Art Is Investigated," The New York Times. December 2, 2011, https://www.nytimes.com/2011/12/03/arts/design/federal-inquiry-into-possible-forging-of-modernist-art.html.

135 Paul, Bryson "Boom". "New York Art Dealer Soli Corbelle Is The "It" Girl Right Now," Substream Magazine. January 7, 2020. https://substreammagazine.com/2020/01/new-york-art-dealer-soli-corbelle-is-the-it-girl-right-now/.

136 Patrick Radden Keefe, "How Larry Gagosian Reshaped the Art World," *The New Yorker*, July 24, 2023, https://www.newyorker.com/magazine/2023/07/31/larry-gagosian-profile.

INDEX

Note: Page numbers for photographs are in bold.

Actor, The (Picasso), 61
aftermath, the, 178–96
 Ann Freedman, 178–82, 187
 Art of Marriage exhibit,
 192–94
 debate re Freedman's guilt,
 187–91
 Glafira Rosales, 183–85
 Jose Carlos Bergantiños,
 185–86
 *Lessons from the Knoedler/Ro-
 sales Affair,* 192-93
 Made You Look, 180–81
 Michael Hammer, 194-95
 Pei-Shen Qian, 182–83
Ai Weiwei, 32, 79
Ameringer, Will, 68
Amsellem, Perry, 131, 189
Andrade, Jaime (Jimmy/Hymie),
 82–83, 114, 142
 as conduit for frauds, 83
 considered complicit, 158–59
 recommends Rosales to
 Freedman, 82, 83–84
André Emmerich Gallery, 66
Andy Warhol Foundation, 160

anecdotal provenance, 24–25
Anfam, Dr. David, 90–93, 166
 Rothko *catalogue raisonné,*
 85–86
Arnauld, Bernard, 21
art
 authentication, experts wary
 of, 160–61
 factory-produced in China, 37
 fake *vs.* forgery, 34
 as financial investment, 22
 freeports for, 22
 types of, spending on, 20
 where/who purchased from,
 20–21
Art Basel, 18, 19
art collectors, 18–21
 angry, 155
 hierarchy of, 23
 high-net-worth (HNW)
 20-21
 types of, 22
Art Forger's Handbook, The (Heb-
 born), 31
art market, *see also* Nazi-looted
 art; provenance

208

American, growth of, 43–44
billionaires and, 21
Chinese, 18, 19
Christie's and, 73
contemporary art dominated, 49
drivers (collectors) of, 18, 19–21
on fire in 1990s, 49
forgeries, prevalence of, 27
Knoedler dominance of American, 47
money laundering and, 39
slowdown in, 18
Sotheby's and, 73
stolen art post-WWII, 57
tax evasion and, 39
Art of Marriage, The (exhibit), 192
Art Students League of New York, 78–79
Art Thief, The (Finkel), 49–50
Arthur, Beatrice, Freedman compared to, 7
Ashton, Dore, 92, 187, 188
Astor, John Jacob, 47
authentication, experts wary of, 93, 160–61
Avrich, Barry, *see also Made You Look*
advice on buying art, 199
Blurred Lines: Inside the Art World, 63
first meeting with Freedman, 5–9
opinion of case, 190–91
takeaway on film and book, 199

Baghdad Museum, 125
Bal du moulin de la Galette (Pierre-Auguste Renoir), 27
Balaÿ, Roland, 46
Baldwin, Alec, 14, 180–81
Banach, Joan, 188
Barnes Collection, 85
Basquiat, Jean-Michel, 125
Battcock, Gregory, 62–63
Bellini, Giovanni *(St. Francis in the Desert)*, 53
Beltracchi, Wolfgang (forger), 30, 31
Bergantiños, Isolina (Soli), 77, 106, 184
Bergantiños, Jesus, 80, 127, 185
Bergantiños, Jose Carlos, 28, F100
author's meeting with, 74–75
background, 75–78
daughter, 77
denies abuse claims, 184
Long Island home, 107
master of deflection, 186
no extradition from Spain, 19, 84–86, 146–47
Pei-Shen Qian and, 79–80, 82, 88
profit from forgeries, 88, 105–107
Bernheim, George, 54
Beyeler, Ernst, 114, 179
Bharara, Preet, 142, 143
Birth of Venus, The (Alexandre Cabanel), 55
Black, Leon, 6, 133, 180
Blankschen, Ruth, 172
Bleckner, Ross *(Sea and Mirror)*, 180–81
Blondeau, Marc, 115–16, 125

Blurred Lines: Inside the Art World
(Barry (Avrich), 63
Boone, Mary, 50, 180–81
Boussod, Gérome Etienne, 42
Boussod, Valadon & Cie, 42
Bredius, Dr. Abraham, 35
Breitwieser, Stéphane, 49–50
Bruce, Ailsa Mellon, 41
buyer beware (due diligence)
 caveat emptor, 154, 156
 defense strategy, 160, 167

Cabanel, Alexandre *(The Birth of Venus)*, 55
Cahill, John, 192, 194
Campendonk, Heinrich, 31
Carmean, E.A., **95**, 166, 167, 192
 Martin testimony re, 168
 Orion Analytical report and, 121, 122–24
 paid to authenticate Rosales collection, 92
Carstairs, Carroll, 46
Carstairs, Charles, 44, 45, 46
Cassirer, Claude, 59–60
Cattaneo family, van Dyck portraits of, 44
caveat emptor, 154, 156
China
 art market, 18, 19
 factory-produced fake art, 37
 Lucheng Museum closed, 37–38
Christ at Emmaus (Johannes Vermeer), 35
Christie's
 art sales, value of (2023), 20
 Beltracchi forgeries and, 30, 31

declined Lagrange's Pollock, 130
domination of established art market, 73
forgeries auctioned by, 36
Rothko prices at, 141
sues Bergantiños, 78
Churchill, Winston, 179
Clarick, Gregory, 157, 161
Clark, R. Sterling, 53–54
Clinton, Bill, 15
Cohen, Martin and Sharleen, 137
Cohen, Patricia, 132–33, 134, 147
 art-scandal reporting, 135–36
 Freedman disliked, 153
 on Freedman's responsibility, 152
 intent not proved, 189
 many not reimbursed, 177
Cohen, Steve, 71
Cohn, Marjorie B., 176
 support for Freedman, 187
Colnaghi, Knoedler Gallery partnership with, 52–54
Colsman-Freyberger, Heidi, 121
Colton, Glenn, 132
con, the, 81–102. *See also* forgeries
 artists forged, 89
 cast of characters, 74
 discovery story embroidered, 89–90
 expert opinions, obtaining, 87, 92–93
 first meeting with Rosales, 82–84
 forgeries sold elsewhere, 114
 Freedman finds fraud story credible, 85–86

THE DEVIL WEARS ROTHKO

Freedman's authentication of
art, 90–92
highlights of, 88
number of paintings sold,
87–88
ongoing sales, 89
panel discussion re, 192–94
profits from, 88
Rothko provenance on
Knoedler letterhead,
86–87
testing the waters for, 80
unravelling begins, 117
Cooper, Anderson, 11
Costco, sale of fake Picasso draw-
ings, 36
Cranmer, Dana, 93, 168
Crowell, Aaron, 157, 161

da Ponte, Jacopo (*Spring Sowing*),
56–57
Dalí, Salvador, 36
Danziger, Thomas, 39
Daumier, Honoré (*L'Amateur
d'Estampes*), 54
David, Michael, 68
De Medeiros, Melissa, 120
testimony of, 165
de Rothschild, Alfred, 54
De Sole, Domenico, 26, **95**
calls Freedman re fraud, 140
cherished day in court, 152
fraud complaint filed, 142
Gucci Group, work with,
108–109
reaction to fraud, 139–40
refused a refund for the
Rothko, 141

required warrant of authentic-
ity, 108–11, 140–41
Rothko purchase, 108–11
sends Rothko to Orion Ana-
lytical, 141
trial reactions, 162, 164,
170–71, 174, 175
trial testimony, 165–66
whether he should have
known, 156, 171
De Sole, Domenico and Eleanore
Freedman meeting details in
writing, 110
opinion of Freedman, 189
reliance on Freedman, 161
De Sole, Eleanore, 12, 33, 177
decision-maker for art collec-
tion, 109
demeanor during trial, 164–65
description of Hammer at
trial, 174
reaction to fraud, 139
Dedalus Foundation, 115, 123
Ashton resigns from, 188
defends against Killala suit
and sues Weissman, 131
Motherwell letter of authentic-
ity, 116, 124–25
sues Glafira Rosales, 131–32
Del Deo, Frank, 173
della Francesco, Piero (*Madonna
and Child Enthroned with Four
Angels*), 53
Diaz Bergantiños, Jose Carlos, *see*
Bergantiños, Jose Carlos
Diaz, Bergantiños, Jesus, *see* Ber-
gantiños, Jesus
DiCaprio, Leo, 50

211

Diebenkorn, Richard, 170
(*Ocean Park* series), 102–103
digital art, spending on, 20
dissonance reduction, 190
Dontzin, Matthew, 134, 135
Drawn to Trouble (Eric Hebborn), 31
Drewe, John (forger), 29–30
Driver, Mary Ann (Lady Holloway), 53
due diligence, *see* buyer beware
Duveen, Joseph, 45

8-31 (Knoedler holding company), 107
defense lawyers for, 159–60
insufficient assets to pay plaintiffs, 155
Elderfield, John
Dore Ashton opinion of, 188
trial testimony, 170
Elegies to the Spanish Republic (Motherwell), 114–15
Ellison, John and Jane, 174
Emmerich Gallery, 66
Emmerich, André, 66
Epstein, Jeffrey, 6

F Is for Fake (Orson Welles), 29
Failla, Judge Katherine Polk, 184
fake art, why prevalent, 27
fake vs. forgery, 34
Federal Bureau of Investigation (FBI)
Flam takes findings to, 125
Freedman/Nikas response to, 149–50

grand jury investigation, 126, 148–49
investigating Freedman, 147–48
Orlando Museum of Art investigation, 125–26
Femme à la montre (Picasso), 27
Fertig, Ann Louise, *see* Freedman, Ann
Fertitta, Frank, 137
Fertitta, John, 114
Fine, Ruth, 93
Finkel, Michael *(The Art Thief)*, 49–50
Flam, Jack, 116, 117
disputes authenticity of paintings, 120–21
Dore Ashton opinion of, 188
doubts re authenticity of *Spanish Elegy 1953*, 116
Freedman meeting to discuss report, 123–24
hires private firm to investigate Rosales, 123–24
identifies Motherwell paintings as fake, 118–20
Motherwell letter of authenticity withdrawn, 124–25
takes findings to FBI, 125
trial testimony, 168–70
Flescher, Dr. Sharon, 24, 192
declares Pollock painting a fake, 104–105
Flynn, Tom, 33
Ford, Tom, 109, 110
forgeries
buyers of, 32–33
Chinese factory producing, 37
examples of, 34–37

THE DEVIL WEARS ROTHKO

vs. fakes, 34
Freedman ignored clues, 106,
 137–38
Freedman's profits from sales
 of, 105–106, 172
long history of, 28–32
prices charged for, 86, 102,
 103, 105
rationale for, 32
Sotheby's buyer/seller disclo-
 sure ruling, 38–39
why prevalent, 27–28
forgers
 global arrests of, 38
 tricks to fool buyers, 34–35
France, art market of, 20
Frank Perls Gallery, 58
Frankenthaler (1976), sale of, 174
Frankenthaler, Helen, 68
Frankfurt, Jamie, 86, 113
fraud triangle, 17
Freedman Art, 10–11, 16, 176
Freedman, Ann, **95, 96, 98,**
 background, 64–65
 claimed to be duped, 8–9, 11
 clout of, 3–4
 collectors suing, 136–37
 comment on her case, 191
 continued to live modestly,
 107–108
 critics of, 189–90
 defends her actions, 62–64,
 90, 138
 Emmerich Gallery, first job,
 65–67
 exhibited works to bolster
 credibility, 91
 got professional endorse-
 ments, 91–93

ignored clear warnings,
 137–38
inspirational quotes, 179
Knoedler Gallery, career at,
 48–49, 67–69, 70–73
leaves Knoedler, 127–29,
 173–74
letter re experts authenticating
 paintings, 121
marriage, 67
meeting to discuss Martin
 report, 123–24
needed Hail Mary, 1, 3, 5
no defense of reputation, 131
opens own gallery, 181–82
as perceived by others, 68–69
reasons for her success, 71–72
response to Martin report,
 122–23
sales career, beginning of, 67
selling art, style of, 66–67, 68
settlement, reaction to, 176
suddenly front-page news, 136
supporters' position re,
 187–88
toast of the town, 102
victim claim, 152
Freedman, Robert, 67
freeports, 22
Frick Collection, 41, 45
Frick, Henry Clay, 41, 44, 53
Fuld, Richard, 182

Gagosian, 50, 72
Gagosian, Larry, 179, 199
Galerie Goupil, 42
Gardephe, Judge Paul, 160, 172,
 175

Gaugin, Paul *(Vase de fleurs)*, 36
Geffen, David, 71
Getty Kourus (fake), 35
Getty Research Institute, 41, 46
 buys Knoedler Gallery archive, 51
Glafira Rosales Fine Arts LLC, 80
Goñi, J.A. Sánchez, 75, 185–86
Göring, Hermann, 29, 60
Gould, Jay, 47
Goupil & Cie, 41–44
Goupil, Adolphe, 42
Goupil, Léon, 43
Grant, Richard, 102–103
Grassi, Marco, 148
Guadagno, Rosanna, 179
Gulbenkian, Calouste, 45
Gulf Stream, The (Winslow Homer), 51–52

Hall-Duncan, Nancy, 33
Hammer family, 1
Hammer, Armand, 45, **96**, 194
 Knoedler Gallery purchase, 47–48
 Rubin and Freeman, hires, 48–49
 Soviet art purchases, 48
Hammer, Armie, 195
Hammer, Dru, 194
Hammer, Michael, **97**, 127–28
 appearance at trial, 174–75
 considered complicit, 158–59
 defense for, 159–60
 enjoying the profits, 107
 gallery townhouse sale, 173
 inattentive to gallery, 72–73
 lawyer's statement re gallery closing, 133

profits from forgery sales, 172
tarnished legacy of, 194–95
Havemeyer, Henry O., 41, 47
Hebborn, Eric
 Drawn to Trouble, 31
 The Art Forger's Handbook, 31
Henry, Martha, 77
Henschel, Charles, 46
Herbert, David, 83
 Flam disputes Motherwell relationship, 119–20
 made part of fraud story, 89–90
Hermitage Museum (Russia) art collection, 45–46
Hernandez, Jason (Jay), 126, 144–46, 177
 opinion re conviction possibilities, 187
high-net-worth (HNW) art collectors, 20–21
Hirst, Damien, 49
Homer, Winslow *(The Gulf Stream)*, 51–52
Hory, Elmyr de (Elemér Albert Hoffmann, forger), 29
Hoving, Thomas, 27
Howard, John, 113, 136
Hunt, Holly, 176
Huston, Jack, 109

International Foundation for Art Research (IFAR), 24, 138, 193
 Pollock authentication report, 103–105
Ismay, J. Bruce, 54
Ismay, James, 54

Janis, Sidney, 83
Jansen, Geert Jan (Van den Bergen, forger), 32
Janssen, Pierre, 119
Johnston, John Taylor, 44
Jones, James Earl, 15–16

Kalantri, Amit, 64
Kelly, Jim, 110, 140
Killala Fine Art, 115, 125
 sues Weissman and Dedalus, 130–32
Kimball, Roger, 68
King's Fine Arts, 78
Klimt, Gustav (*Lady with a Fan*), 27
Knoedler & Co.
 archives, 46
 clients, 41–42, 44–45
 collections of, 44
 Hermitage collection sale, 45
 history of, 41–51
Knoedler building, sale of, 6, 173
Knoedler Gallery, *see also* Goupil & Cie
 buyers respected the brand, 26, 110
 closing of, 40–41, 132–33, 173
 collectors suing, 136–37
 considered complicit, 158–59
 contemporary art post-WWII, 47–48
 decline of, 50, 72–73
 defense lawyers, 159–60
 eclipse of, 50
 fee for Rothko, 110
 financially strapped, 84

fraud triangle circumstances in, 17–18
Freedman's response to closing of, 133–34
Hammer purchase of, 47–48
invitation to Freedman celebration, **99**
Lagrange suit against, 135
Mirvish investment partnership, 111–12
needed miracle, 1–2
no assets, 155
no defense of reputation, 131
profits from forgery sales, 88, 102–103, 105–107, 171–72
scandals and legal disputes, 55–61
stagnates, 72–73
subpoenaed by grand jury, 127
transactional highlights of, 51–54
volume of forgeries sold, 86–87
Knoedler, Edmond, arrest of, 55
Knoedler, Michael, 42–44
Knoedler, Roland, 44, 45, 46
Konnikova, Maria
 Freedman victim of con artist, 189–90
Krasner, Lee, 113
 (*Untitled*), 86

L'Amateur d'Estampes (Honoré Daumier), 54
Lady with a Fan (Klimt), 27
Lagrange, Pierre, 113
 fiery reaction to discovering fraud, 130

meeting with Freedman, 134–35

Lane, William, 137

lawsuits, settling of, 154, 155

Leffmann, Paul, 61

Lehman Brothers, collapse of, 49

Lessons from the Knoedler/Rosales Affair (panel discussion), 192–93

Levy, Jack, 103, 105

Lewinsky, Monica, 15

Lohse, Bruce, 60–61

Lucheng Museum, China, displaying forgeries, 37–38

Lustig, Victor, 190

M. Knoedler & Co., 44

Made You Look (documentary film), ix, 13, 62
 De Sole's participation, 11–13
 Freedman's participation, 9–11, 13, 15–16, 179–80
 Freedman's reaction to, 181
 impact of, 180
 trial insights, providing, 153–54

Madoff, Bernie, 88

Madonna and Child Enthroned with Four Angels (Piero della Francesco), 53

Manny Silverman Gallery, 137

Marchesa Elena Grimaldi (Anthony van Dyck), 52

Mark Hotel, the, 6–7

Martin Hilti Family Trust, 136

Martin, James
 assessment of Rothko painting, 157

forensically tested Motherwell paintings, 120–22
 Motherwell forgery report and meeting, 123–24
 testimony, 168
 trial assessments, 157

Martin, Steve, 31

Mary Boone Gallery, 50

Matisse, Henri *(Odalisque)*, 56

media
 Nikas description, 162–63
 response to Freedman, 152
 trial coverage, 161

Mellon Bruce, Ailsa, 41

Mellon, Andrew W., 41, 44, 45
 Hermitage art, purchase of, 45–46

Mellon, Paul, 41

Messmore, Carman, 46

Metropolitan Museum of Art (the Met), 41, 194
 fake art at, 27–28
 provenance research role, 38

Miami Basel, 40

Michelangelo, forgeries of, 28–29

Miller, Michael H., 152
 comment on trial, 175–76

Mirvish, David, 52, 111, 135, 174
 Freedman, relationship with, 111–13, 124
 Rosales collection investments, 111–12
 sues Knoedler, 136, 137

Mnuchin, Robert, 192

money laundering, art market and, 39

Morgan, J.P., 47

Morrisseau, Norval, 37

Motherwell paintings

doubts re authenticity, 117
Elegies to the Spanish Republic,
114–15
Flam testimony re, 169–70
identified as fakes, 118–20
sales chain of forged painting,
123
Spanish Elegy 1953, 115–16,
124–25
Motherwell, Robert, 66, 68, 72
Dore Ashton cites possible
reaction of, 188
Mr. X, 85, 89–90, 106, 120
not available to meet, 106
Munsch, Edvard *(The Scream),* 6
Museum of Modern Art
(MOMA), 41
Myatt, John (forger), 29–30

Nasr, Laili, 92, 93, 166
Nazi-looted art
German claims process, 58
Knoedler Gallery disputes re,
55–61
legal battles over, 60–61
Pissarro painting in Spain,
59–60
Neiman, LeRoy, 72
Neubauer, Lilly Cassirer, 57–59, 60
New York Abstract Expressionist
School, 66
Nikas, Luke, 14, **98**, 112, 127
assessing impact of plaintiffs'
testimony, 155–57
buyer beware defense strategy,
160, 167
FBI, response to, 149–50
focus groups, 154–55

Freedman supporter, 187–88
how to tell Freedman's story,
156
joke re prevalence of fakes, 28
media statement re trial,
175–76
playing to jury, 164
provenance, comments on,
26–27
trial opening statement,
162–63
trial preparation, 153–55
No. 10 (Mark Rothko), 141
non-fungible token (NFT) digital
art market, 20

Odalisque (Henri Matisse), 56
Officer and Laughing Girl (Jo-
hannes Vermeer), 53
Olitski, Jules, 176
Orion Analytical
declares De Sole Rothko a
fake, 141
forensically tested Motherwell
paintings, 120–22
trial assessments, 157, 158
Orlando Museum of Art, 125
Ossorio, Alfonso, 104, 193

Parker, Dorothy, 179
Parrish, Martha, 137, 172–73
Parsons, Betty, 83
Pei-Shen Qian, 32, 74, **97**
background, 78–79
Bergantiños and, 79–80, 82, 88
claimed innocence, 151
forgery prices increased, 82

implicated but fled to China, 145–46

inspired by modern art, 78–79

life post-scandal, 182–83

prices paid for forgeries, 79, 82, 88, 106

Perenyi, Ken (forger), 31

Pfeiffer, George E., 55

Picasso, Pablo
The Actor, 61
Femme à la montre, 27

Piero della Francesca (*Madonna and Child Enthroned with Four Angels*), 53

Pissarro, Camille (*Rue Saint-Honoré in the Afternoon. Effect of Rain*), 57–60

Polcari, Stephen, 128, 166
endorsed full Rosales collection, 92–93

Pollock-Krasner Foundation, 112, 113

Pollock, Jackson, 37, 66
Untitled 1949, 103–105, 111

Portrait of Philip IV in Fraga, The (Vélasquez), 53

provenance, *see also* fakes, forgers, forgeries
anecdotal, 24–25
defined, 24
forgers and, 34–37
ideal, characteristics of, 25–26
importance of, 25
missing documentation and, 26–27
Rothko fraud story re, 4
signature not considered as, 26
types of, 24–25
vs. value appraisal, 25, 26

withholding, 26

Rauschenberg, 72

Reisbaum, Emily, 157, 161
media statement re trial, 175
opening statement, 161–62
opinion of Freedman's case, 189
trial preparation, 157–59
witnesses deposed, 158–59

Rembrandt
Self-Portrait, 52
The Visitation, 54

Renoir, Pierre-Auguste (*Bal du moulin de la Galette*), 27

Richard Feigen Gallery, 137

Rittner & Goupil, 42

robber barons, art purchases, 47

Rockefeller, Clark, 77

Rockefeller, John D., 47

Rogers, Katy, 117

Rosales, Glafira, **100**
abuse claims, 184
arrested and charged, 142–44
background, 75–76
confession and sentencing, 147–48
daughter, 77
fee for Rothko, 110
first meeting with Ann Freedman, 1–4, 82–84
fraud story, 4, 84–85
Freedman knew little about, 106
Freedman memo to, 120–21
Freedman's art purchases from, 4–5

THE DEVIL WEARS ROTHKO

groomed to sell forgeries, 80–81
life post-scandal, 183–85
Long Island home, 107
profits from forgeries, 105–107
response to suit settlement, 132
takes the fifth, 158
targeted by FBI, 126–27
tax charges against, 145–46
Rosenberg, Elaine, 56
Rosenberg, Paul, 56, 61
Rothko, Christopher, 92, 166
Freedman claimed authentication by, 109–10
Rothko, Mark, 66
catalogue raisonné in works, 85–86, 92
No. 10, price of, 141
status in art world, 3
Untitled (*1956*), **101**, 108–11
Rubin, Lawrence (Larry)
hiring of, 48
Jaime Andrade as his assistant, 83
president of Knoedler Gallery, 67, 69
retirement of, 49, 50–51, 70–71
Rubin, Richard, 123, 124
Rubin, William, 69
Rue Saint-Honoré in the Afternoon. Effect of Rain (Camille Pissarro), 57–60

Sabah, Sheikha Paula Al-, 114–15
Saff, Donald, 49, 70

St. Francis in the Desert (Giovanni Bellini), 53
Salle, David, 50
Sandler, Irving, 92, 166, 167
Schaus, William, 43
Scheidwimmer, Jakob, 57–58
Schiff, Lisa, 50
Schmerler, Charles, 127, 133
buyer beware defense strategy, 160, 167
defense lawyer, 159–60
Flam testimony, frustration with, 169–70
opening statement, 163–64
Schnabel, Julian, 50
Schoenberg, Sydney, 58
Schöni, Frederic, 61
Scream, The (Edvard Munch), 6
Scully, Jim, 109
Sea and Mirror (Ross Bleckner), 180–81
Seattle Art Museum, dispute re Matisse painting, 56
Seifert, Roger, 171–72
Self-Portrait (Rembrandt), 52
Seymour, Jane Margaret, 54
Sheffer, Adam, 193
Shidler, Jay, 86, 119
Shnayerson, Michael, 68, 152
Simmons, Lucian, 38
Skarlatos, Bryan, 183–84
Soli Corbelle Art, 77
Soli-Diaz Corbelle, Isolina, 77, 106, 184
Sotheby's, 38–39, 49
De Sole chairman of, 109
declined Lagrange's Pollock, 130

219

domination of established art
market, 73
Spangle, Morgan, 116, 117, 123
Spanish Elegy 1953 (Motherwell),
115–16, 124–25
Spencer, Ron, 112, 187
Spoutz, Eric, 36
Spring Sowing (Jacopo da Ponte),
56–57
Springfield Library and Museum
Association, 56–57
Steinbeck, John, 139
Stella, Frank, 69, 176
Storr, Robert, 193, 194
Stout, Martha, 64
Streep, Meryl, Freedman com-
pared to, 2, 7
Stuart, Robert Leighton, 44
Sulzbacher, Julius, 58

Taubman, Nicholas, 103, 115, 137
tax evasion, art market and, 39
Taylor, Tim, 113
Tempest, The (Shakespeare), 17
Terrus, Étienne, fraudulent works
of sold, 36
Thaw, Eugene, 121
Thyssen-Bornemisza Collection
Foundation, 59
Thyssen-Bornemisza, Baron Hans
Heinrich, 58–59
tolling, 57
trial, 151–77
beginning of, 160–61
buyer beware defense strategy,
160, 167
De Sole testimony, 165, 166
defense lawyers, 153, 159–60

defense opening statement,
162–64
Del Deo testimony, 173
experts deny authenticating,
166–67
fraudulent vs. negligence, 164
Freedman reaction to, 178–80
Gallery defense opening state-
ment, 163–64
Hammer appearance at,
174–75
issues at stake, 161
Knoedler reliance on forgery
sales, 171–72
Martin testimony, 168
Parrish testimony, 172–73
parties settle suit, 175–76
plaintiffs' lawyers, 157–59
prosecution opening state-
ment, 161–62
reactions to settlement,
175–77
risks of for defendants, 154
Rothko painting displayed at,
160, 171, 175–76
settlement discussed, 158
witness and expert testimony,
163–74

UBS (investment bank), 18, 19
Uffizi Gallery, 56
United Kingdom (UK) art market,
8, 20
United States (US) leading art
market worldwide, 19
Untitled (1956) (Mark Rothko),
101, 109–11,

Untitled (Lee Krasner), price charged for forgery, 86
Untitled 1949 (Jackson Pollock)
 IFAR couldn't authenticate, 103–105
 Mirvish purchases, 111
 new provenance for, 105

Valentiner, W.R., 54
van Dyck, Anthony, 44
 Marchesa Elena Grimaldi, 52
van Gogh, Cent, 43
van Gogh, Theo, 42
van Gogh, Vincent, 42
van Meegeren, Han (forger), 29, 35
Vanity Fair, 68, 186
 Michael Hammer profile, 194
Vase de fleurs (Gaugin forgery), 36
Vélasquez *(The Portrait of Philip IV in Fraga),* 53
Vermeer, Johannes
 Christ at Emmaus, 35
 Officer and Laughing Girl, 53
Vibert, Théo, 43
Visitation, The (Rembrandt), 54
Voss, David (Morrisseau fakes), 37

Weissler, Edye, testimony of, 165
Weissman Gallery, 124–25
Weissman, Barry, 130–32
Weissman, Julian, 87
 authenticating Motherwell's *Spanish Elegy 1953,* 115–16
 Freedman unaware of sales to him, 119

selling Motherwell forgeries, 114–16
Welles, Orson *(F Is for Fake),* 29
White, Frances Hamilton, 103, 136
Whitney, The, 41
Wick, Oliver, 108, 114, 137
Widener Collection, 44
Widener, Peter A.B., 52
Wilde, Oscar, 64
Wilkins, Karen, 192
Wolfe, Catharine Lorillard, 44

Zhang Hongtu, 79
Zhang Libing (forger), 37
Zuckerman, Laurel, 61

ACKNOWLEDGMENTS

TO JAY HENNICK FOR always finding the best stories; to Kyle Loftus and Steve Fisher, my agents at IAG; to Debra Englander, Caitlin Burdette, Aleah Taboclaon, and the *Post Hill Press* team; to Maura Blain Brown—index editor; to the Fortier PR team; to editorial and research assistants Sanda Fischer and Heidi Blaire; to art director Josh Sinclair; to my friend Steve Paikin for giving this the once-over; to Mark Selby, Raluca Alexe, and David Steinberg; and in particular, to my muses Max and Sloan, and all of the galleries that continue to seduce me every season with beautiful art.